Sketchbook Confidential

Secrets from the private sketches of over 40 master artists

edited by Pamela Wissman *and*
Stefanie Laufersweiler

NORTH LIGHT BOOKS
CINCINNATI, OHIO
www.artistsnetwork.com

Table of Contents

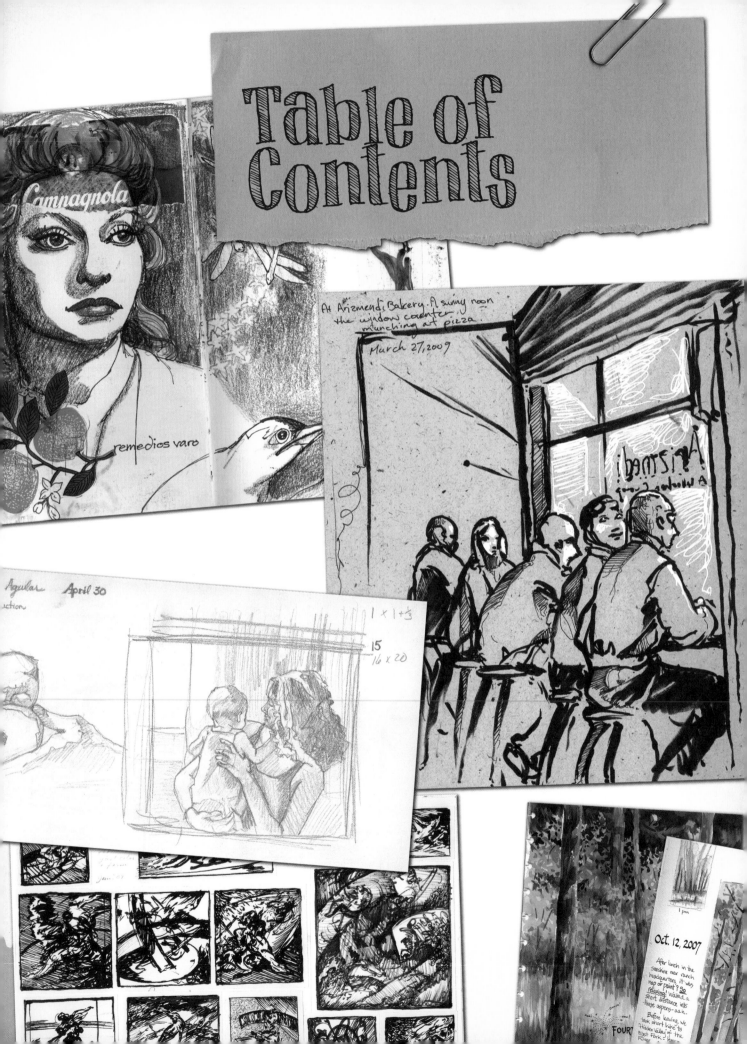

Campagnola

remedios varo

At Arizmendi Bakery. A sunny noon the window counter munching at pizza.

March 27, 2009

Aguilar April 30

1 x 1 + ⅓

15
16 x 20

Oct. 12, 2007

After lunch in the sunshine near ranch headquarters, it was nap or paint? So relaxing! Walked a short distance into Hidden Valley of the East Fork – then

Before leaving, we took short hike to Hidden Valley of the East Fork – then

1 pm

INTRODUCTION 5

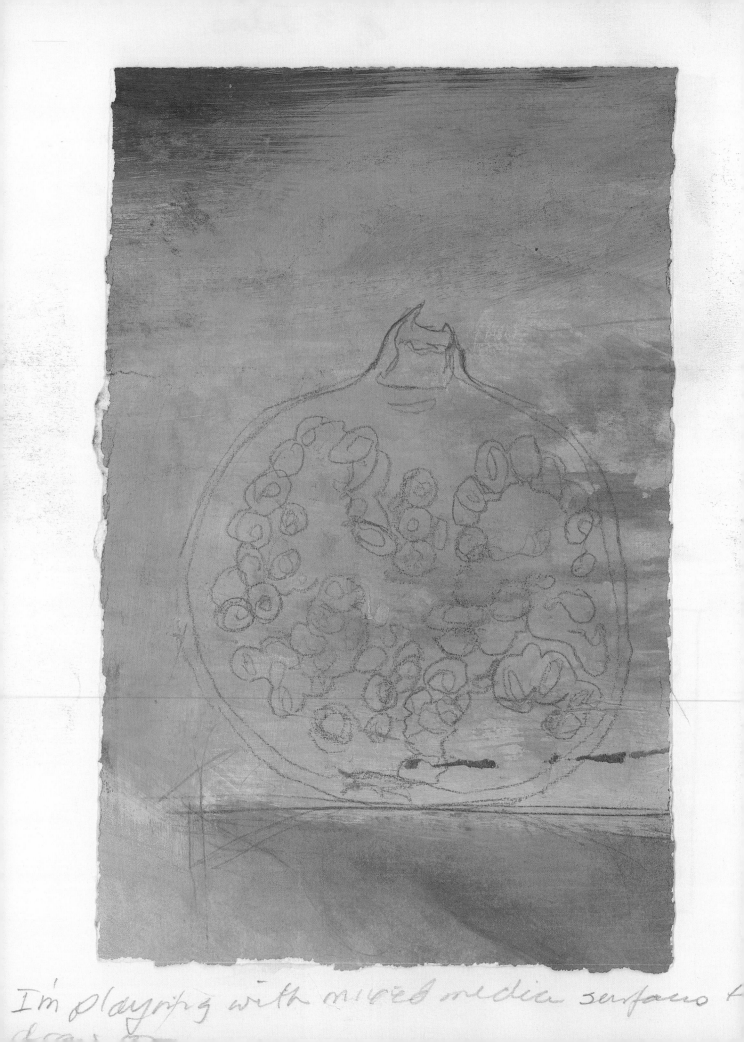

I'm playing with mixed media surfaces +
drawing

Introduction

Most of the pieces here were produced quickly, intended to be transient, not for public view. They provide a place to work out creative ideas and problems, or just have fun—arranging forms, dealing with life, escaping, studying subjects, trying approaches, getting "one of those days" down on paper. They range from traditional to unexpected. They come as loose drawings, sketchbooks, journals and colorful painted sketches. Some were done on location or en plein air. Some are small, while others are sizeable. Whatever they are, they reveal something about the creative processes, inner history and finished work of the artist.

Thank you to all of the wonderful artists presented here who were eager to participate and patient with our demands; as well as Stefanie Laufersweiler, Wendy Dunning and all the editors and production staff at F+W Media for making the process of this book as smooth as it possibly could be. You are all such pleasures to work with.

Pamela Wissman

Editorial Director
North Light Books

OLIVE TREE
GARDEN OF GETHSEMANE
"of all the cities, mountains, places
where the atonement may have taken
place, it took place here."

The Garden Tomb.
owned by the Garden Tomb Association of
London England (the place of a skull)
Golgotha- Bus Station was quarry-
many O.Jews were stoned by this quarry
common criminal not given proper burial-
or the Hill - called Skull hill locally-

108

180 yrs to build this temple but
work stopped many times
TEMPLE AT KARNAK

Still
excavating here.

- 3 religions represented -

Robert T. Barrett

A painter, muralist and illustrator, Barrett also teaches at Brigham Young University in Provo, Utah. He has worked for Random House, HarperCollins and OUTDOOR LIFE magazine, among numerous other publishers, and he illustrated a book for kids on President Barack Obama (OBAMA: ONLY IN AMERICA, Marshall Cavendish Children's Books) as well as a companion book on the life of Michelle Obama. His book LIFE DRAWING: HOW TO PORTRAY THE FIGURE WITH ACCURACY AND EXPRESSION was published in 2008. He was selected by the Society of Illustrators in New York as their 2010 Distinguished Educator in the Arts.

As a writer may keep a written journal of their life's experiences, so an artist keeps a sketchbook. An artist thinks, feels, sees and draws.

I sketch for different reasons but primarily as a way to document visual experiences or to solve various problems. I draw pretty much every day even if only for short periods of time. Drawing regularly is a way for me to practice my motor skills as well as to keep my visual/spatial aptitudes sharp.

I sketch both in a formal sketchbook and in the margins of paper while in various meetings. I also sketch for students in classes I teach to demonstrate different ways for solving visual problems. When I draw in meetings, I usually draw from my imagination or from memory, which is a great way to determine what you understand without a model or other subject matter.

*Young there waiting
for turn of
the*

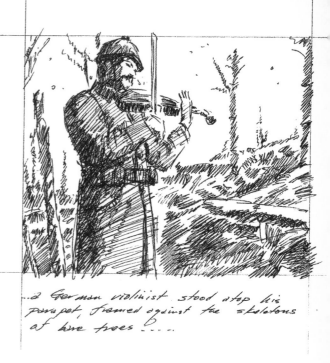

*...a German violinist stood atop his
parapet, framed against the skeletons
of bare trees*

As an illustrator, I often do quick sketches as a way to
explore various compositions for more finished illustra-
tions. My sketches are often the seeds or seed beds for
more ambitious creative works. Unless I'm just doodling
or practicing, I try to think about the visual problem
I'm trying to solve. I often like to draw on toned paper,
which is a quick way to establish a full value drawing.

Sketching is usually a quick way to explore a variety
of subjects including motion, perspective, construction,
proportion, composition, value, etc. One consequence of
drawing quickly is the need to edit and simplify, which
usually makes a visual idea more powerful.

Sketching tends to be more spontaneous and ener-
getic and of much lower risk than a complete painting.
Because it is low risk, sketching is perhaps more honest
and is often more creative.

*Because it is low risk, sketching is
perhaps more honest and is often
more creative.*

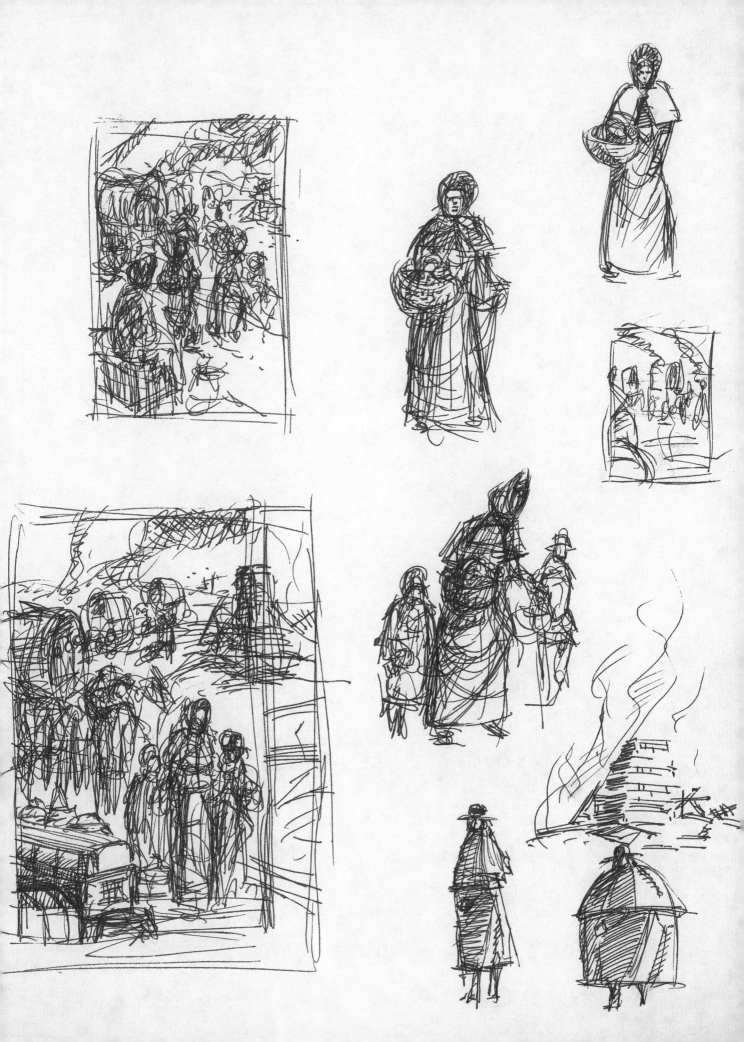

Dan Beck

After high school graduation, Beck took to the road and began a string of jobs ranging from a ranch hand in Arizona to a soldier on a two-year tour in Germany. For his own pleasure, Beck carried his cherished sketchbooks and journals wherever he went, which ultimately led him to pursue art as a career. Now settled in Colorado and "firmly rooted" in the tradition of Impressionism, Beck paints figures, still life and landscapes in oils and pastels. He has earned six consecutive Oil Painters of America awards of excellence (three national, three regional).

Sketching is a way to think visually. I sketch on a regular basis to work out compositional ideas, to stay in tune with the drawing aspect of painting and to just connect with my subject in a no-pressure situation. There is a freedom about sketching that keeps me grounded, and it's just plain fun.

With the sketch I feel an immediate dialogue back to myself. It doesn't matter much what media I use—pencil, ballpoint pen, charcoal, color pencils, pastels. I like to sketch with a variety of tools. Often, just to see marks on paper is enough to get the juice going, to feel that urge to paint.

I think sketching works because it eliminates the complexities of painting. It allows one to see the essence of the subject or the idea or even to find that idea. It's much harder to do that when dealing with color mixing, painting application, etc.

Sometimes I sketch to see that essence of what will become a finished painting. Sometimes I sketch just to doodle around. That fun aspect to sketching is very important to maintain. I think and hope that the spontaneity of sketching carries over into the painting and that the daring and innovative qualities that come so easily in sketching translate into painting.

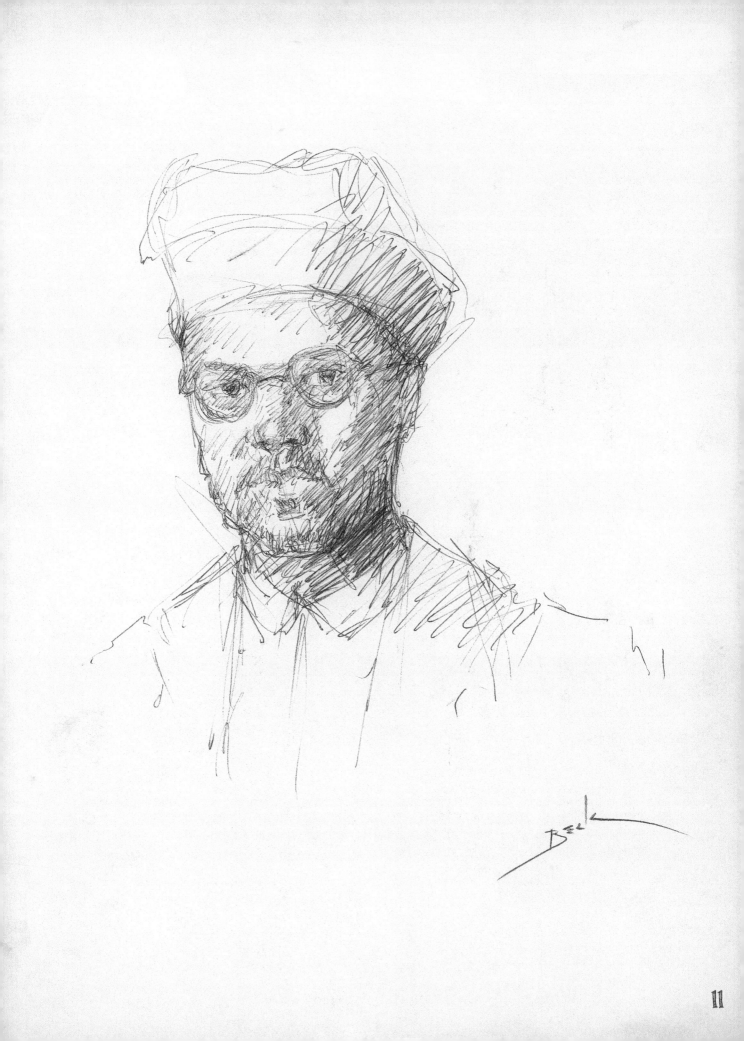

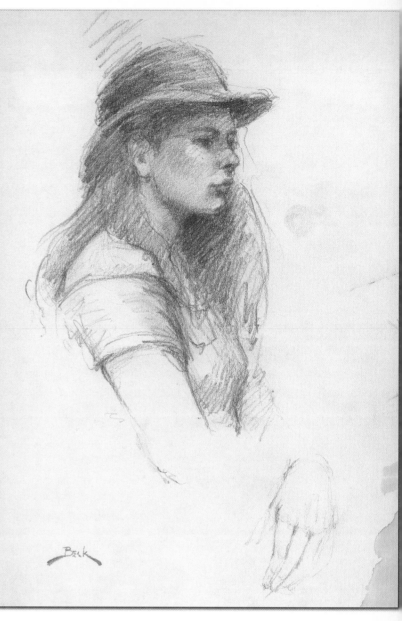

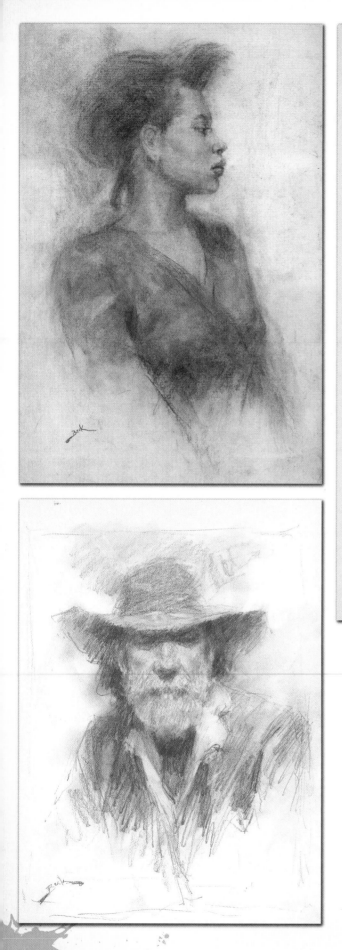

I think what and how I sketch is definitely an ongoing teaching aide, showing me how I see the world and life. I sketch until the image "feels" right. What feels right shows me how I see and feel.

Another aspect to sketching is that it is just good practice in regards to drawing, and drawing is the most important skill in holding a painting together.

Beck

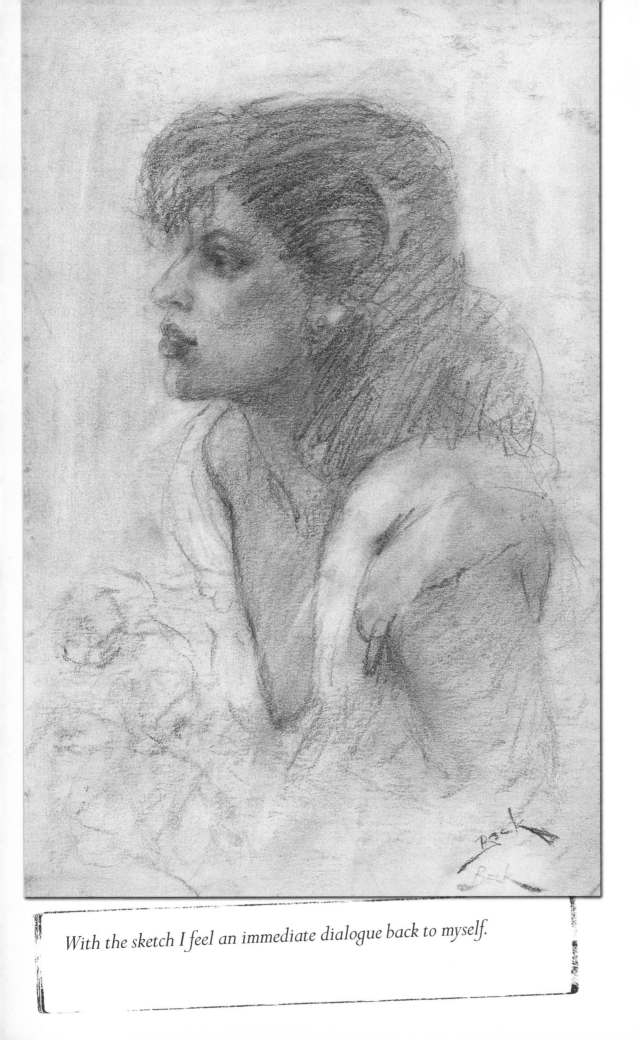

With the sketch I feel an immediate dialogue back to myself.

William Berra

Living in Santa Fe, New Mexico, Berra regularly spots painting possibilities in his daily surroundings, but he also travels abroad for inspiration as often as he can. He experimented briefly with abstract expressionism and nonobjective painting before turning his focus to plein-air painting, although Berra now completes many of his oils in the studio. A painter of Impressionistic landscapes, still life and figures, the Pennsylvania-born artist has appeared in over forty competitions and shows, including group and solo exhibitions.

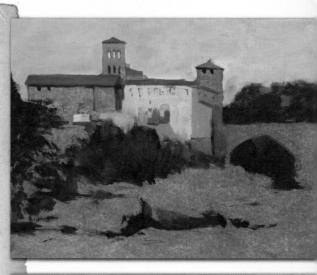

The opportunity to have an intimate moment with the scene before me inspires me to sketch. Sketching in nature is a very spontaneous experience that grants me the freedom to ignore the rest of the world and concentrate on the image before me.

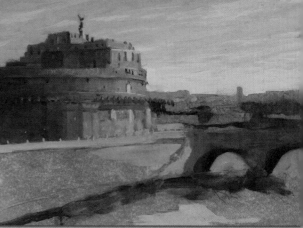

I sketch when traveling, when investigating a new subject, or when I need to refresh a particular motif that I have worked with in the past. I execute the sketches in a half hour or less in order to retain a quick impression of a particular moment in a particular place: if I spend more time on it, if I labor over it, I lose the fresh joy of the moment.

When sketching, I think only of my immediate surroundings. I am totally engrossed in the subject, the change of the weather and the environment. It is a very refreshing experience, being in the moment.

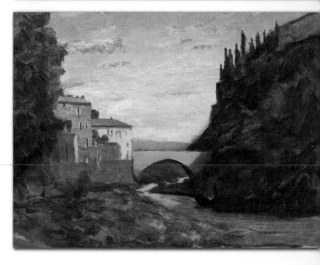

I try to achieve various objectives in these small, quick works: in some I am working out a composition, in others I am trying to capture the moment's light, in others a color scheme. Each sketch brings a different experience. For example, when executing a sketch of Tiber Island, Rome, the light on the building at that moment was positively iridescent, a mosaic of color. The sketch was devoted to capturing that impression of light: all else was superfluous.

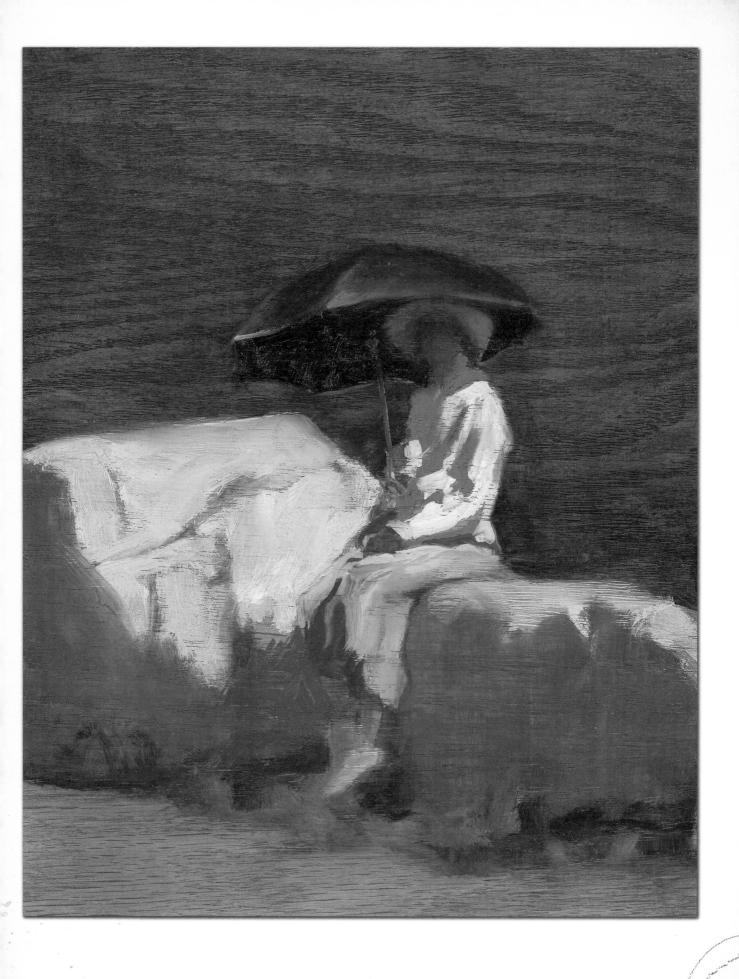

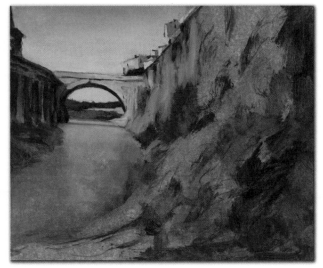

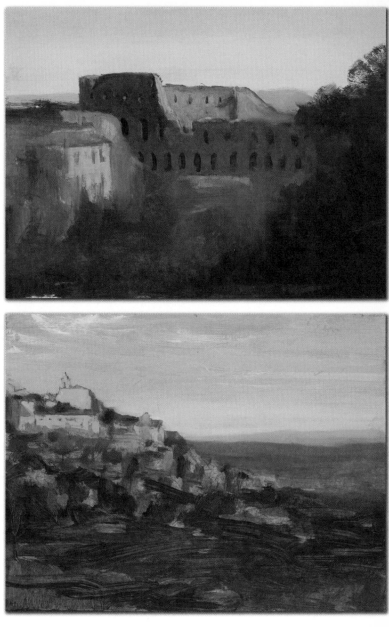

Sketching provides feelings of spontaneity, freedom and exploration. I don't have the pressure of having to produce a finished work, but instead can feel free to concentrate on any aspect or aspects of a subject that interest me at that moment.

I sketch in oil paint, so you can see my signature brushwork in my painted sketches. You have my artist's shorthand. The sketches provide a great springboard for a finished painting. A completed painting may incorporate one or many sketches.

The world provides infinite interest and variety. It's impossible to look at something too closely or too often; you always see something more. Often, a sketching session leads to finding a motif that I didn't expect: I go out looking for a particular subject but find something else. Everything changes: I experience the wonderful surprise of discovering something utterly new.

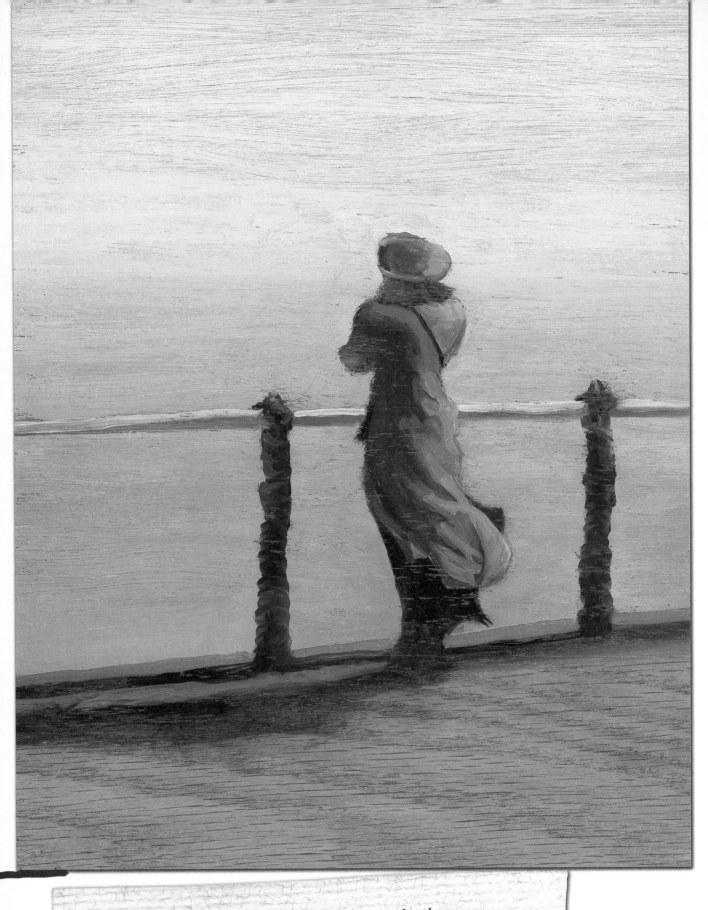

It's impossible to look at something too closely or too often; you always see something more.

Roberto (Bob) Cardinale

Churches hold a special significance for Cardinale: "The church form speaks to my love of ecclesiastical architecture and springs from my monastic background as a Benedictine monk and my travels." His sculptures of real and imagined churches, towers and synagogues, many of them commissions, are made of pine and richly painted, average about 16 inches (41cm) tall and require 60 to 90 hours each to make. The Santa Fe artist (originally from Colorado) has made over 400 of them, focusing on the churches in New Mexico, Texas, California and Mexico, and many from the Tuscany region in Italy.

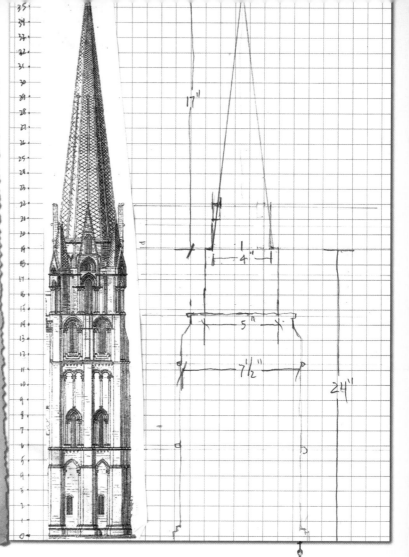

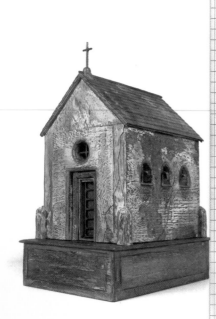

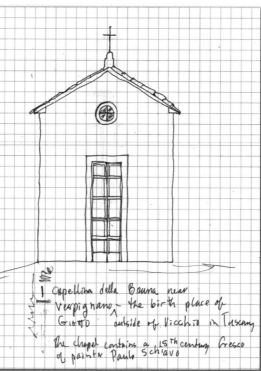

Cappellina della Bruna near Vespignano — the birth place of Giotto outside of Vicchio in Tuscany

The chapel contains a 15th century fresco of painter Paulo Schiavo

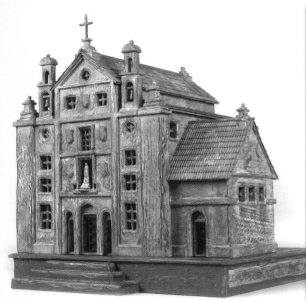

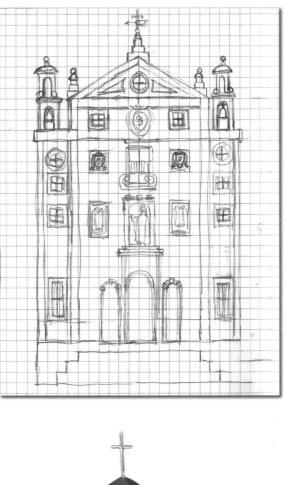

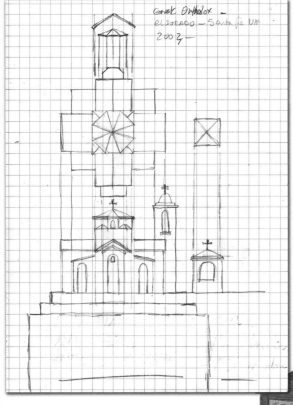

Greek Orthodox —
Eldorado — Santa Fe NM
2002

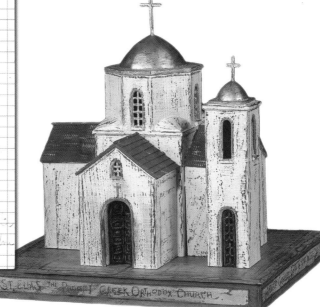

I journal mainly when I travel as a way of capturing some sculptural element of a church or other structure that will remind me of my emotional response when I first saw the building. I sketch mainly to get a feel of the piece that I want to sculpt, and often to work out some problem or way of achieving some detail.

Most often, this is in the evening as that is when I spend the most time in my studio, and the distractions of the day are pretty much behind me. I usually use a no. 2 or other soft pencil and often work on grid paper. Many times, I sketch directly onto the wood that I am going to work with.

When sketching, I try to be very conscious about the feeling of the piece and what part or parts I have to exaggerate in order to get the feeling that I am after.

When I sketch, I feel very open and relaxed, as I am not trying to do a finished or important drawing. It's as if I'm just thinking about a form and not trying to create one. The sketch is free to do what it wants, and I feel no need to exert control over it.

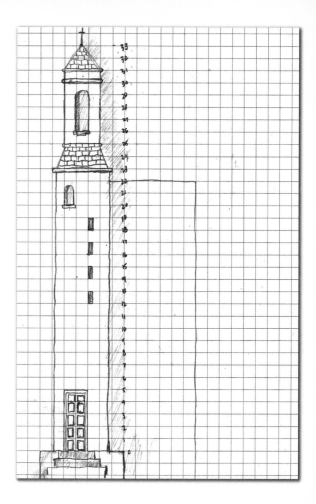

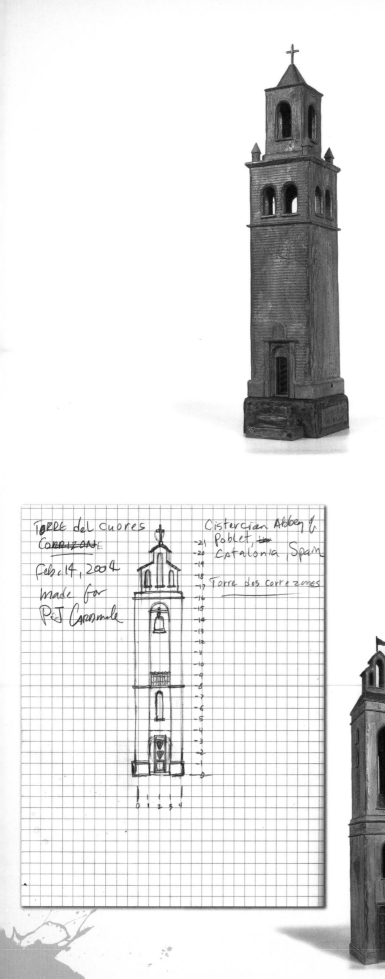

I like the fluidity and freedom of sketching as it allows me to wander through the ideas in my mind. Sketching helps me to think out loud as it were. It is fanciful and doesn't have to go anywhere or be something specific.

Sketching lets me be free of material and process. I don't have to worry about the cost of material or the logistics and tools that come into play in doing a three-dimensional piece.

My sketches only suggest the physical work, and often after I sketch some detail of the piece or the overall idea of the piece, I set the sketch aside and get directly to work.

Sketching helps me see detail that my eyes would miss if they were not guided by my pencil.

Roberto Cardinale

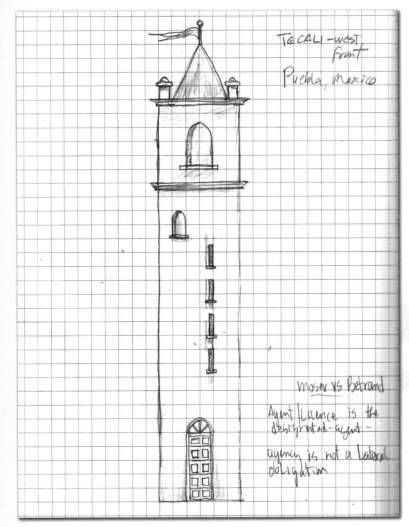

TECALI - WEST
front
Puebla, Mexico

Moser VS Betrand

Agent/Licence is the
designated agent -

agency is not a Lateral
obligation

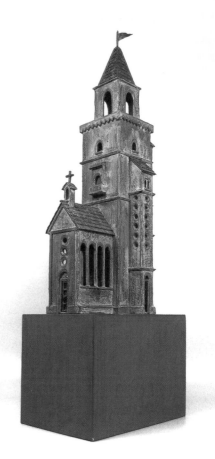

Sketching helps me to think out loud as it were. It is fanciful and doesn't have to go anywhere or be something specific.

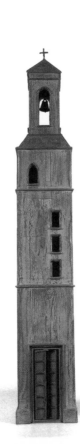

34 spaces

60"

81"

21"

24x18x4

21

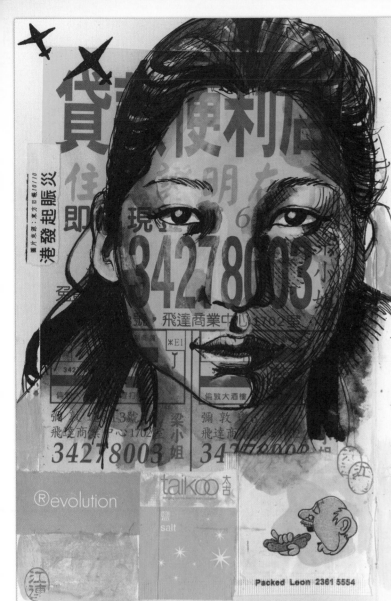

Oct. 8

There are few hours more satisfying than the first spent in a foreign country — after the 14 hour planes, the layovers, the border crossings, the long, exhilarating drive from an airport to a city, the uncertainty of the pension one has chosen ~ (is it full? does it still exist?) — after all of this, one steps into a cramped, but decent room, throws open the window where one is hit all at once in the face with the balmy breeze of the unknown — familiarly unfamiliar sounds and smells from the night street below. No shower equals the shower taken after a full 24 hours or more of travelling, no sleep quite so sound and sweet, no morning so bright and full of potential...

erin Currier

Activism and art-making are inseparable for Currier. Her passion for artistically addressing social inequality and economic disparity has grown with her travels. The native New Englander has immersed herself in the daily life of countries such as Nepal and Nicaragua—thirty-five in all—returning to her Santa Fe studio to create works which are part portraiture, part collage with refuse collected from those places. "I travel the world's streets collecting the discarded with which to portray the discarded," says Currier, who describes her art as "part sociopolitical archive, but wholly humanist."

No person, place or object is exempt, immune or overlooked by my pen and sketchbook! But I am particularly inclined to sketch people: my own friends, family and myself, as well as people I meet when I am traveling—people on trains and buses, in parks, plazas and cafés. I am especially inspired by urbanscapes.

I draw every day. I keep moleskin journals, though sometimes I draw on brown paper bags, butcher paper or scrap paper and glue it in later. I use brown or black pens and china markers.

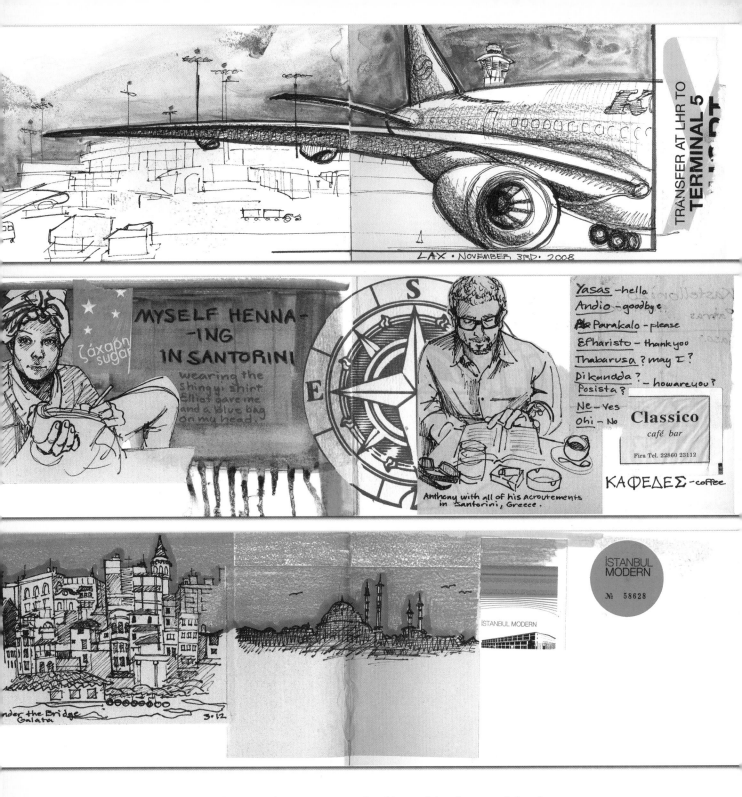

When I travel to other countries, I sketch constantly, in order to archive and absorb what I am experiencing in a way that is more profound and personal than snapping a photo. I also sketch when I am at a dinner party or out at night with a group of friends. I can tolerate frivolous banter if I am drawing; I can tolerate mediocre music, tasteless food and pointless conversation. As long as I have my sketchbook, I am having a good time! My parents could bring me anywhere as a child. As long as I had a box of crayons, I was content.

For me, sketching and drawing extend that place between thoughts—that place which is still conscious, but more contemplative, more meditative.

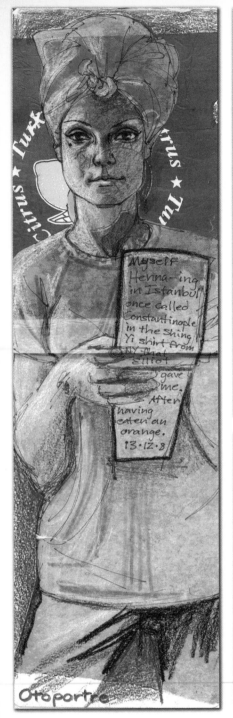

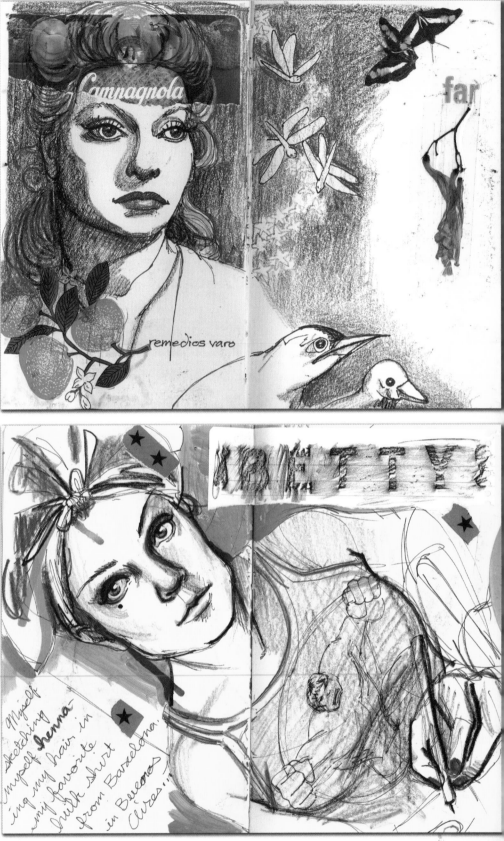

When I travel to other countries, I sketch constantly, in order to archive and absorb what I am experiencing in a way that is more profound and personal than snapping a photo.

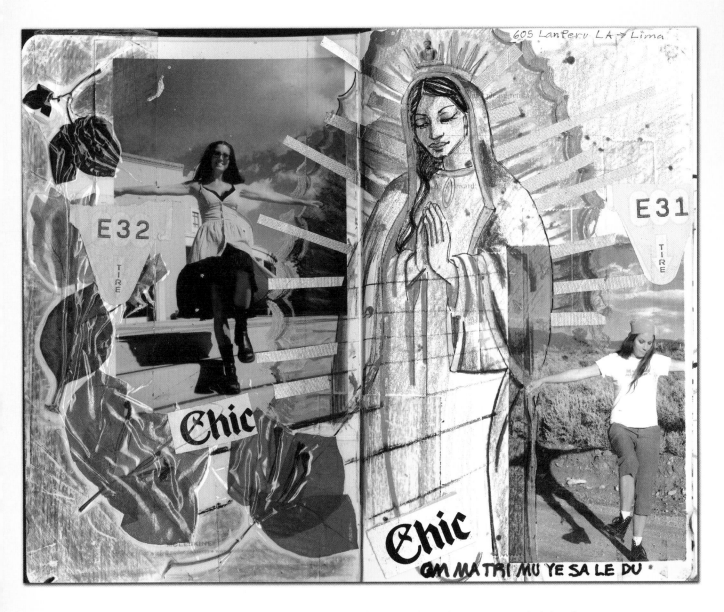

Drawing and sketching are good practice for my larger work and keep my painting freer and less constricted. They keep my eye honest and my hand quick. Sometimes I draw studies that become larger works; regardless, all my big painted collages begin by my drawing them out with marker on board. I am less attached to the outcome of a sketch than I am to a large piece I am working on for an exhibition or commission, and can therefore be freer, more spontaneous and chaotic with my sketches.

Often, when I travel to other countries, I find that drawing is a good way to connect with people—a way that transcends language, age, class and nationality. I often draw people and give them the drawing. Sometimes, in turn, they draw me. Always, we are able to communicate through the process, even if we don't speak one another's language. We share laughs, maybe food, and communicate through art.

George Allen Durkee

A longtime painter of San Francisco's cityscapes, Durkee sought new artistic stomping grounds when he headed for Northern California nearly a decade ago and switched his focus to landscapes. "I read somewhere that an artist ought to risk his career about every two years just as a way of keeping his work fresh," he has explained. "Well, it was time. I was hungry for a new challenge." A contributing writer for THE ARTIST'S MAGAZINE and AMERICAN ARTIST, Durkee is also the author of EXPRESSIVE OIL PAINTING: AN OPEN AIR APPROACH TO CREATIVE LANDSCAPES.

I draw by fits and starts, sometimes not for a week or more at a time. Then again, I may spend whole days moving from one location to another, returning home with a pile of new drawings.

I use sketches to think about ideas for paintings. Thumbnail sketches are an enormous help when planning a composition. My sketches are the beginning stages of my paintings, in simplified form. The structure needs to be there from the beginning. The more I know about my landscape subject, the more liberties I can take when painting it.

A sketch is a way to feel my way into a composition, capturing the light and shadows before the sun arches across the sky and everything shifts. It works out best for me to draw during the same time of day that I plan to paint the subject so I can study the light and see how it's going to change over a period of time.

Vision is such a common human experience that we may think that because we look, we see. To draw, you have to see in the artist's specialized way. Half of drawing is seeing.

When I draw I ask, "What's most important in this landscape? How will I relate it to the rest of the composition so it gets the most attention?" I think about lines and angles; how big is this shape compared to that one? How dark? How light?

Drawing keeps me humble because it is almost never easy. If I want to draw well, I need to pay attention to what I'm doing. Drawing helps me cultivate a quiet mind.

I try to get into a relaxed state when drawing and detach from whether I'm drawing well or not. Sometimes I may need to remind myself that it's just paper. There's less time and effort invested in a drawing or sketch, so you can experiment and take risks to see how an idea works. Doesn't work? Turn the page and try again. It's okay to take a few risks just to see what might happen.

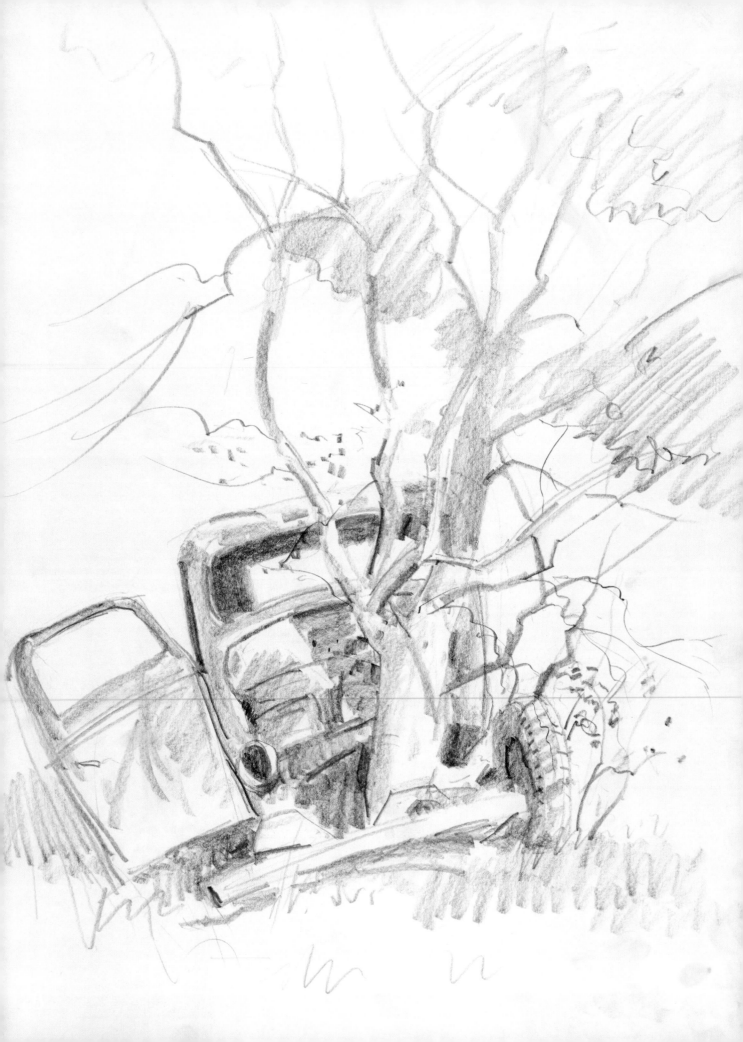

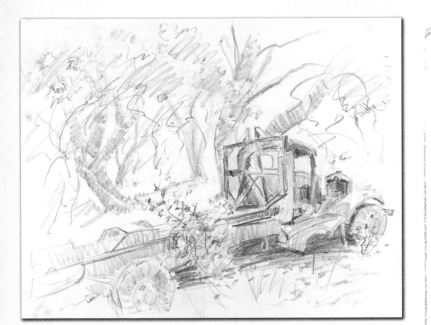

The more I know about my landscape subject, the more liberties I can take when painting it.

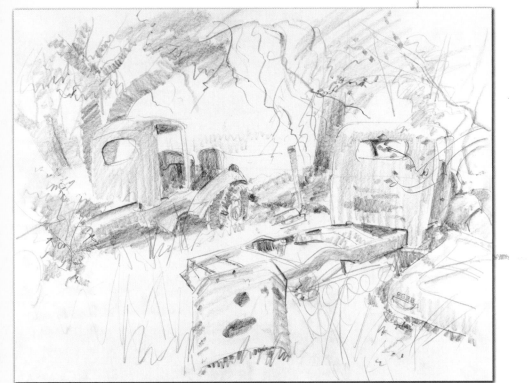

For me, drawing requires mindfulness and inner silence. However, some of the artists in our figure drawing group like to talk and draw at the same time. This drives me nuts! And more so since they draw so well! I would enjoy the community drawing experience more if the loudest voice in the room was a cacophony of pencil strokes, but clearly, my way is not the only way.

Drawing is hard for me. I've been drawing for fifty years and I still struggle. When I draw a lot, I become more fluent, but then it begins to slip away. I should draw more.

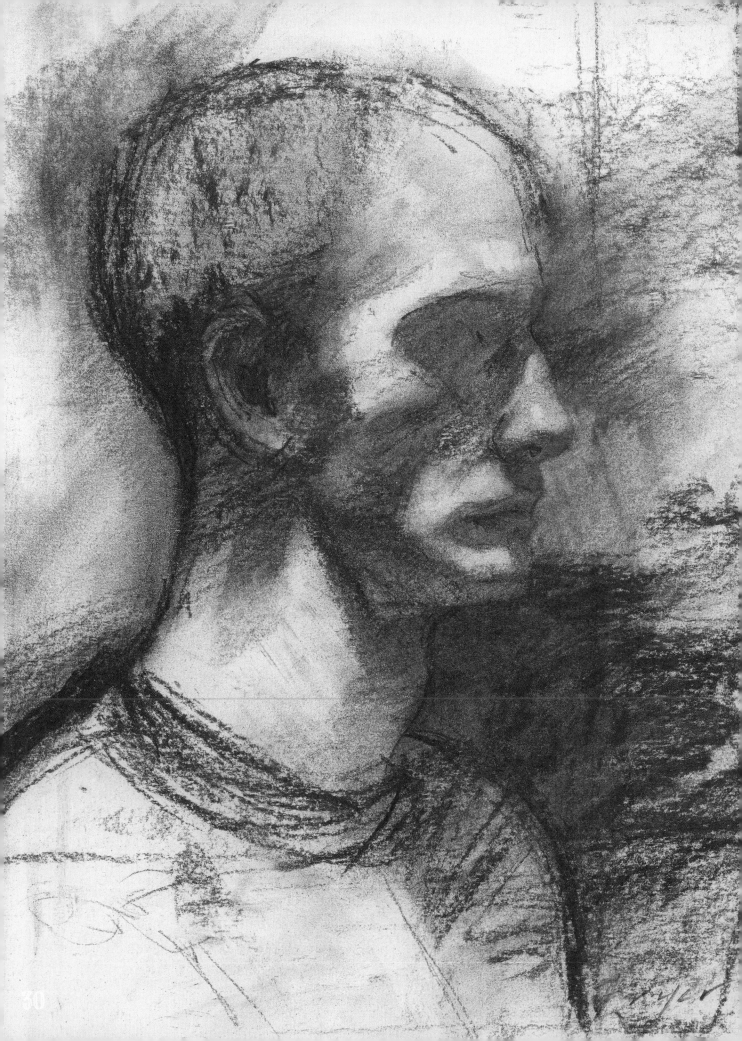

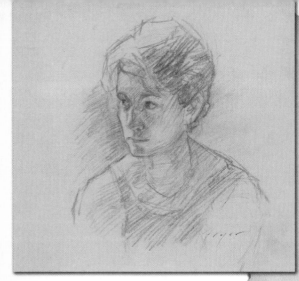

Douglas Fryer

Fryer developed his love of landscape while living in rural Vermont, California and presently in the farmland and mountains of central Utah. He paints primarily in oils but enjoys watercolor, printmaking and digital mediums as well. Fryer has taught fine art and illustration at several universities and art schools, including his alma mater, Brigham Young University, and the Fashion Institute of Technology in New York, and he has illustrated for numerous clients in publishing and advertising. His works are of places, objects and people "that have been significant to me."

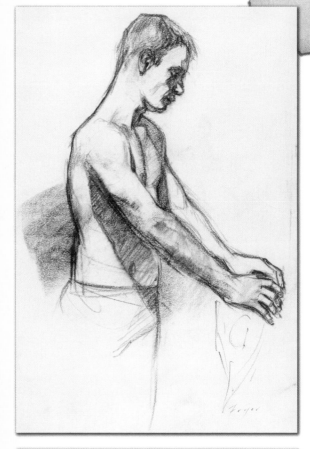

The word "sketching" seems to refer mainly to drawings that are done quickly, with little attention to detail and more attention to concept, gesture and important generalities. Most of the drawing I have done in the past few years has been in relation to preparing compositions for paintings. The best drawings, however, are the drawings I have done from life or from the model. But, even the humorous little sketches from my imagination, made to entertain my kids, have been very enjoyable.

I don't routinely draw or sketch every day, and unfortunately not nearly as much as, say, when I was a student or teaching. I tend to go in spurts, and may do nothing but draw for several days at a time, especially when I am preparing compositions for paintings.

Much of my most valuable and satisfying drawing time is spent in sketching the figure. The immediacy of the process never fails to be an amazing, exhilarating experience. The human form is endlessly fascinating, challenging and beautiful.

Also, I usually do compositional studies as preparation for paintings. These drawings are rarely what anyone would call finished or resolved, but mainly serve the purpose of solving design and compositional problems. Through these sketches I am able to explore the ratios of the rectangle in which I will work, the placement and flow of elements, and the division and balance of space, planes and masses within in the composition. Much of the initial conception and excitement about the finished piece is contained in the preparatory sketches I make. The essential subjects, patterns, relationships, gesture and flow are expressed and explored at an early stage.

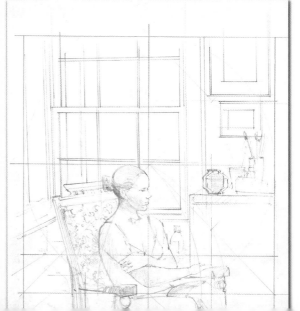

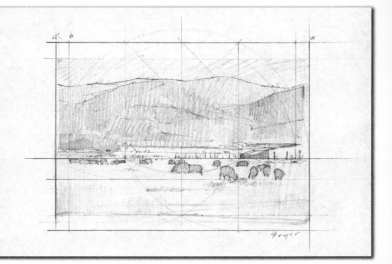

It is rare that anyone sees my sketches or drawings. I don't usually mean for anyone to see them; they are usually only meant to be done.

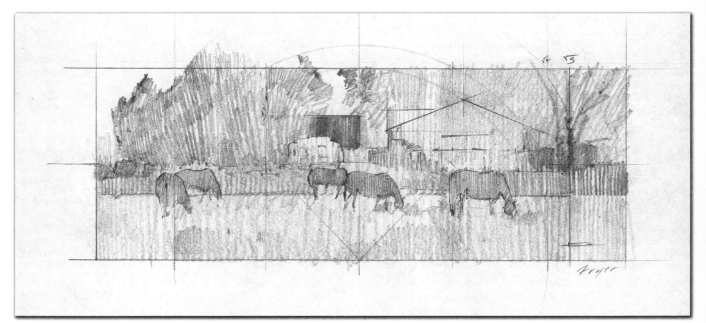

The materials used to create a drawing are intimately tied to the character of the work. When working from the model, I most frequently use a more tonal medium like compressed or vine charcoal, Conté crayon, graphite stick or Nupastel, though sometimes a sharp graphite pencil is better for smaller drawings. Depending on the drawing, I also enjoy using subtractive methods that require different types of erasers. I use various papers (again, depending on the character of the drawing), but mainly look for something with a moderately smooth tooth—nothing too aggressively rough as to upstage the drawing with its texture, but nothing so smooth that it won't hold the pigment. It is also sometimes enjoyable to work on a gray or tan paper, as it adds an element of value and color to the final piece. I sometimes draw with a brush and pen with ink, or even with powdered graphite with brush and water.

Sketching can be a wonderful connection between the artist, his world, his ideas and values. Drawing—or the creating of any art, really—is best when I enter a profound, meaningful and enjoyable state of mind. It can be a physical, mental and spiritual exercise that is both fatiguing and exhilarating at the same time.

A wonderful benefit I have realized from drawing has been in having a greater ability to express and communicate what I feel and what I think. I also love to analyze the form and relationships of things. But I have to consider, apart from the merits of any finished work, that the process of drawing, the activity itself, is revealing and enlightening to me.

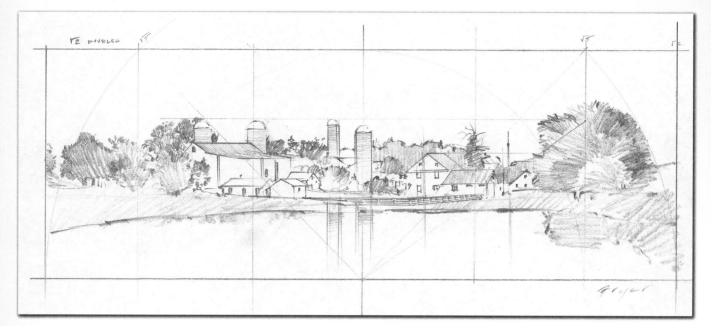

It is rare that anyone sees my sketches or drawings. I don't usually mean for anyone to see them; they are usually only meant to be done. Considering this, I should think that drawing is always freeing, uninhibited and unconstrained. But, unfortunately, I usually fret over even the littlest sketch, judging it as harshly as any finished painting—embarrassed if anyone should see its flaws.

A little planning ahead will certainly help most drawings. Thinking about the balance of elements within the working rectangle, the way the eye will travel and rest, and the relative importance of subjects within the composition should be initial considerations. Of course, the most important element to consider—one that is forgotten too often—is the emotion the subject inspires in you. It is around this emotion that the drawing will be constructed; the emotion will dictate what it wants as expression. Naturally, during the course of the drawing, the artist has to make conscious decisions and judgments: proportion, space, form, line quality, relationships between lines, relationships between adjacent tones, relationships between light and shadow, the quality of the light source. A good drawing (or any work of art, actually) will come after the artist both consciously and intuitively expresses the relative importance, meaning and beauty of all the elements considered.

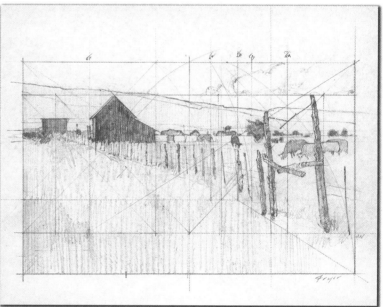

Sketching and drawing, at their best, reveal and confirm important things about ourselves, our values, our motives and our beliefs. Drawings are concrete statements about the artist's state of mind at a given point; they are records of thoughts and processes. However, great drawings and great art don't speak to the viewer's head, but to his heart and to his spirit. Can, or should, all drawings aspire to this? Of course not. But even a little thumbnail sketch can be beautiful and meaningful in fulfilling the purpose of its conception.

Fryer

Tammy Garcia

Born into a family of potters from the Santa Clara Pueblo in New Mexico, Garcia's Southwest-inspired ceramics have been described as "at once instantly recognizable, yet difficult to categorize." Rather than adhering strictly to the Pueblo pottery tradition of carving individual bands into clay, Garcia completely covers her vessels with distinctive designs that reflect her singular contemporary take on cultural motifs. In the past ten years, Garcia has expanded her artistic interpretations to include bronze sculpture, blown and sand-carved glass, and fine jewelry design.

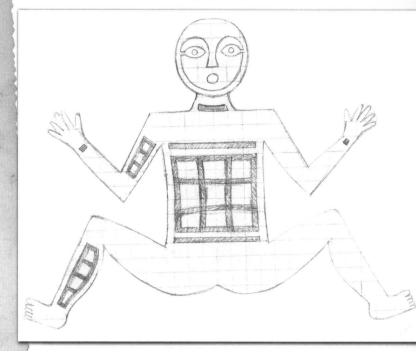

Sketching was never really a part of my art process until about five years ago. When creating pottery, I would draw my designs directly on the vessel without using paper beforehand. The sketch was in my mind, and as I would proceed to translate it to the original work of art, a story would develop. The same is true for much of my work in bronze.

It was only as recently as five years ago that I felt the need to begin sketching. It became a useful tool for me in communicating necessary information when working on what are often referred to as my "bronze boxes." I have also found this process useful when working with glass—both my glass panels and vessels.

I suppose there are hundreds of filled-up sketchbooks stored in the archives of my mind.

Six-year-old Serafina (drawing at left) and ten-year-old Elaina (art below) often create their own artwork alongside their mother as she works.

34

If I had to draw a distinction between working on paper versus working directly on the clay surfaces of my pots, other than the obvious difference, I would say that paper provides me with a greater window of time. I have the opportunity to contemplate and reflect on something a bit longer because I must translate my designs on the pottery before the clay has an opportunity to dry.

Much of my artwork is inspired by Pueblo culture and the storytelling tradition of these native peoples. In the instance of two of my sketches used in this book, I have continued that storytelling tradition. The Mimbres figure is not only representative of an ancient culture, but for me, the figure symbolizes the power of imagination and one's ability to craft a grand story. The horse did not bring radical change for Pueblo peoples, as they have always been considered a sedentary group and mostly a

"foot peoples"; however, the horse did find a place in some aspects of ceremonial life for the Pueblo peoples. My drawing of the horse, which was translated to bronze, represents the spirit of the horse and its place in Pueblo society.

As with much of my artwork, when I draw, it is deliberate; it is with the purpose of creating a final piece. The sketches are continually taking shape in my head. I suppose there are hundreds of filled-up sketchbooks stored in the archives of my mind.

Tammy Garcia

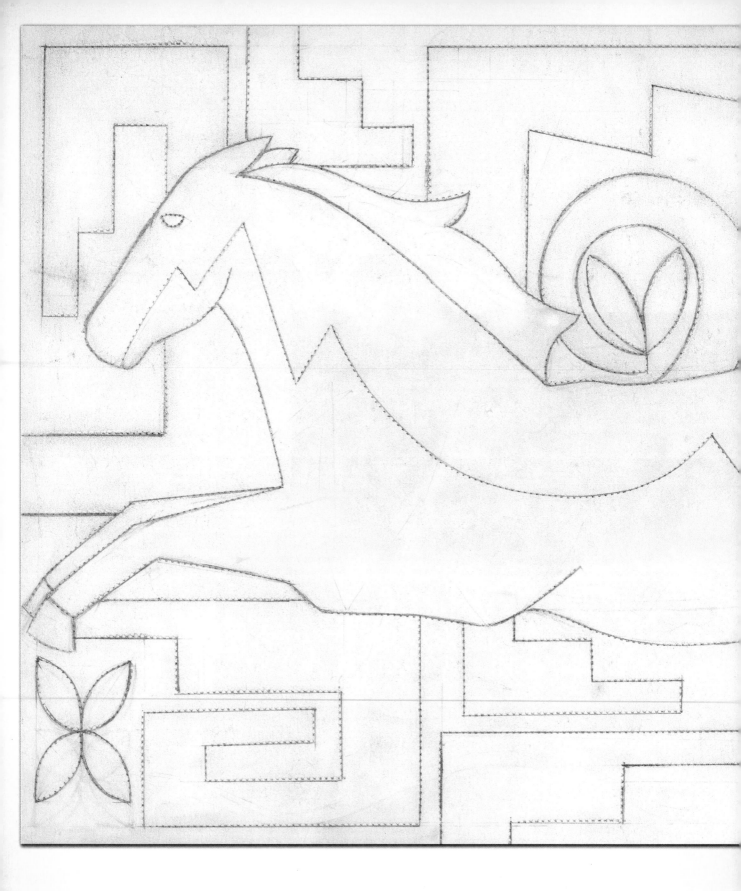

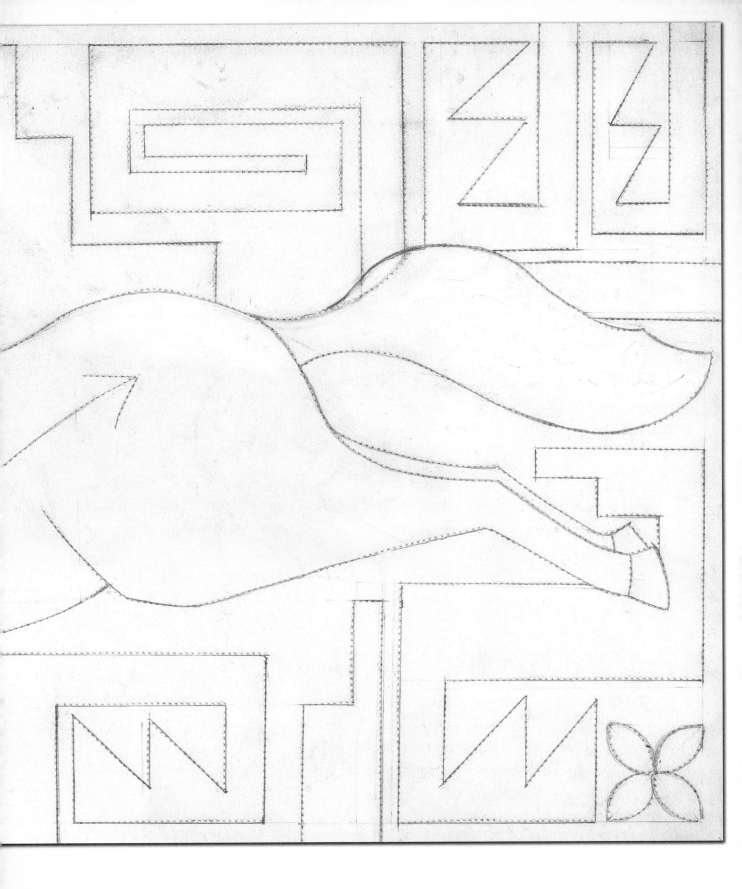

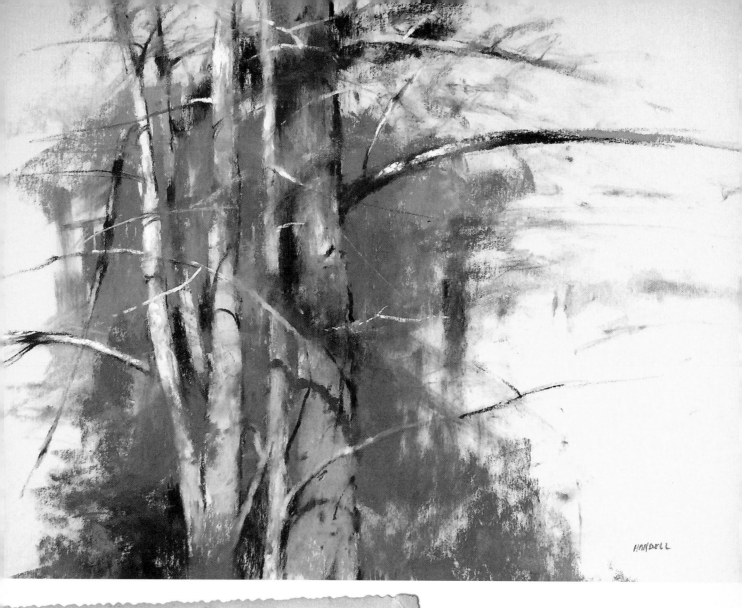

Albert Handell

Throughout the sixties and early seventies, you couldn't flip through an American pastel book without spotting Handell's artwork. Today, the Brooklyn-born artist's pastels and oil paintings alike are appreciated by a worldwide audience and housed in a number of permanent collections, including New Mexico's Capitol Art Collection in Santa Fe, where he resides. Inspired by scenes from nature, Handell paints indoors and out, often beside his workshop students. In 2007, he was honored with a retrospective exhibition of his pastels at The Butler Institute of American Art in Youngstown, Ohio.

Sketching for me is more of a playful thing, and I don't play every day. Building paintings is different from sketching, and a lot of times I'm building large oils.

I like to go outdoors for my sketching. It gives me a break from the other attitudes that are necessary for creating full-blown paintings. It's playful for me; it's fun. When sketching, I don't care about money or exhibitions or anything like that. I'm usually outdoors with pastels or watercolor, and I have my pencils and charcoal, in case after a while I'm tired of dealing with color. I don't take my oils outdoors.

What inspires my sketching is always a mystery to me. I'm a landscapist; I like to paint the outdoors. When something hits me, I know that something out there is touching something inside of me.

The difference between sketching and painting is the sketch actually gives me the essence of what I was touched by, and I don't care about the rest of the picture.

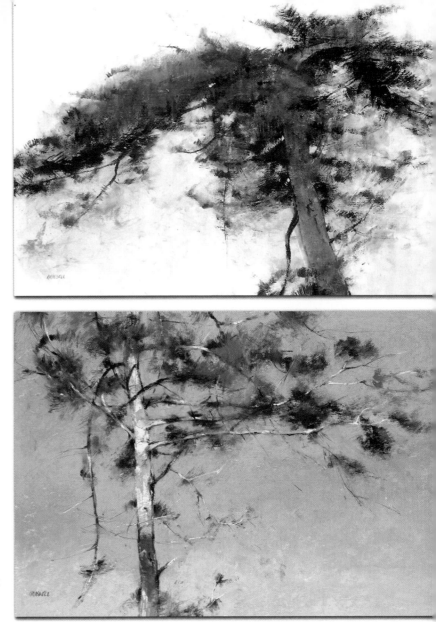

What I like to do is go on painting trips, where for a few days I paint from beginning to end and I just want to play. Sketching is more of a recording of a few specific things that caught my eye, and I'm not interested in anything else. Most of my sketches are vignettes, and I keep them that way.

When a sketch is more involved, it becomes a study. If more than a certain amount of elements get into that drawing, it becomes more of a study than a sketch. In a study I get a little more involved with specifics, with details.

When I'm sketching, I don't really think. When something hits me, that's the thing that drives me to do anything. Where to place it on the paper is the first thing I have to decide. And then, what is it that grabbed me? A specific little detail somewhere?

I feel very excited when I sketch. The blood's flowing. A benefit of sketching is you get the immediacy of the moment. You get down and do it right then and there. There's an immediacy that is crucial for the life of these sketches.

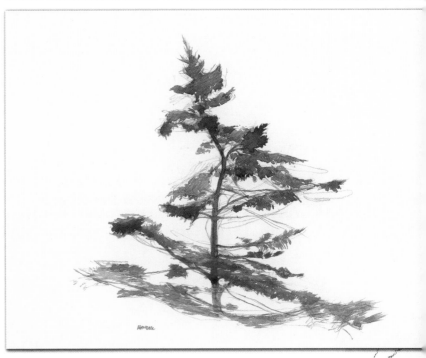

What sketching has taught me is that nothing stands still. Things are always moving or changing, and this is a fleeting moment I'm going after. Unless it goes into a study! Lots of moments are beautiful, but it was this particular fleeting moment that grabbed me and that's what I'm running after.

Sometimes when sketching, I eliminate a lot of things so I can emphasize the one thing that hit me immediately. You can eliminate anything and everything that does not relate to exactly what you're interested in.

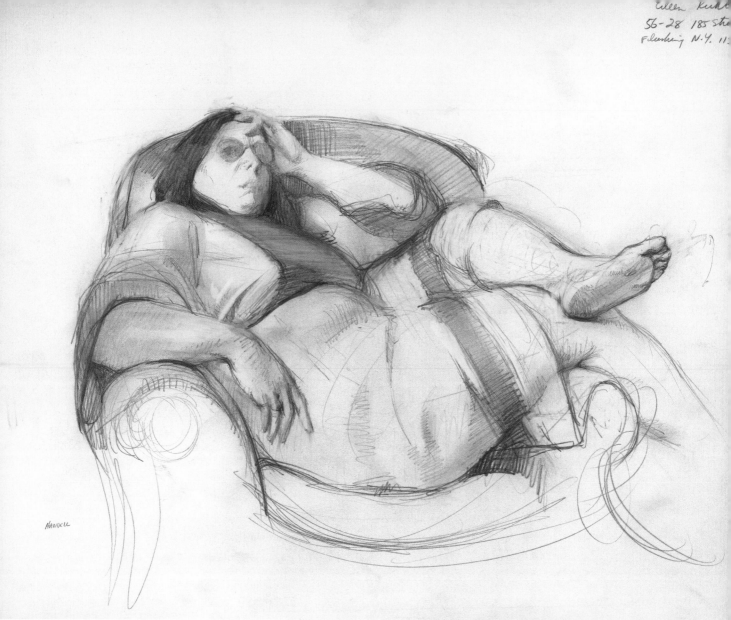

Eileen Kuhl
56-28 185 St...
Flushing N.Y. 11...

HANDELL

For me, sketching is part of my repertoire. When I'm painting from a photographic reference, my painting doesn't look like the photograph at all, but without the photograph, there's no painting. Realizing that, I have to thank my sketches and studies outdoors for giving me a real reservoir of information and sensitivities that I put into my work.

I don't just make a sketch or study outdoors and then go inside and paint the big picture. What happens when I work later indoors with large oils is that the photographs taken and sketches and studies done just excite me. They don't give me all the information I need. A lot of the information that comes into my paintings was already a part of me, and that has a lot to do with the sketching and studies outdoors.

The difference between sketching and painting is the sketch actually gives me the essence of what I was touched by, and I don't care about the rest of the picture. If I get involved with a painting instead of a sketch, then the subject and the light that attracted me becomes involved with the entire world that it sits in, and that calls for a lot of other types of thinking and searching longer hours.

I hold onto most of my sketches and studies. When I have a one-man show, I like to take eight to ten of them (depending on the show) and have a few of those around so people can see the thinking that goes into the finished work.

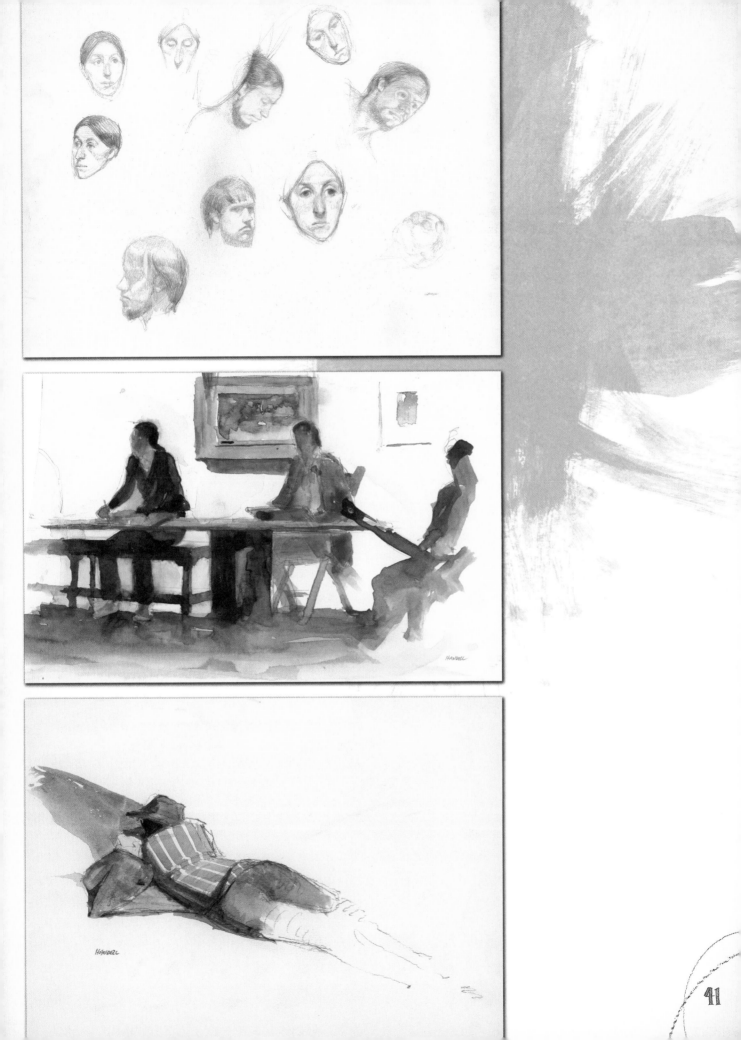

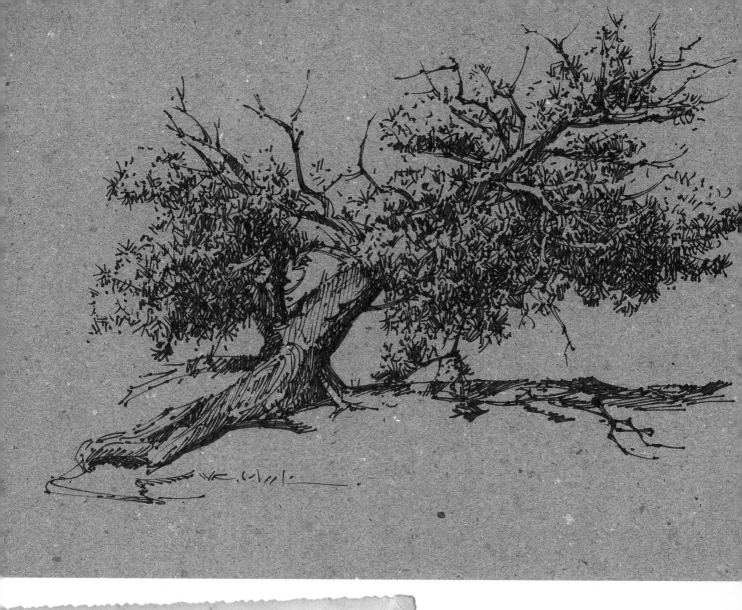

William Hook

When not plein air painting on the California coast, in the Rocky Mountains or on desert terrain in the Southwest, Hook works from his studios in Carmel, California, and Santa Fe, New Mexico. Once named "Acrylic Artist of the Year" by the National Academy School of Fine Arts, Hook also appeared in Donald J. Hagerty's book LEADING THE WEST as one of a hundred leading contemporary painters and sculptors. Originally from Kansas City, Hook has earned "master artist" status in Allied Artists of America, a nationally recognized annual exhibit of contemporary representational art.

I am a bit unromantic about the sketching process. The need to remember an idea is reason enough to sketch. For me, sketching is a thought process more than an inspiration. Sketching is my mind's eye. I am mentally trying to visualize the end product.

A good drawing is the underpinning of any successfully painted artwork. I paint daily and I sketch out each painting before I put brush to canvas. When I am sketching out a painting, I use a water-soluble pencil on canvas. I use ink and paper or watercolor on location.

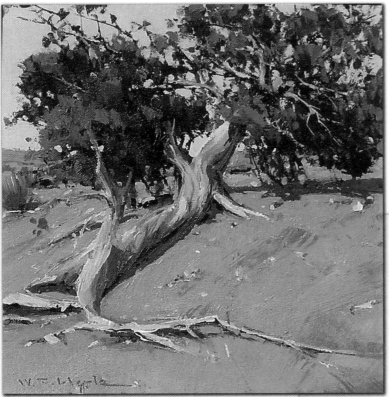

Living Treasure
Acrylic on canvas (finished painting)
12" × 12" (31cm × 31cm)

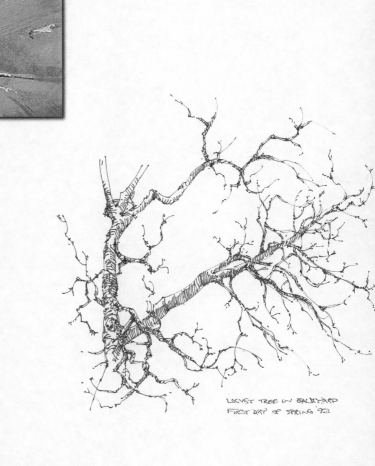

Sketching is, more times than not, a means to an end. It is not meant to be an art form in and of itself. For the most part, sketching is problem solving—e.g., perspective, composition, and how to transmit my thinking into art. Leonardo da Vinci, while being a scientist, was a fantastic sketcher. He best demonstrates my attitude toward drawing. I'm pretty relaxed when I sketch, as long as I'm not thinking about making a finished drawing.

When I cannot verbalize a thought or an idea, I pick up pen and paper and best express my thoughts through drawing. A picture is indeed worth a thousand words.

The advent of the computer has taken away the ability to express thoughts through the bravado of a hand-drawn line. I am not a fan of "electronic thought." The genius of the computer programmer eliminates sketching's spontaneity and emotion, two essential qualities of human-made art.

> *I'm pretty relaxed when I sketch, as long as I'm not thinking about making a finished drawing.*

Some of the sketches I submitted for this book are the result of phone doodles made in hotels, as well as drawings made at restaurants where my sketching becomes my surrogate dinner partner. My use of a formal sketchbook is rare these days. I majored in drawing as an undergraduate and found that experience to be invaluable when it comes to understanding art. One day I will rediscover my drawing roots and put pen to paper for pure enjoyment.

W. C. Hook

KCI, gate 6, flight 403 to Phoenix —

A-1 horse parking

11·06 2009

US Airways

follow early morning passengers sleep, read or work — too dark in the plane to draw much, yet. Cabin lights are out.

Josephine mother died right before last and we are on the way to California — we were trying to get there while she was still alive, but she couldn't hang on — she was tired and ready to go. Wish we were staying on this plane. Going to San Francisco!

I am apparently determined not to use more than one page for this flight!

I can see snowy mountains, even from my aisle seat

She is sound asleep

lovely sunrise colors

HOORAY, they moved our gate closer!

coffee smells so GOOD coming down the aisle toward us

fellow journaler

both of our flight attendant have long, long braids

Cathy Johnson

Sometimes known as Kate, Johnson has been a naturalist, writer and freelance artist for more than three decades. She was a staff naturalist and contributing editor at COUNTRY LIVING for eleven years and has been a contributing editor for THE ARTIST'S MAGAZINE and WATERCOLOR ARTIST. The longtime Missouri resident has written and illustrated for a number of national magazines, and her writing and art have appeared in several nature anthologies and over thirty books. She's taught sketching and painting for nature centers including the Sierra Club, for whom she's authored two guides to sketching and painting in nature.

I don't always sketch daily, but close enough to it. I feel odd if I don't, as if I've wasted a day, or one passed me by.

I sketch whenever something catches my eye, or when I have a few moments. I don't want to make it a chore, but just try to respond, when I can. Life is full of serendipitous surprises. I like to document them so not only do I remember them later, but because it heightens my enjoyment at the time.

Of course, I'm speaking from the perspective of a lifelong journal keeper—I also sketch to plan a more formal painting. However, many times my sketches ARE the finished work. They MAY be planning or inspiration for a more formal work, but much more often they are an end in themselves. I love to look at other people's sketches, from Da Vinci and Rembrandt right up to the present-day artists on the Web.

When sketching, I feel as if I'm truly myself, I think. Truly present in my life. Sometimes it's pure joy, as when I'm sketching musicians as they play. Sometimes it's contemplative, if I'm sitting on the ground somewhere in nature and responding to the beauty of a wildflower.

Usually I think about what's before me, when I sketch. It helps me to step outside whatever's going on in my life; it's a real stress-reliever for me. It also helps me to deal with emotions—fears, anxieties, anger. I can step outside them. Sometimes it's frustrating, of course, when my subject moves, or my materials don't cooperate—and sometimes they don't!

I love toned paper, smooth watercolor paper, and cold-pressed watercolor paper—I need a GOOD paper, something nasty really bothers me. Unless, of course, I feel a sudden need to capture something and all I have available is a paper napkin, the back of an envelope or a grocery bag; then that's fine, too! I'll often paste that sketch into my journal.

I like mechanical pencils when sketching out, so I don't have to worry about sharpening them. When sketching in ink, I use Pigma Micron and Zig Millennium pens, and a couple of vintage Waterman 52 pens for a lovely, varied line. I use Prismacolor colored pencils, often in black, gray, indigo and Black Grape, and then do quick washes over them; Prismacolors are wax based and don't lift and muddy my washes. If I'm using toned paper, I love to sketch with light and dark on that medium surface—it's almost like sculpting, pulling forth an image that appears dimensional. I sketch with good artist-quality watercolors, and occasionally gouache (especially when sketching on that wonderful toned paper), as well as watercolor pencils or crayons.

Sketching has taught me that everything is worth paying attention to; it's Zen-like, in that. Being fully present. Taking time to appreciate the moment. Even, on magical occasions, that feeling of being one with my materials—the pen is an extension of my hand, my eye, my soul.

I'm much more likely to explore new approaches, compositions, mediums and so forth when sketching than if I'm setting it in stone in a finished piece. I just feel freer, and I think it often shows.

I believe regular sketching can shape how we look at the world; everything becomes more interesting, more of a challenge. I'm awake. I'm aware.

Cathy Johnson

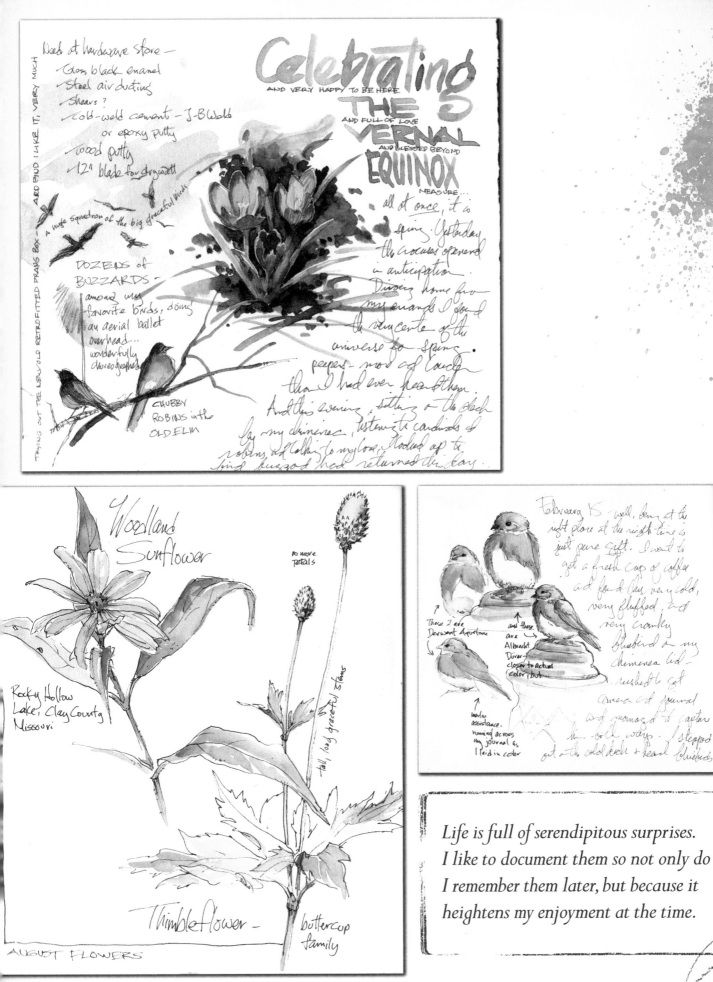

Life is full of serendipitous surprises. I like to document them so not only do I remember them later, but because it heightens my enjoyment at the time.

nancy Kozikowski

Famous for her abstract weavings, Kozikowski has spent thirty years honing her craft, immersing herself in every step of the process, from raising sheep and spinning wool to designing and weaving her distinctive tapestries. An artistic journey that began in the States (California, Oregon and New Mexico) eventually led her to the Artist Village of Song Quang near Beijing, where she currently works from her studio to develop her singular geometric designs. "Working within and against the limitations of the loom and evolving from vegetable dyes to unlimited chemically dyed colors," says the artist, "these designs have begun to express power, movement and light."

I must do journaling or morning pages every morning to find out what's happening. This usually includes sketching. There are several projects, obligations and responsibilities that are competing in my subconscious for attention. When they take form on a page, they begin to prioritize and materialize. I also schedule drawing time, almost daily, to seriously nail down thoughts and ideas and to complete drawings.

I work in several media—wool, silk, pastel and colored pencil—so several decisions must be made regarding materials, loom preparation, dyeing, and so on. When sketching, I use pen, pencil and colored pencils. I have a lot of paper and sketch pads always at hand, but I'm always looking for the right size, texture, thickness and smoothness for the thought to be expressed.

There are at least two kinds of sketching: sketching when you know the subject and have an idea, and sketching when you are looking for an idea and subject. The first is a struggle but a pleasure. The second is scary, frustrating and doubtful, but can produce interesting results.

I love drawings. They can be immediate and personal. They can be surprising. And a good sketch can be the root or seed of a great piece. When sketching, I am looking for an interesting relationship in the drawing—one that is solid, unpredictable and mysterious.

I believe humans share a mostly unconscious sensibility to pattern. This sensibility is manifest throughout art history. Cave paintings and petroglyphs reflect this sensibility. Some contemporary abstract paintings also reflect this sensibility. When Picasso, Matisse, Modigliani and Klee saw African sculpture, pottery and textiles, they recognized an expression that appeared spontaneous and unique, something lacking in formal European painting. The attempts to approach their paintings from this new perspective led first to modern art and then to abstract expressionism. The structure of the designs and the unusual perspective of the African work were liberating, made sense and felt right to these European artists, even though they were not realistic representations. But even though the European artists recognized the perfection of these designs, they still felt that the artists were primitive. I don't think the African masks and textiles were spontaneous or primitive. I think they were formal, traditional representations from a different culture.

There was a discussion once between Tony Berlant and Andy Warhol (both collectors of Indian artifacts). Tony asked Andy why he couldn't make a piece of art (a design) as great as a Navajo chief's blanket. That's a good question and one of the main motivations of my

art. Indigenous and ancient art often have relevance and meaning over a long period of time. This is why I study Persian carpet patterns, ancient pottery designs and many other art forms. At this time in my life I am more interested in ancient art than contemporary art. This is one reason why I'm living in China. I consider myself a contemporary artist exploring how patterns move through time and space.

I believe abstract patterns are universal, a common language that may reflect internal biological or intellectual patterns or structures, possibly related to mathematics and/or music. In sketching we can ride the wave of our own unconscious and at the same time tune into this universal language. The more personal and unconscious the better.

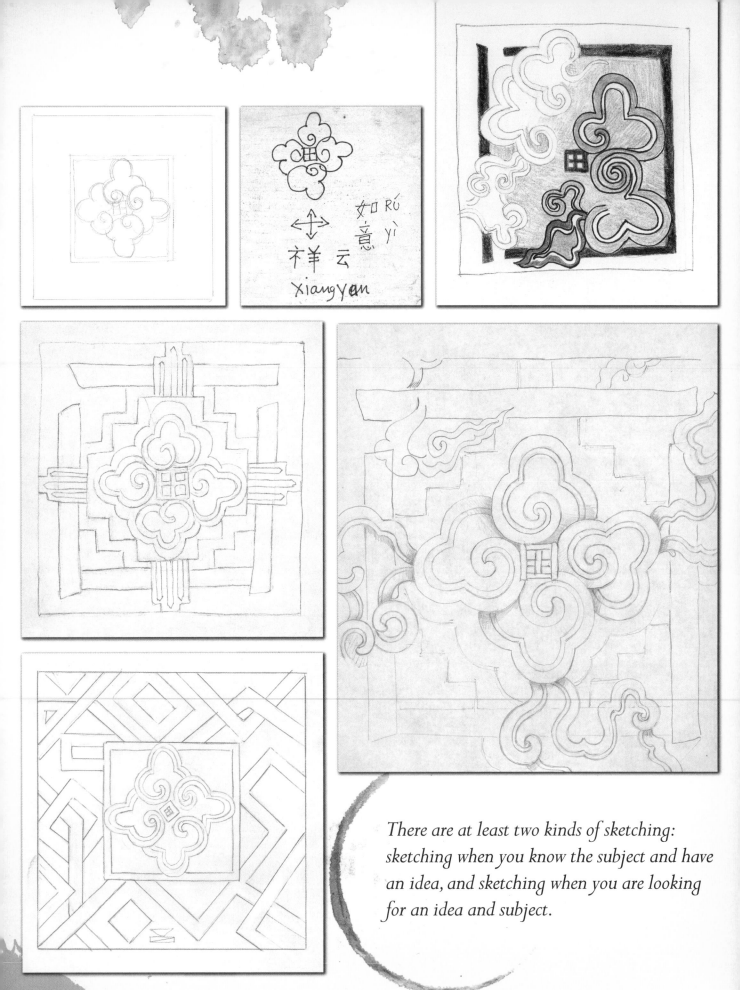

如 RÚ
意 YÌ

↔

祥 云
XIANGYUN

There are at least two kinds of sketching: sketching when you know the subject and have an idea, and sketching when you are looking for an idea and subject.

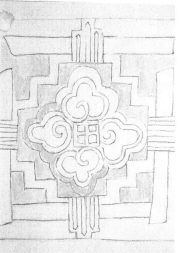

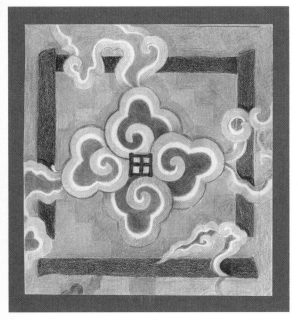
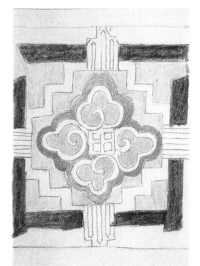

Sketching can be spontaneous. There is a shorter distance between my subconscious and doing a sketch than there is between my subconscious and doing finished weaving. I work hard to make my tapestries look like drawings or sketches. Even though weaving is a geometric grid medium, I want the designs to look hand drawn and spontaneous, even floating; not perfectly symmetrical, not too straight.

Nancy Kozikowski

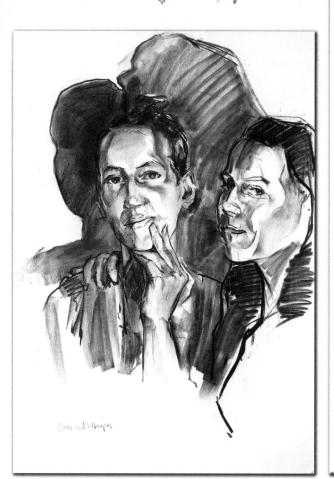

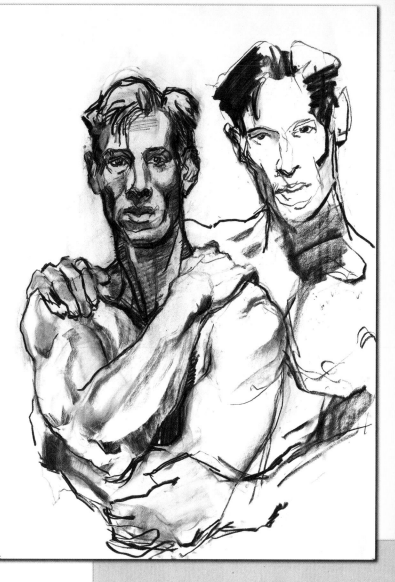

Geoffrey Laurence

Drawing and painting the figure has been the focus of Laurence's illustrious career, which has spanned over three decades. Born in New Jersey to Holocaust survivors, Laurence moved to England at age 4, ultimately attending three art schools there before receiving his master's degree from the New York Academy of Art and moving to New Mexico. "I became very interested in learning the skills of drawing and painting that I had observed in many classical paintings," says the artist, who connects the classical with the contemporary in his oil paintings.

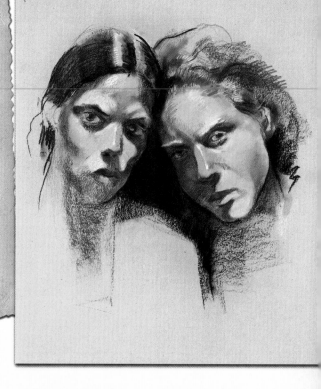

I make sketches to explore visual thoughts. Drawing is a learned language, both for the artist and the viewer, just like the alphabet. I believe it is much older than speech. We were describing the world by making marks in the ground with sticks a long time before we were uttering words. Sketching is a step towards understanding how I see the world through my own visual language.

I usually draw with charcoal or pastel. For years I used to draw with a pencil but I find charcoal quicker. I also do painted sketches in oils on canvas paper.

If I am not life drawing, I make sketches at the start of my project to explore its possibilities. Thinking a painting is not the same as making one. The idea has to be physically drawn for it to exist.

Sketches are models for the composition and light in my paintings. I am also made aware early on of the possible problems I might encounter in making the painting, so I can prepare myself for the particular troubling or difficult passage and make changes in the painting because of what I learned in the drawing. They are my early warning system!

With sketching, I get the same benefits a writer gets from keeping a diary. Sometimes I am made aware immediately of whether the model will have problems holding the pose or if it is too uncomfortable for them to hold—models will try their very best to give the artist what he wants despite their obvious pain—and can make changes based on their relatively short time spent with the pose before I commit to many hours of painting it.

I feel free to make a mess if necessary, and find out what will or will not work visually in trying to bring my inner world into the outer world. I don't get pictures in my head, complete and ready to paint. They are more like feelings or impulses—messages from beyond, if you like. No one is going to see my sketches unless I specifically show them, so I feel unrestrained by that awful and scary word ART.

There are some days when I don't draw. I have been making figure sketches on a weekly basis for at least 40 years, hardly ever missing a week. Life drawing is, in my opinion, a necessary form of practice, like a pianist playing scales on a piano. If I miss drawing for a week, my drawing 'muscle' diminishes. It's amazing how quickly my drawing ability is affected when not continually practiced.

Stephanie Pui-Mun Law

After three years of programming software by day and painting imagined realms by night—an activity she'd begun as a child—Law committed herself to her art full-time almost ten years ago. Her illustrations have appeared in various games and books through publishers Wizards of the Coast and HarperCollins, among others, and she has also designed her own deck of tarot cards. She is also the author of two DREAMSCAPES books on watercolor technique for fantasy. The artist currently lives in California, where she earned her double bachelor of arts degree in fine arts and computer science at Berkeley.

At Arizmendi Bakery. A sunny noon the window counter munching at pizza.

March 27, 2009

Most of my finished work is inspired by stories and mythology. But I also frequently am inspired by the motion of dance—I've been a flamenco dancer for fifteen years—and nature. The winding branches of live oaks often make their way into my sketches, and not just as literal trees. The sinuous curves lend an aesthetic that melds into my compositions and human figures. Sometimes I have a concept in words in my head of what I want, but I don't know how exactly to visualize it. It might be an interesting phrase that strikes my fancy or a line of poetry. I'll start exploring ways to approach the concept in a series of sketches.

Sometimes I enjoy sketching just for its own sake and working on site from live scenes. For these in particular I try to capture motion and action as the world moves around me. These feel more like pieces for a visual journal, and because I don't intend to paint these sketches, they have a more raw and immediate feel.

When journal-sketching I like to work with pen and ink, as it forces me to commit to the lines and each mark that I make so that they all have meaning, rather than aimless scratching. I have several different sketchbooks, all of them about 6" × 6" (15cm × 15cm). They're easily carried with me in my purse whenever I'm out and about. One sketchbook is plain white paper, and several others are various shades of brown. When working on a neutral tone, I use ink and a white gel pen, as well as some light gray markers, and I can work in both darks and highlights since the paper is a nice in-between color.

Sketching from life gives me a chance to pause and observe the world around me for a bit, and not get caught up by only what is in my head. I think that all artists need to remind themselves of the basis for their art, even if the focus of their work is in the fantastic or imagined realms.

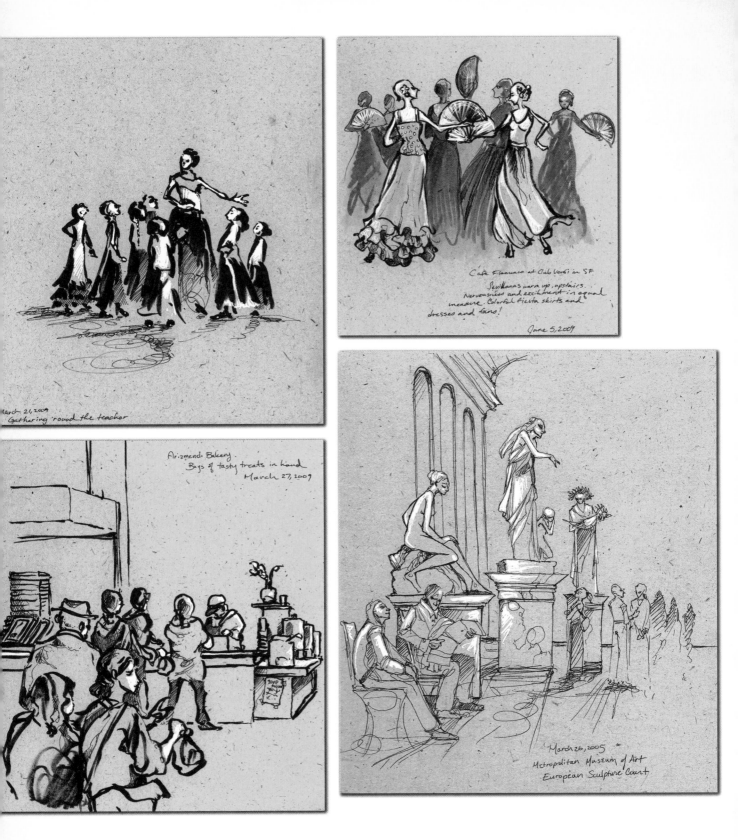

March 21, 2009
Gathering 'round the teacher

Café Flamenco at Club Verdi in SF
Sevillanas warm up, upstairs.
Nervousness and excitement in equal
measure. Colorful fiesta skirts and
dresses and fans!

June 5, 2009

Arizmendi Bakery.
Bags of tasty treats in hand
March 27, 2009

March 26, 2005
Metropolitan Museum of Art
European Sculpture Court

I particularly enjoy sketching when I am traveling and
on vacations. Being able to record my experiences in
drawings helps me to enjoy the excursions all the more,
and looking for opportunities to frame some visual
experience into an image lets me appreciate things visu-
ally that I might otherwise overlook.

The reward at the
end of the hiking
trail! An icy, clear
pool with the
distant high up
waterfall that fed
it visible through the
cleft of the valley.
"Freshly squeezed
cloud juice!"
Too cold for me to go beyond
dipping my feet!

On the way back...
Big ol' Banyan tree that
has this boulder in its living
embrace. Tangle of roots
sneaking and snaking around and down
into the stream. "The Tree Ball"!

June 23, 2009
Maunale. Arboretum trail head. Up along the ridge, scraping the
clouds. Owned by a Pineapple plantation... Hazy Moloka'i on the horizon.
A view out over the central valley when we got to the
end of the Lookout Point. Leafy, shady trails.
Banyans and Ficus religiosas. A fresh burst of
rain at one point that felt wonderfully
cool and refreshing after
trekking uphill.
Windy as always seems
to be.

June 27, 2009
At Ohe'o Gulch.
Seven Sacred Pools.
After a long windy drive
from Hana. Was nice to
have the place mostly
to ourselves, since
we have a head
start, staying in
Hana. The waters
looked inviting, but,
"No swimming today,
dangers of
flooding," said the
rangers at the
park. That's okay,
we had a glorious
dip at the Venus Pool
instead, later in the
day.

About halfway up to
Waimoku Falls,
a bamboo grove.
Thick stalks arching
up in the dim
green light. Each
time the wind
blew, it was like
a hundred
bamboo wind
chimes swaying
musically amidst
the susurrus of
their leaves.
"Quiet and listen!"
they seemed to
say.

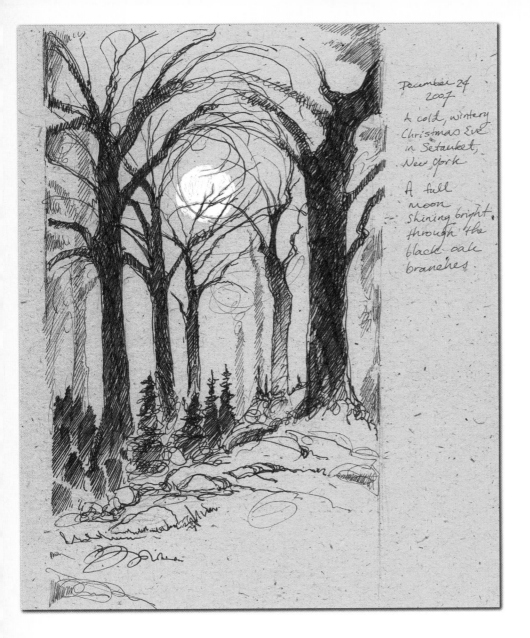

December 24
2007

A cold, wintery
Christmas Eve
in Setauket,
New York

A full
moon
shining bright
through the
black oak
branches.

Sketching lets me appreciate hidden beauty in the world and sharpens my observational skills. Anything that I see can be inspiration for a sketch, and so whenever something interesting catches my eye, if I don't have pencil and paper handy, my mind is making a mental photograph. I remember the lines and curves and colors; the way light comes streaming through some leaves; the curve of an egret's neck contrasting with its angular stilt legs as it stalks through the rushes of nearby Lake Merritt; the flourish and motion of a dancer's arms as I watch a rehearsal for a show.

Occasionally the sketches that I do in my journal make their way into becoming finished paintings, though this is more rare. I don't sketch them with a painting in mind. They're more of just momentary snapshots, but sometimes they end up being my favorite finished paintings of all.

When journal-sketching I like to work with pen and ink, as it forces me to commit to the lines and each mark that I make so that they all have meaning, rather than aimless scratching.

Bev Lee

Light and color reign in Lee's realistic, painterly pastels and oils. Her favorite subject is children, although she paints adults, still life and animals as well. Largely self-taught, Lee has become a signature member of the Pastel Society of America and a member of the Pastel Society of Colorado, and she now teaches others through her workshops. Her award-winning work has been featured in THE ARTIST'S MAGAZINE, INTERNATIONAL ARTIST and THE PASTEL JOURNAL, and Lee is the author of PAINTING CHILDREN: SECRETS TO CAPTURING CHILDHOOD MOMENTS. She intends her paintings to be "a source of peace; to make the viewer feel better about the world."

Ideas inspire most of my sketching. When ideas begin to stir in my mind, sketching helps to sort them out into those that will work and those that won't.

Being mainly a portrait artist, I find even out in nature I get inspired to sketch portraits of trees, animals or flowers.

My sketching varies from season to season and year to year. I aim to sketch at least one day per week. It all depends on what projects I am working on. In a perfect world, I would sketch every day. I encourage my students to do that.

I sketch mainly to work out my ideas on paper before I begin a new painting. This helps me to see how the work will flow. I make decisions on format, size and so on. My sketches usually tell me if a painting is going to work or not before committing myself to the time and effort of a painting.

Once a week, I go to a life drawing session at my local art center. We draw several two-minute and five-minute quick sketches. This is a wonderful way to warm up and learn what is really important to get a thought across. It also keeps my drawing skills sharp. Trips to the mountains and vacations are other opportunities I take to draw. I'll draw the people waiting in terminals or at cafés or chipmunks sunning themselves on rocks.

I sketch with both soft pencils and charcoal. I like Strathmore sketchbooks. After working up some thumbnail sketches in a book, I might use a large sheet of newsprint and vine charcoal and do a work-up the size of my finished painting.

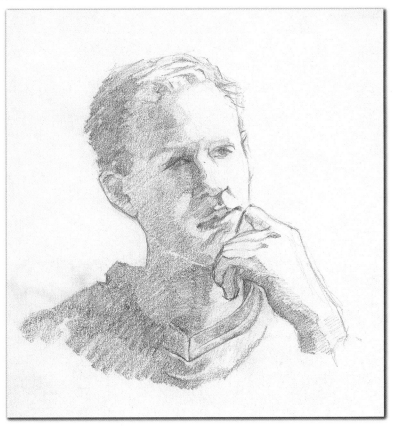

When I am sketching for a finished piece, I think about what I want to say with the painting, what dimensions might work, how the light will travel and what compositional design will work best. I get involved in the subject deeply by concentrating on angles, lines, and shapes. When I am sketching for fun, I let my mind wander. It is quite therapeutic.

Sketching is relaxing and freeing for me. I am a perfectionist, but my sketchbook doesn't have to be. I know in my mind that these don't have to say anything in particular. I just sketch with no worries about the outcome. It is kind of like writing in a diary. My sketchbooks aren't something I generally share with the world so I don't put pressure on myself with them. They are for fun.

My sketches mirror my life: sometimes things work out and sometimes they don't. Going out for a day and sketching what I see has taught me that every created thing is beautiful—a work of art. Every person is beautiful. You can find beauty in the everyday mundane as well as the exotic. Art is anything that enriches our lives.

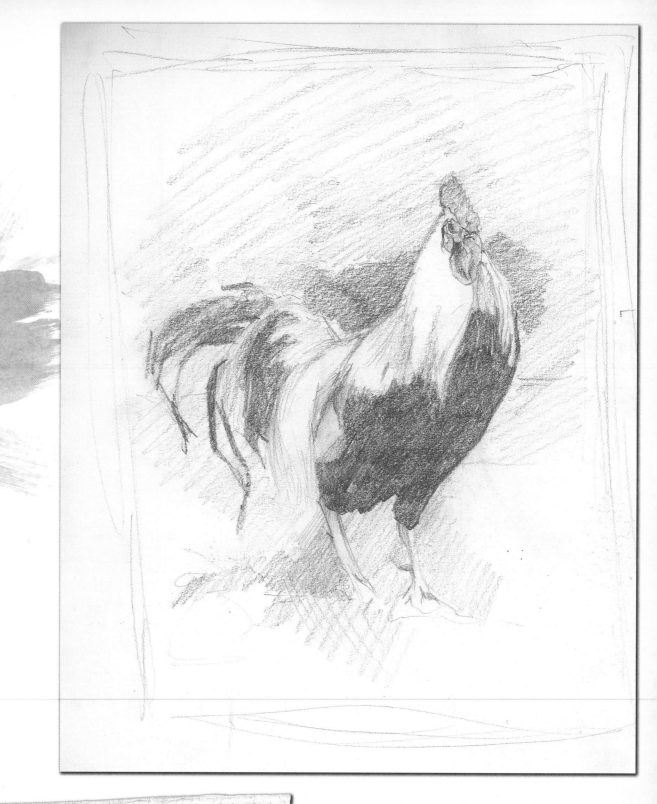

My sketches let me take a closer look at the world. I see things that I might otherwise pass by. Sketching has taught me to slow down and really see as I sketch out a leaf, the way my dog sleeps on the top of the couch, or a tree bent by years of being pushed by the wind. As I walked with a friend one day pointing out things that were inspiring me, she told me that I see differently than others in the world. I pointed out things in her neighborhood that she had never seen. Do artists see differently because they do art, or are artists artists because they see differently?

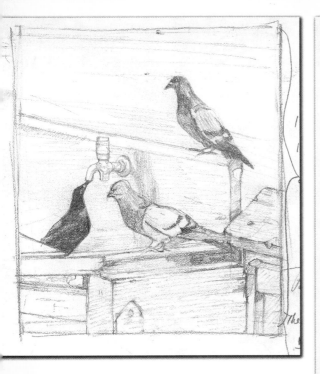

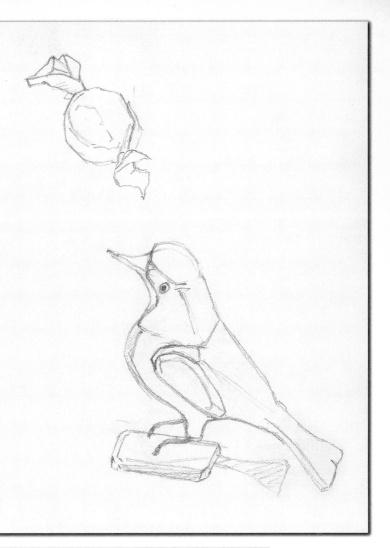

Sketches and drawings have a certain kind of grace that painted images do not. Look at the works of Wyeth: how beautiful, thoughtful and full of meaning, all gotten with a pencil and piece of paper.

Because a sketch isn't going out into the world, I am free to experiment. The sky is the limit. A face doesn't have to look like anyone in particular. I can sketch out several different poses. I can make a figure do whatever I want it to. Once I commit to beginning a painting, decisions scale back and become more limited. There will only be one pose. Once the dark and light patterns are established, again my choices become more limited.

I sketch little clay figures of myself on some of the pages of my sketchbook showing how I am feeling at the moment. Sometimes they are standing tall; sometimes they have strings attached to their limbs or are slumped over. I can play or doodle or do whatever I want with them. I can make a world of my own with my pencil and sketchbook.

My sketchbooks serve as a well of ideas when I am in a dry spell. I take them out and look through them. I'll see sketches that never went anywhere that all of a sudden spark a new work or series of works.

Blee

> A sketch or a painting is always changing and will continue to change, as the model will, and as I will.

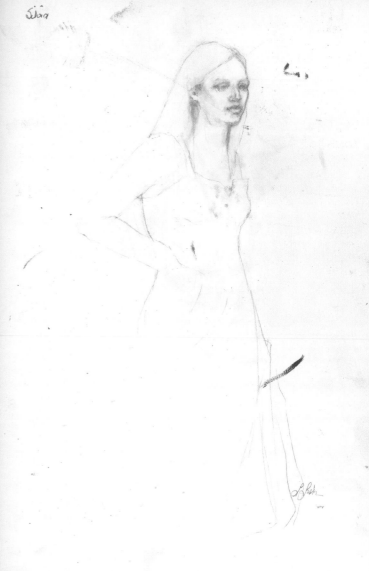

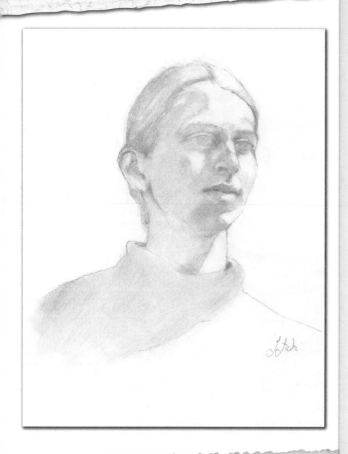

Linda Leslie

Hailed by gallery owner Jay Etkin as bringing a "fresh voice" to figurative art, Leslie approaches her portraits with traditional techniques and a contemporary eye. The artist, originally from Connecticut, studied at the Art Students League of New York and the National Academy School of Fine Arts in New York before moving to New Mexico. She has dedicated over thirty years to classical figurative painting, developing a signature style described as "romantic" and "gracefully contemplative," where intimate views are often balanced by "splashes of light or color" made with Impressionist strokes.

I am inspired by the human figure found in contemplation, by beauty and the abstract design of life in a form of dance. I think about proportion, movement and feeling when sketching.

I do not sketch daily. I often wish I did. It is wonderful practice. I usually sketch in a class or group session. I also will hire a private model for a few sessions of one long pose and work the drawing into a painting, with the help of photography.

I generally sketch with graphite mechanical pencils in a journal. I enjoy charcoal and Conté crayon too. I will also sketch with graphite directly on an oil painting in progress.

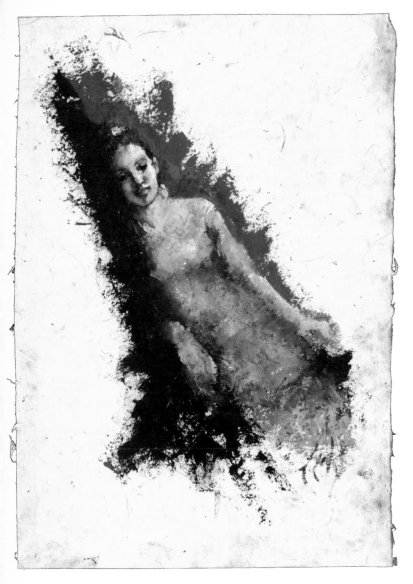

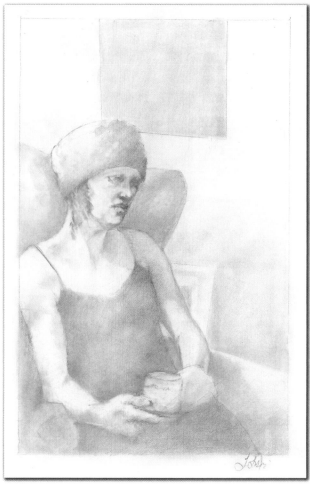

Sketching keeps my eye working. It helps to keep my work loose and more confident. I feel calm, peaceful and happy when sketching. I try to think of nothing. I feel less pressure and more freedom than when painting.

Although the feeling of my sketches relates to the finished work, many times the finished piece is different from the original idea. A sketch or a painting is always changing and will continue to change, as the model will, and as I will. Although it is not my intention that the sketch becomes a finished work of art, many times it does. I try to put the two together: freedom and finish.

I learn more about myself from my sketching and painting than from my thinking. Something will appear that I would not have been able to put into words.

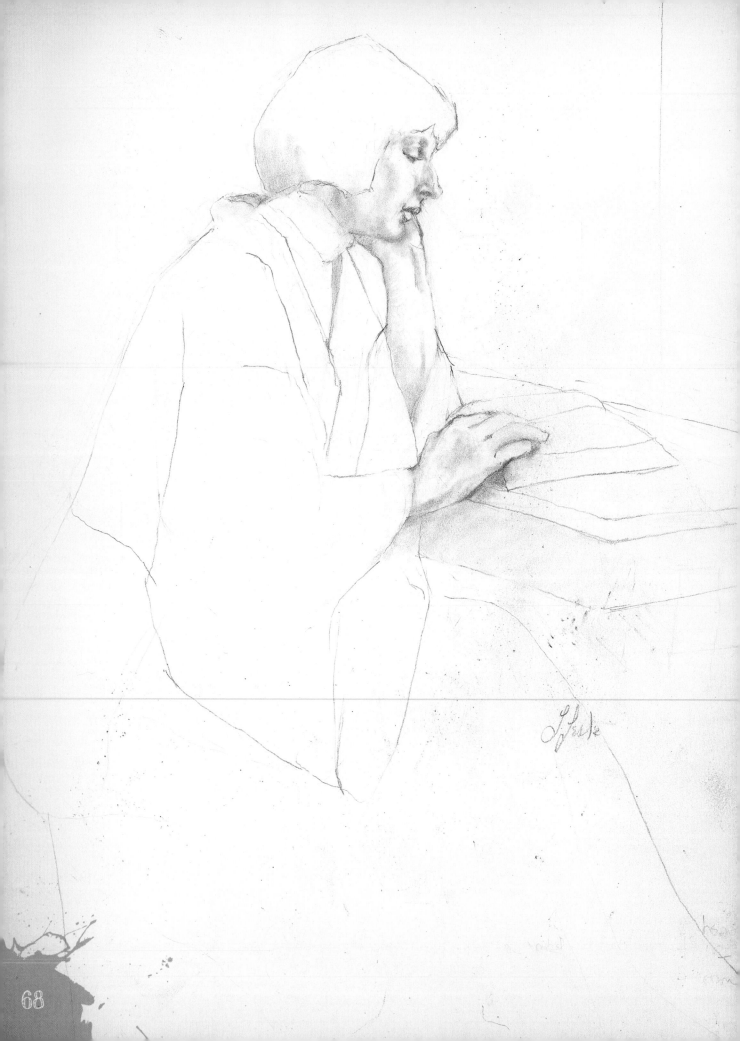

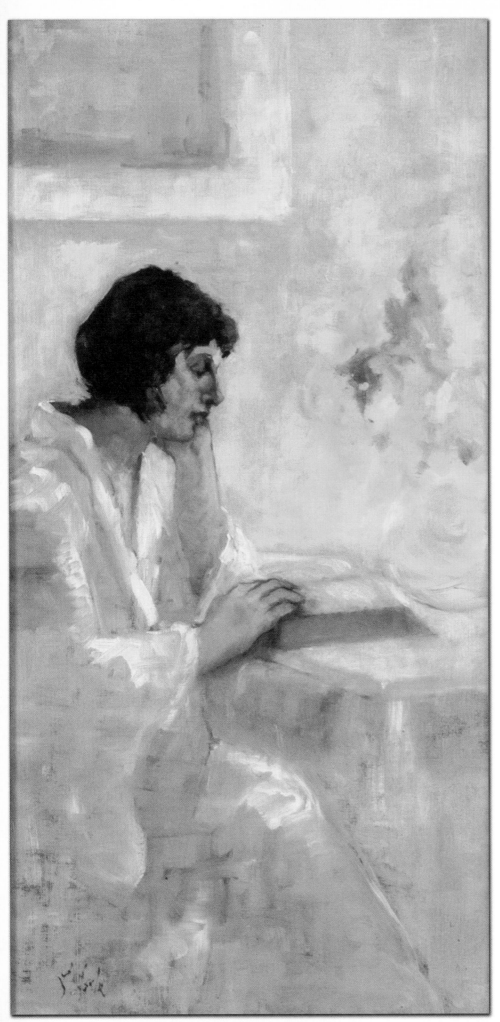

Louella
Oil on canvas (finished painting)
34" × 15" (86cm × 38cm)

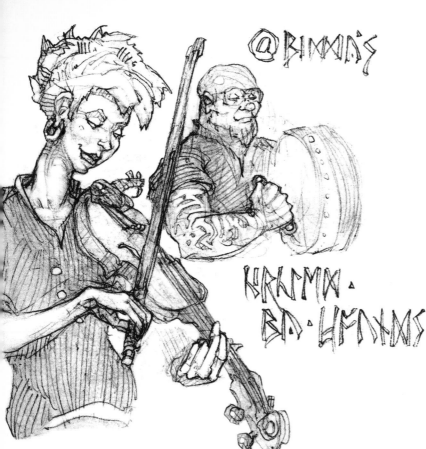

Chuck Lukacs

Lukacs has been illustrating for the sci-fi and fantasy community for nearly a decade, working mainly in oils for the past six years. A graduate of the College for Creative Studies in Detroit, Michigan, Lukacs was featured in SPECTRUM 7: THE BEST IN CONTEMPORARY FANTASTIC ART (Underwood Books). His illustrations can be found in DUNGEONS & DRAGONS manuals and magazines and several collectible card games, as well as his book FANTASY GENESIS: A CREATIVITY GAME FOR FANTASY ARTISTS, which creatively combines role-play gaming with art instruction.

My sketches are inspired by both real life and complete fantasy. I rarely sketch paying jobs in my sketchbook, but will often take parts of my sketches and use them in *Magic: The Gathering* cards or other illustration work. As an SF&F (science fiction and fantasy) illustrator spending most of his time inside, I look fondly to the times I can get out and observe some social conversation and interaction, or perhaps a trip to the zoo to both document and stretch my brain muscles a bit. I regularly go to the local tavern or pub, and sketch the barkeeps and waitresses.

I do most of my work at night. Ever since school, I've felt it's the least distracting time to create, and you can focus your attention on one task as best you can. When I'm out at night, folks are livelier, the expressions are more direct and pronounced, and the lighting is foreign and often dim, so it always makes for a fun sketching session.

I've been using Sanford Union gray and white erasers and Mono B pencils from Tombow for years. They have a smooth consistency that I've not found anywhere else. I also handcraft and handbind my sketchbooks. They are handcrafted from sculpted papier-mâché boards, hand sewn onto cords, and 1/16 bound in black pigskin leather.

Your sketchbook is a bit of a life documentary, and depending on how well you know the folks you draw, it can sometimes affect your future. I've sketched past relationships and people who have since died, so that now every time I look back in the sketchbook, I remember the loss quite vividly. I've even erased some of my sketches that are particularly jarring when I see them. My sketchbooks also document the good things in life, or simply the forms and characters and costumes that were interesting enough to document, but what you put in is there for a reason. British illustrator Patrick Woodruffe once said that when he painted or sketched his bad dreams, they would go away. So I suppose documenting your life in such an intimate way is neither bad nor good, but simply your life.

Sketching is the original gesture, the initial moment or fluid light that drives one to pick up the pencil. The original sketch holds a "spirit" that is often lost in translation to paint, and it's something that is sought after throughout completion of finished art. You can capture the basis of most subjects with only a few lines—they needn't be perfect, often aren't, and the viewer's brain will do the rest in completing the image. Viewers make the finished piece themselves in their own mind's eye, and sometimes what looks completely normal and believable in a sketch will need to be changed as a final piece, rendering it rather unbelievable or odd-looking. It can be rather difficult, when it comes to bringing that original "spirit" to the painting, while remaining just as believable as it was in the original sketch.

When sketching, mostly I think about the mind's image of what the sketch will be. There's sort of a thousand different outcomes that flash through my mind: framings, perspectives and gestures that influence what looks best in the moment. If sketching from life, then I'm focused on the subject, and stop occasionally to talk to a friend, but ultimately it's a series of learned visual cues that I think about when sketching.

Emotion can often affect a sketch, as can sketching affect my mood. I will sometimes sketch a self-portrait to depict my mood or condition in life at the moment, and the mood might creep into a sketch in the form of a jittery hand, or overly patient and belabored focus; trying too hard, or perhaps not trying hard enough, to reach a moment of clarity or Zen-like emptiness. Sketching can bring you to an almost meditative state where you are purely documenting what you are looking at in the real world, in your imagination or mind's eye, or what you've remembered from a dream.

Sketching develops your skills and maintains them. I always tell students that being an artist for some is quite like athletic training. If you lag off for only a couple of days, the next time you sketch you'll notice it's a bit more difficult and strained. Your mind will have lost some of the things learned, so it's best to keep on sketching anything for practice.

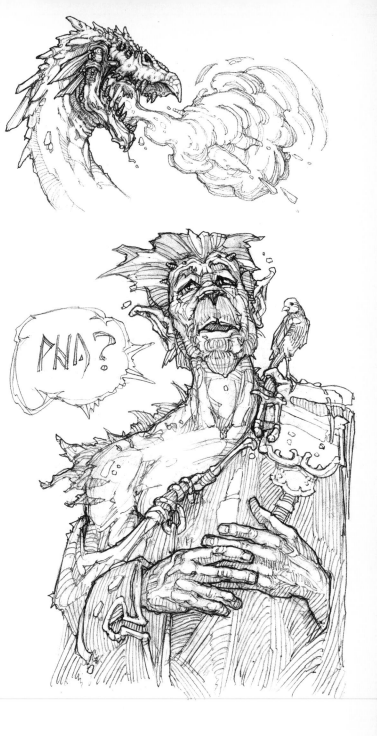

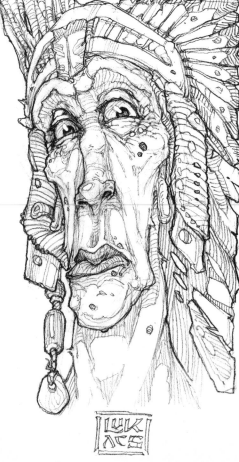

We all form our own little utopias with the skills required in SF&F art, and these elements will find themselves popping up in our daily lives. So in this way sketching not only shapes how we see the world and planet, but as artists we can also affect the way the world sees itself. Today's fantasy is tomorrow's invention, so sketching not only shapes how you see the world, it ultimately shapes everyone whom you share it with as well.

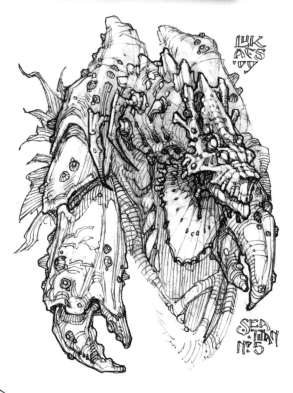

The original sketch holds a "spirit" that is often lost in translation to paint, and it's something that is sought after throughout completion of finished art.

Jennifer McChristian

Born and raised in Montreal and now living in Los Angeles, McChristian was an animation artist on projects for various studios such as Disney and Nickelodeon before devoting herself to painting full-time about ten years ago. With a penchant for plein air painting, she paints mainly in oils and occasionally in watercolor, and her work has appeared in SOUTHWEST ART and AMERICAN ART COLLECTOR magazines. She conducts an ongoing, uninstructed figure drawing workshop twice weekly from her studio in Los Feliz, and McChristian says her own learning continues through workshops, research, travel and frequent visits to museums and galleries.

I either sketch in the morning when the mind is more fertile and as a way to warm up for the day's painting session, or in the evenings at our (my and my husband Ben's) figure drawing workshops. I also like to use the opportunity to sketch during idle times (waiting for my meal at a restaurant, waiting to board my plane at the airport). I figure with our lives being so busy and hectic, I like to grasp those opportunities to make my waiting time more useful and productive. These times have no relevance other than the convenience of location and availability of free time.

I sketch with 2B graphite pencils and a small, portable sketch pad. I carry a small sketch pad in my purse and I also have one handy in my vehicle. That way I have no excuse not to sketch.

> Sketching teaches me about art through its disciplined repetition and about life through its precise observations.

I am inspired by the external images around me, either some interesting composition or the shadow and light shapes that engage my curiosity. It is also very invigorating to capture fleeting moments of time. I also sketch ideas or concepts for paintings.

Typically, my mind drifts into a very Zen-like state when sketching, free of any extraneous thoughts, noises or concerns. Like jogging, it takes a little effort at the beginning to get warmed up, but once in a steady stride, it becomes a very enjoyable and sometimes cathartic experience for me (like meditation).

I feel at peace when sketching, like a relaxed concentration or meditation. It seems my mind transcends from a conscious to a semi-subconscious stage. It creates a safe and nurturing place for my wandering, distracted and often 'noisy' mind to repose.

The benefits of sketching are immeasurable. Sketching teaches me about art through its disciplined repetition and about life through its precise observations. It's a constant sharpening of the artistic skills, a honing of the eye/hand coordination which is essential to the creation of a solid, well-structured finished painting. It also offers an opportunity to anchor my impetuous feelings and thoughts.

Sketching doesn't really shape my paradigm so much as record it. It does help me to transcend a certain amount of pessimism, as the shift in consciousness created by sketching helps me focus on the beautiful things and people around me. Sketching helps me to extract the inner beauty and virtuousness of the individuals surrounding me.

Sketching doesn't really provide me more creative license than working on a finished painting. I suppose it could but perhaps I don't invoke it. I find there's more use of creative license in a finished piece than in sketching, which I use as an exercise in observation and discipline. Again, it's a sharpening of the skills and tools I need for my larger works as well as an enjoyable venture that offers solace and tranquility.

My sketches are like the evolutionary ancestors to my finished work. They are the unseen weight bearing bones beneath the meaty muscles of my stronger pieces; the reptilian brain of automatic tasks beneath the frontal lobes of my higher expressions.

McCHRISTIAN

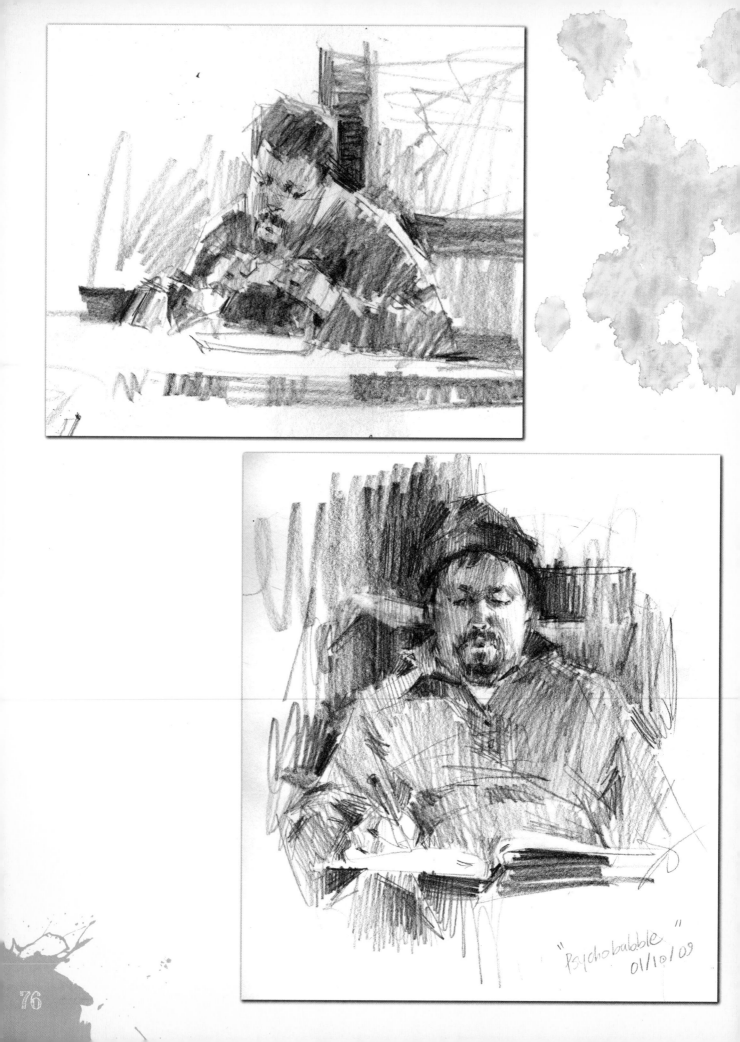

"Psychobubble"
01/10/09

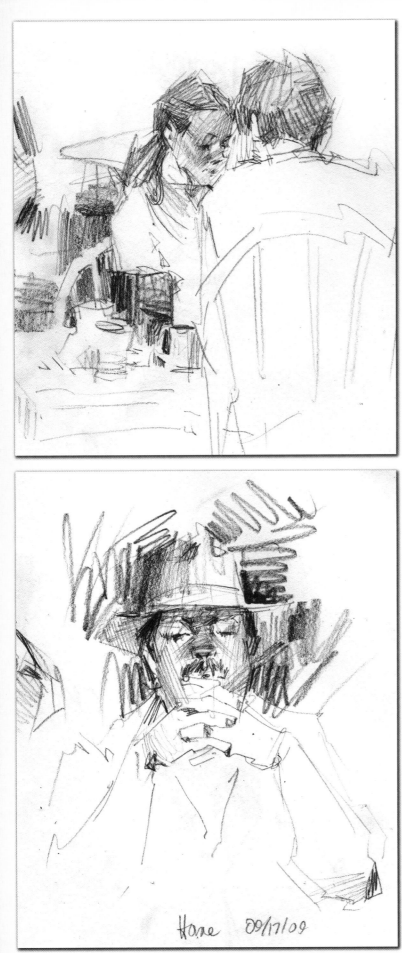

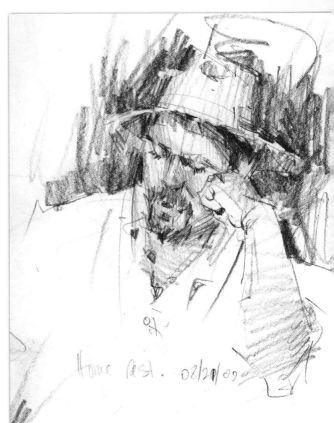

Home rest. 08/20/09

Home 09/17/09

Richard McKinley

A professional painter for almost four decades with over thirty-five years' teaching experience, it's hardly surprising when McKinley says, "Trying to capture a piece of the world around me in paint is something that has consumed my life since I was thirteen." Passionate about painting outdoors, the artist has earned many accolades for his oils and pastels, among them the honor of being inducted into the Pastel Society of America's Hall of Fame in 2010. A contributing editor for THE PASTEL JOURNAL, McKinley recently compiled years of his columns and blogs published for the magazine for his book PASTEL POINTERS: TOP SECRETS FOR BEAUTIFUL PAINTINGS.

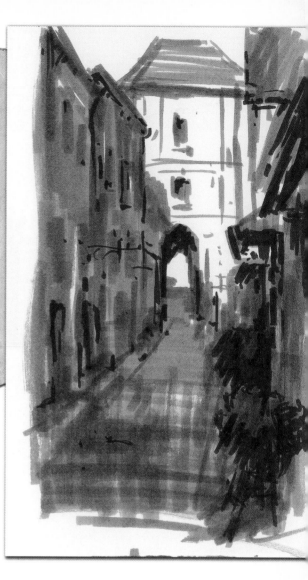

The inspiration to sketch comes from the intimacy it produces with the subject matter. Instead of quick snapshots, time is spent looking and analyzing. This leads to a more sensitive interaction and outcome.

Sketching can serve two purposes for me. It can be the beginning step in advance of a painting. This entails a series of thumbnail sketches used to work out composition and value placement. Or it can be a means of artistic expression often done while on exotic travels. These sketches quickly record my impressions for later reference and inspiration beyond what photography can provide.

Sketching is an attitude for me. It implies that I am working quickly to record information that the camera cannot. For this reason, my sketches are often produced on a variety of surfaces with various mediums. Small thumbnail sketches are usually done with a standard 2B or 3B pencil in a small commercial sketchbook. For composition value studies, Tombow value markers (Dual Brush Pens) are great. They make it easy to quickly mass in large simple shapes of value abstractly. Water-soluble graphite pencils are another choice. When water is applied the graphite becomes like ink. Utilizing a brush makes the transition to paint easier, allowing me to think more like a painter than a draftsman. When sketching for reference, especially when traveling, pen and ink with watercolor washes in a travel watercolor sketchbook is preferred. For larger sketches, often done in studio, I like to use painting surfaces I plan to paint on. This gets me into the flow for the ultimate painting. Pastel surfaces, like Wallis pastel paper and Pastelmat, are common choices.

Sketching is a warm-up for painting. It gets me into the sensitive side of my brain. I like to begin simply with small composition doodles, analyzing the elements of the composition: shape, motion and value-mass. I ask myself, What is it I want to say about this scene? What can I leave out to strengthen that intention? I also remind myself that it is not about a pretty sketch. Sketching is utilitarian for me, and once I begin to worry about how polished it appears, I stray from the purpose of the sketch. To stay loose and true to this purpose, I console myself that I don't have to show anyone what I have done; it is for me.

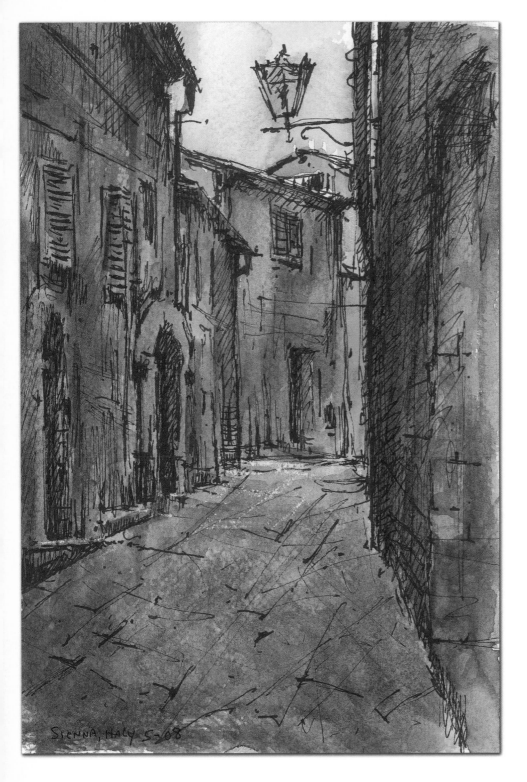

SIENNA, ITALY 5-08

The first marks of a sketch are always anxious. I have formed a mental picture and am now making it literal. A sketch—or a painting, for that matter—is a performance. Stage fright in advance of beginning is common. It is like I can't remember my lines, play the instrument or throw the ball. Once the physical motion begins, intuition takes over and I become calm and focused. It becomes a response to the interplay between the subject and surface.

Sketching keeps the artistic muscles toned. It reminds me of the fundamental design elements that are the foundation of every good piece of art. It helps me to organize the visual elements of a scene making it easier to relate my intentions to an audience. A simple sketch can solidify a concept. These sketches provide clarity in advance of painting, ultimately producing a stronger, less overworked end result.

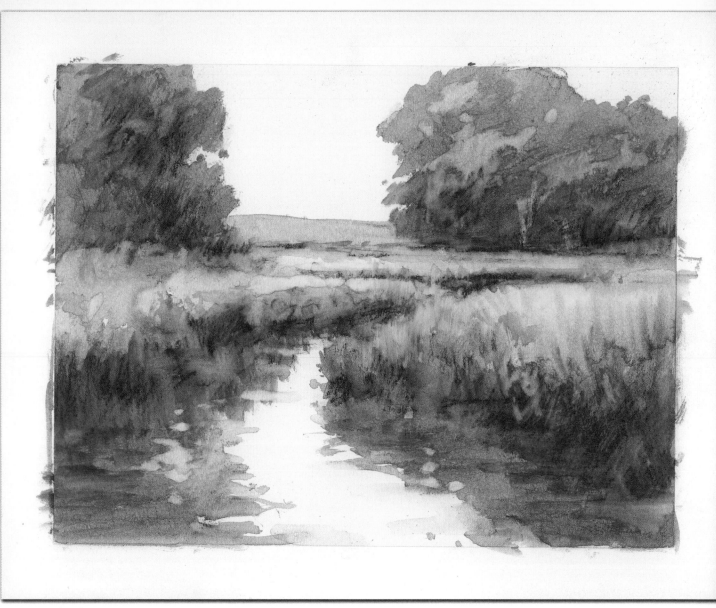

Large sketch done with water-soluble graphite pencils on Wallis pastel paper.

The best lesson of sketching is that a little advance preparation can make the journey easier. Life and art are filled with pitfalls. A little preparation can make them less troublesome.

A sketch—or painting, for that matter—is a performance. Stage fright in advance of beginning is common.

The mind works very symbolically. It quickly associates meaning to the flashing symbols before the eyes. Taking time to sketch forces my mind to slow down and become contemplative. As this happens, an unnoticed world comes into focus, making me more aware and sensitive.

Since the word "sketch" implies looseness, it is easier to let go of the desire to fuss and polish. When I work on paintings that are meant to be important works, it is easy to let that goal get in the way of creative freedom. There is an underlying fear of making a mistake, of the end result not meeting expectations. When sketching, there is nothing to lose, so it is easier to allow intuition to take over.

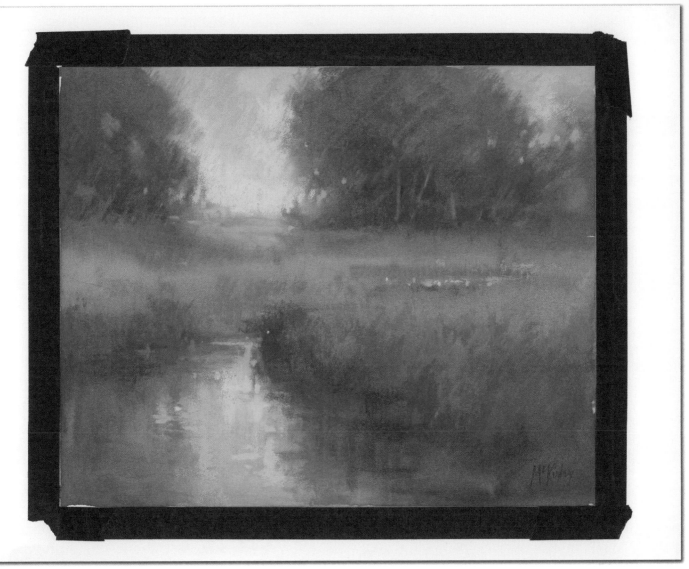

Pastel sketch in advance of painting.

My sketches are not done with the intention of merely copying them later as a finished painting. They provide more of an artistic warm-up and a way of making thought literal. It is easy to experiment with a sketch. If it doesn't work, I move on to the next attempt. This gets the creative juices flowing. Even when a painting goes in another conceptual direction, I feel more intimate with the subject.

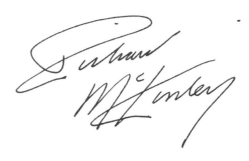

Jeff Mellem

A professional artist and graphic designer, Mellem has designed for magazines, video games and theater and worked in various industries over the last decade. He earned a Bachelor of Fine Arts degree from The California State University, Fullerton, and studied drawing at the American Animation Institute in California. Traditional drawing techniques are the foundation of his work, to develop characters and stories. His book SKETCHING PEOPLE: LIFE DRAWING BASICS was released by North Light Books in 2009.

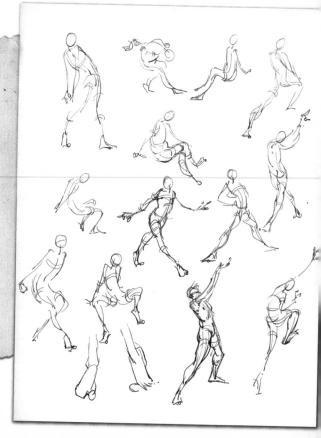

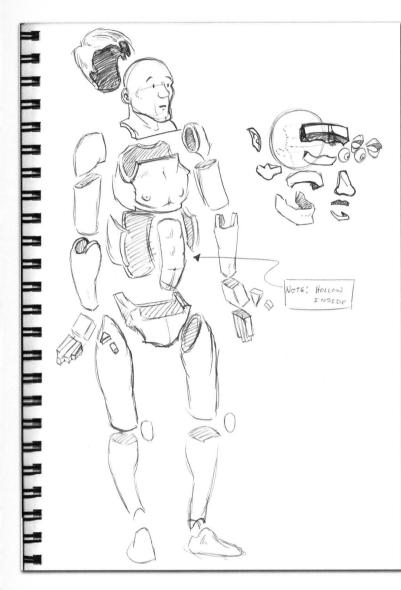

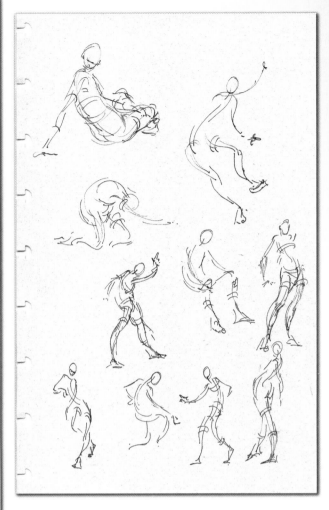

I've never really considered myself an artist; I'm just a guy who likes to draw. I think it's fun to sit down and let the pen wander around the page until some character reveals himself. The wonderful thing about drawing in a sketchbook is that it turns the act of drawing into a process of discovery. In a sketchbook, you can start a drawing with one thing in mind, but as you draw, you can discover new ideas along the way and you end up somewhere completely different than where you thought you were going.

Drawing has a magic about it. From simple lines, shapes and forms are created that carve space from the flat page. The lines disappear when something we recognize emerges. The sketchbook is such a great place to explore because there doesn't have to be an end result—it can be whatever you want it to be, and no one is there to pass judgment.

Sketchbooks are pieces of art in and of themselves. Sometimes a sketchbook can be a personal journal filled with notes and sketches of the artist's experiences; other times it can be a place to practice techniques or study a new subject. I've seen sketchbooks that are wild assemblages of drawings and clippings pasted together, and I've seen very neat books filled with exquisite drawings and watercolors. The sketchbook reveals the artist's thoughts, methods, skills and personality more than a finished work does because it shows his or her process, and it often captures the development of an idea or the moment of discovery.

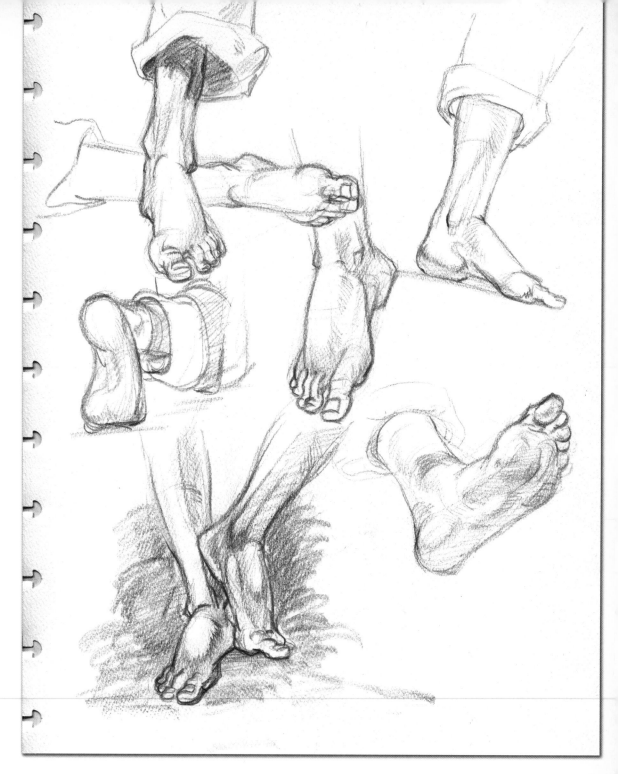

Drawing in a sketchbook is one of the many things I
enjoy doing. It's so convenient when inspiration strikes
to sweep up my sketchbook, Namiki fountain pen, a
watercolor brush, and a couple of Prismacolor Col-Erase
pencils and sit down at my desk or some other location
and just draw. The time spent may end up being produc-
tive or it may just be a pleasant waste of time. The whole
point is to enjoy the process and see where it goes.

In a sketchbook, you can start a drawing with one thing in mind, but as you draw, you can discover new ideas along the way and you end up somewhere completely different than where you thought you were going.

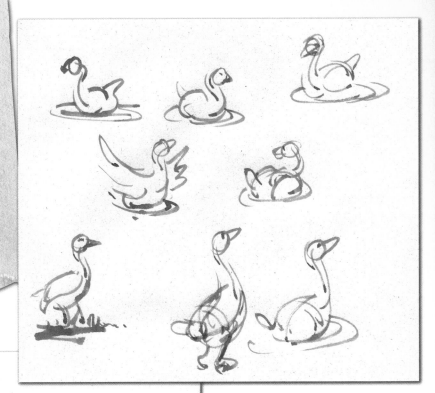

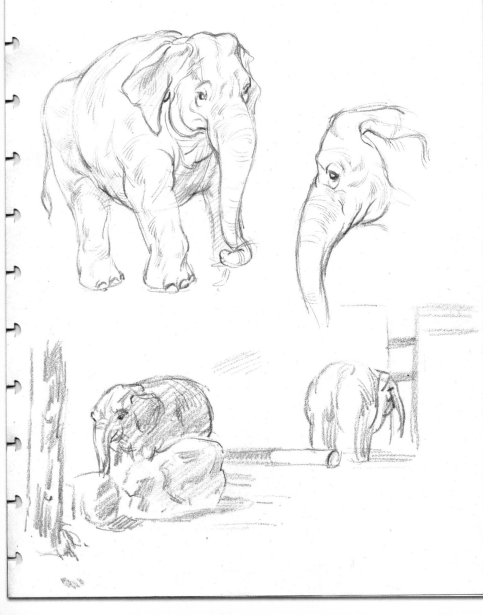

ed Morgan

Morgan's unique, finely detailed embossed impressions of Native Americans, animals, birds and flowers are the result of a highly involved, incredibly painstaking and unforgiving production process that has singled him out among master engravers. Thinking "backwards and in reverse"—essential when handcarving his designs into metal plates, which may total up to nine for a single piece—has made his lifelong dyslexia a significant advantage in his art. Watercolors and intricately handcut silk complete his works, which typically take many months to finish in his New Mexico studio.

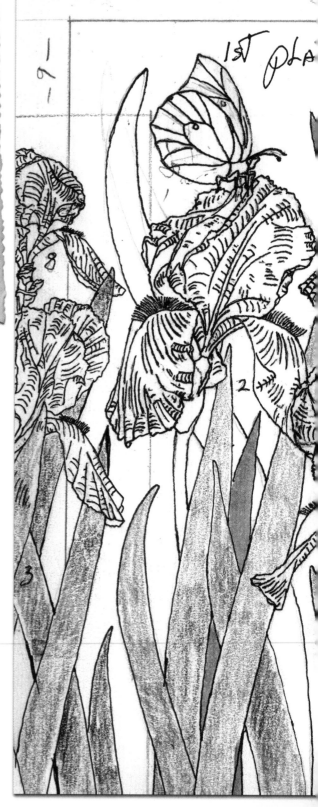

I don't "sketch" anything. My artwork is very technical. In engraving, there is no sketchiness; you don't have two lines. You've got a single line, and that's it. If you're carving backwards and in reverse, your finished drawing is the template for the engraving plate. Once you take the metal away, you can't put it back, or erase a line and put in a new one. Once it's cut into the metal, that's it.

I don't carry a sketchbook with me; I walk around and look at everything. I capture images in my mind and I take photographs. I use models, too; all my figures are live models. I don't have them sit there for me because it takes so long to engrave, but I photograph them in fifty different positions so I can see their hands, the back of their ears, or whatever I need to. My whole house is full of artifacts, and I have my garden outside, and I look and read and scan through books in my library. If that causes me to think of an idea, then I just build that idea in my mind, and I go over and over it. Once I've got that down in my head and I can see it, then I start to draw it.

After I draw out an idea, I start working with all the problems I'm going to have when trying to do the engraving. For example, I can only make up to a certain-size plate (no bigger than 10" × 15" [25cm × 38cm]). If I'm creating a person that's, say, 12 inches (31cm) tall, I have to do two different plates and splice them together, and figure out how the splicing goes. It's this constant thing of, "Well, is that gonna work?"

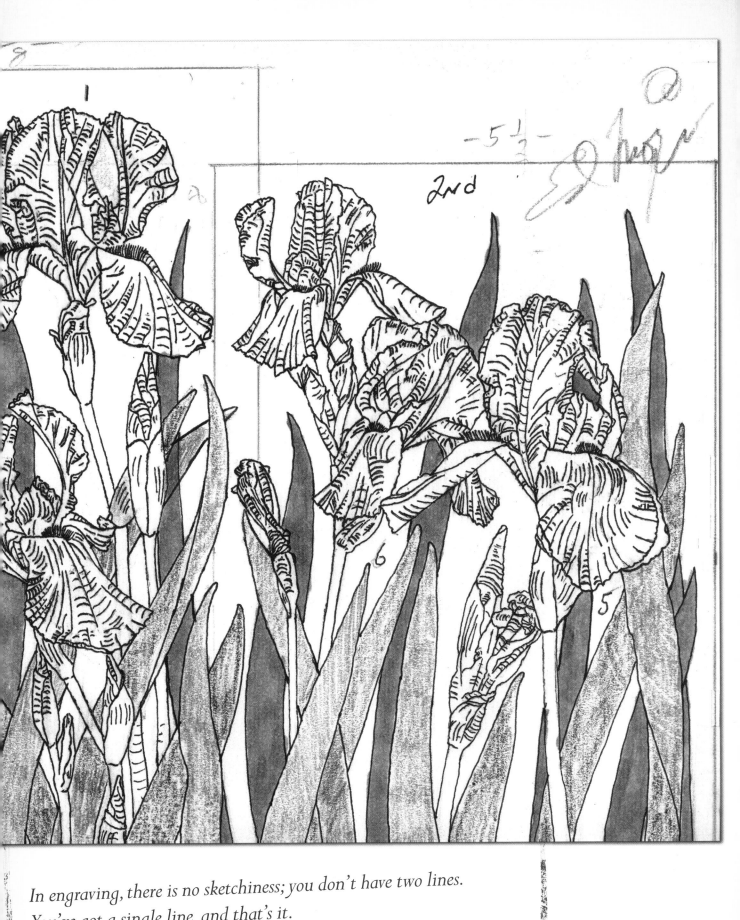

In engraving, there is no sketchiness; you don't have two lines.
You've got a single line, and that's it.

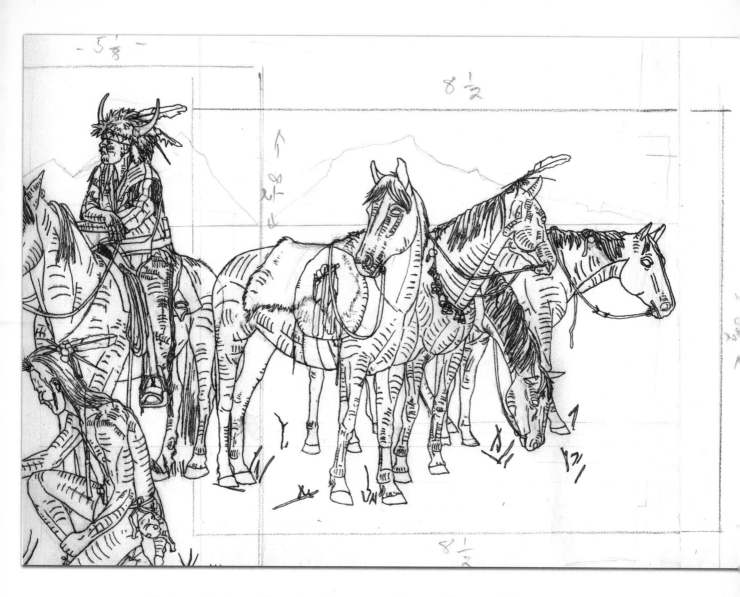

I don't consider the problems when I draw out an idea; I just consider what I want to do. When I start to do the tracing and then the carving, that's when I work out the problems. There are times when I have absolutely no idea what I'm doing. When I first sit down to draw, it's kind of "sketchy" when I do it. Then it cleans itself up when I sit down to ink, and I "erase" all the scraggly stuff that wasn't the final line I decided on. The piece of paper that you see in these drawings is the one I started out with.

After I've got the idea and have drawn it out, it's usually on the drawing board up in my library for at least a month or two, because I'm often working on finishing another piece. So, I'll go up there and look at that every day and think, "Well, that's not gonna work." I won't make changes on the drawing itself; I make all my corrections when I do my tracing on Mylar. I draw first

with a pencil, then I go over it and clean up the drawing with an ink pen. That way, I've got precise lines. The drawings have on them the size of the plates, how those fit together, and all of those kinds of things, but they're not "sketchy." When I sit down to trace the idea, that's when I clean everything up and see if I've made any mistakes, and when I go over what I'm going to have to do when I carve it backwards and in reverse into metal.

After I've got all of the sculpting done for the plate, I push modeling clay onto the plate and see what I'm doing. Then, after I run it on the press, and I get to look at the image for the first time to see if I can actually pull it off as a whole, I deal with colors and all of the other stuff that goes into it. It might take me a year and a half to do one design that has four or five plates. So, while I'm doing that, I'm thinking about what my next project's going to be.

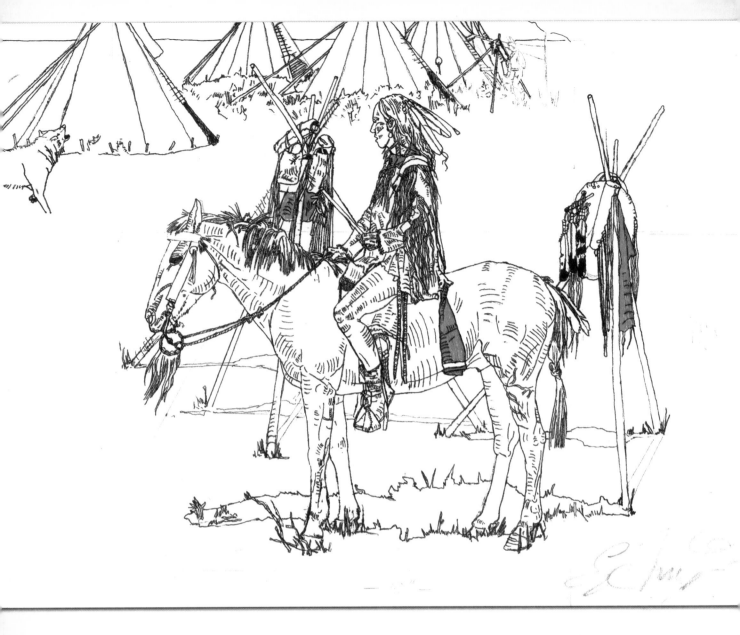

There have been times when I draw things out and I don't end up doing that piece. I go on to something else. I've got drawings laying around that I did not take further (that's very few). I have a safe that I use for storing the layers of my drawings. I've sold maybe two or three of those over the years, and how I sold them was not as individual drawings, but when some of my hard-core collectors bought a piece from me and wanted the plates and drawings—everything for the piece, which I ended up framing for them to keep (not to use, just to have). You can see the entire process and have the engraved plate there next to each piece, which is pretty cool for people to look at.

In my drawings, I don't put in every bead and every hair, but I do that in the engraving. Engraving lends itself to detail. You could be a minimalist in engraving, too, but I never wanted to. The people that have my pieces love detail. They actually look at them with magnifying glasses.

Azusa Drive-In
Acrylic on canvas (finished painting)
15" × 30" (38cm × 76cm)

art Mortimer

Considered an originator of the contemporary mural movement in Los Angeles, Mortimer has painted nearly a hundred murals since 1971, several which have won community beautification awards. A freelance artist since 1969, Mortimer gave up his commercial art business in 1988 to focus on murals, paintings and drawings. His hometown of Long Beach, where he completed a 300-foot-long (91m) historical mural of the city, honored him as their Artist of the Year in 2004. In his plein air paintings, Mortimer is most interested in "the intersection between the man-made and the natural world."

My sketching is mostly done to work out composition and basic structure for my paintings. I look for dramatic or interesting subjects AND compositions. I use sketches to work out the basic structure of the composition and the arrangement of lights and darks.

I don't sketch daily or as a habit. I do it mostly when I want to visualize something for a project, whether a painting or a mural. It is a tool I use to get me where I want to go.

I usually sketch when I am on location, standing in front of my easel, and trying to decide how, exactly, am I going to set down what I see in front of me. We spend our lives experiencing the world in three dimensions, but in order to be able to communicate effectively in representational art, we have be able to express ourselves in two dimensions. So doing small, thumbnail-type sketches is a way to quickly try out various compositions and variations to help me decide how to do my painting. Sketching helps me learn to see the world in two dimensions.

Palisades Coast
Acrylic on canvas (finished painting)
15" × 30" (38cm × 76cm)

I prefer to sketch with a black Pentel Sign Pen on plain bond sketchbook paper—nothing fancy. The most important factor in a good composition is the basic arrangement of lights and darks, and working with a relatively wide, solid-black marker limits me to either solid black or solid white, with a little cross-hatching for gray areas. The Sign Pen is water-based, so it's easier to draw with (it doesn't soak into the paper very much). With these tools I am forced to simplify my composition in my mind in order to be able to express it in a small sketch with a relatively broad-tipped marker.

I deliberately do NOT try to do a beautiful sketch. The sketch is a tool to help me work out my composition, and I find that if I get caught up in trying to do a "good" sketch, I lose sight of my goal. And I lose the spontaneity and fluid strokes that are so important to help me express what I am experiencing. Sketching with fairly crude tools forces me to think in two dimensions and helps me to see what works and what doesn't work on the most basic compositional level.

I deliberately do NOT try to do a beautiful sketch. The sketch is a tool to help me work out my composition, and I find that if I get caught up in trying to do a "good" sketch, I lose sight of my goal.

91

At right: The artist's first, rejected sketch of the scene. Below: His final sketch with a better composition.

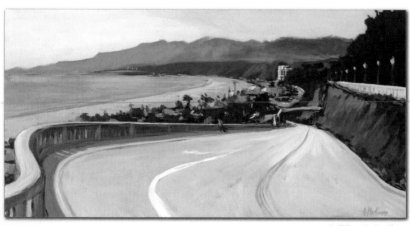

California Incline
Acrylic on canvas (finished painting)
18" × 36" (46cm × 91cm)

When I am sketching, I think about the scene I am looking at and the painting I am going to create. And I think about how I can express my feelings and appreciation of the scene in front of me through my composition and communicate that to the viewer.

Sketching a scene before painting it helps me distill it to its essence and then figure out how to communicate that essence in my painting. When I look at a scene, preparing to sketch it with a black marker, I am forced to look for the most fundamental building blocks of my composition—the light areas, the dark areas—and see how they can work in my painting. I have learned so much about how we experience the world by having to deconstruct and simplify it for my work. I can then put it back together in a way that creates an interesting and meaningful experience for the viewer.

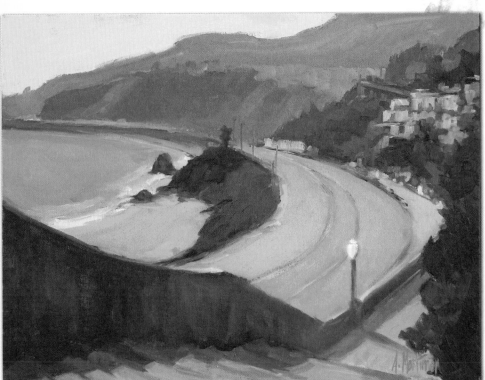

PCH Curve
Oil on canvas (finished painting)
12" × 16" (31cm × 41cm)

I feel blessed to be able to do this work—to paint, to draw, to experience the world through an artist's life and eyes. I feel the glory and beauty of the world we live in, no matter where I am and what I am going to paint. Doing a sketch of a scene I am going to paint helps me feel connected to the scene and be a part of it. And it helps me to feel more confident in the adventure I am about to embark on: my painting.

Working on small sketches with a fairly broad tip black marker makes it essential to try to express as much as possible with as little as possible. This opens the door for free, gestural strokes; a willingness to let simple lines and shapes express a lot; and practice at letting accidents happen and using them to one's advantage. There's no going back when sketching with a black marker.

When I am sketching,
I like to empty my mind
of everything except the
sights, sounds and smells
of my surroundings.

Claudia Nice

Nice is a self-taught artist who developed her realistic art style by sketching from nature. The Pacific Northwest native has traveled internationally to conduct workshops, seminars and demonstrations, and she operates her own teaching studio, Brightwood Studio, in the beautiful Cascade wilderness near Mt. Hood, Oregon. Nice has authored more than twenty art instruction books, including SKETCHING YOUR FAVORITE SUBJECTS IN PEN & INK, HOW TO KEEP A SKETCHBOOK JOURNAL and her latest, HOW TO SEE, HOW TO DRAW (published in 2010).

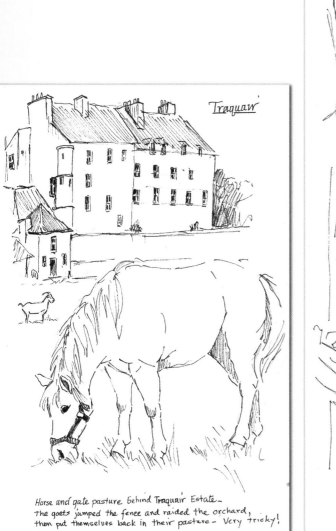

Traquair

Horse and gate pasture behind Traquair Estate.
The goats jumped the fence and raided the orchard,
then put themselves back in their pasture - Very tricky!

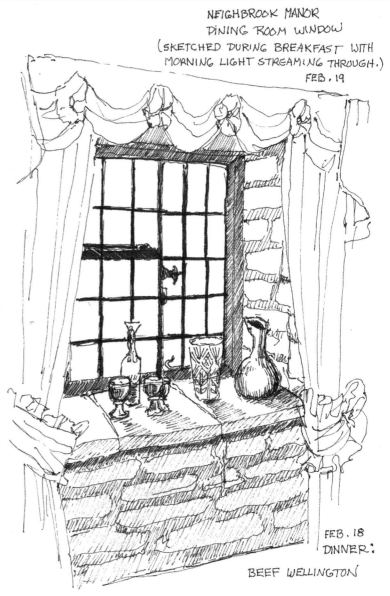

NEIGHBROOK MANOR
DINING ROOM WINDOW
(SKETCHED DURING BREAKFAST WITH
MORNING LIGHT STREAMING THROUGH.)
FEB. 19

FEB. 18
DINNER:

BEEF WELLINGTON

My greatest inspiration is nature. Those things created by the Master's hand can be so unexpected and fascinating. I like it all, from the crusty rust on a horseshoe to the magnificence of an incoming storm. Where composition is concerned, contrast turns on my artist's eye. I like light against dark, bright colors against muted tones and strong shapes against open areas. When I come across such a scene, I get excited.

Being the author of "how to" art books, I am painting or sketching most every day. I like to carry my sketchbook journal when I am headed to interesting places or when I am walking in the wilderness behind the house. I carry my camera with me a lot, to record unexpected treasures, which I can use later for reference. A lot of my work is based on sketches backed up by a series of photos.

I sketch for artistic pleasure. It's just plain fun to capture bits of this and that in my sketchbook journal. When I review what I have entered in my journals, memories come flooding back. Photos recall places and people. Sketches recall scenes and subjects plus some of the personal impressions and emotions of the artist.

Pencil, pen and ink, and watercolor washes are my favorite sketching tools.

When I am sketching, I like to empty my mind of everything except the sights, sounds and smells of my surroundings. When I look at that landscape sketch at a later time I will also recall the sound of the birds singing in the brush, the splash of the frog that belly-flopped into the pond and the smell of the flowers in the air. It's a total recall package, triggered by a few lines in a book.

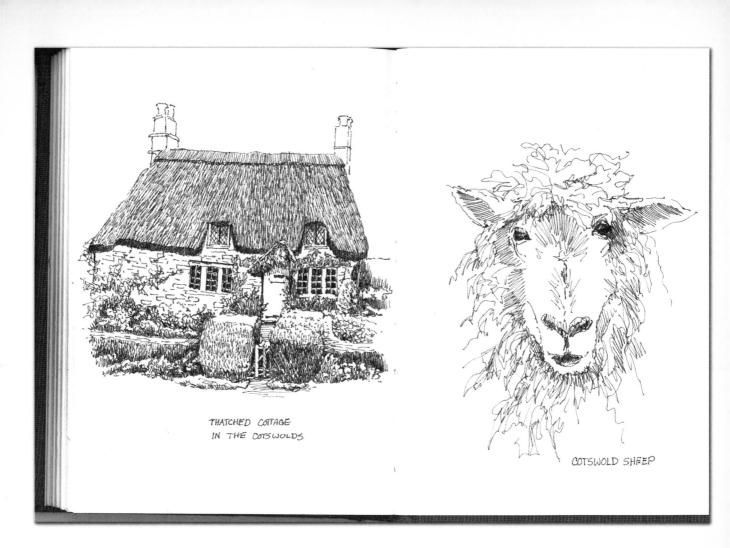

THATCHED COTTAGE
IN THE COTSWOLDS

COTSWOLD SHEEP

When I am sketching, and I'm not pressed by time or worried about getting something else done, I feel totally relaxed. I let myself become part of the scene as if I were planted in place. I take more time observing than I do drawing, and from the experience I gain many insights. Sometimes sketching is a spiritual experience for me.

The more I sketch the better my observation abilities become, and the faster and more accurate my drawings are. When I haven't sketched for a while, I can tell it in my work. I learn a lot about art and life in general by observation. Observation and the ability to draw are closely related.

The world as seen by the media, community, world leaders and even by family and friends can be a very negative place. Sketching out in nature can balance those feelings of negativity and provide me with natural beauty, hope and spiritual inspiration. Sketching outdoors is like listening to beautiful music—it lifts the soul.

I take creative license whenever I feel like it, whether I'm sketching or doing a finished painting. However, I put more effort into "finished work" and I am more apt to ponder what the results of my actions will be so as not to spoil the overall effect.

I usually make a finished painting using both field sketches and photographs. The photos are my reference for shapes, colors, value changes, shadows, highlights and textures. The sketches are a more personal guide to these composition elements, plus an insight to my thoughts and feelings while I was working on location. Combining structural elements with mood and emotion can turn an interesting scene or subject into "art."

Claudia Nice

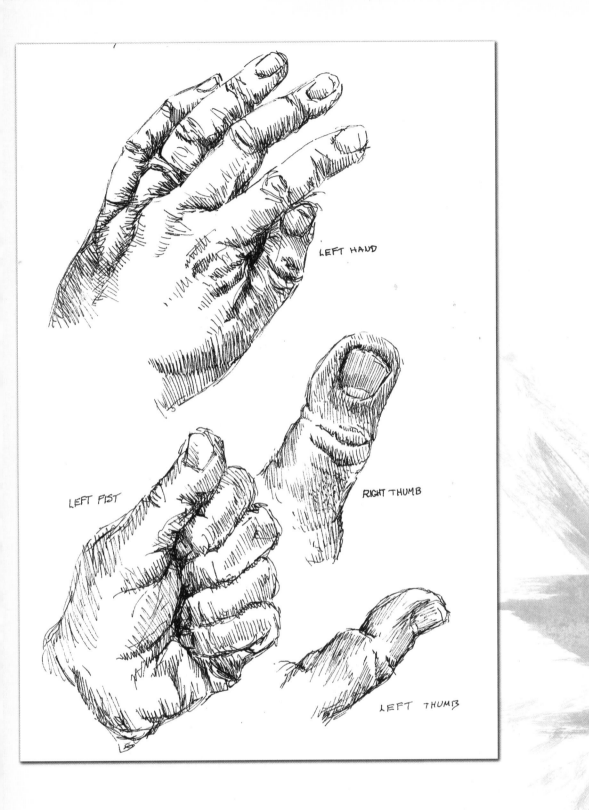

LEFT HAND

LEFT FIST

RIGHT THUMB

LEFT THUMB

Crowned Jewel
Oil on canvas (finished painting)
28" × 20" (71cm × 51cm)
Collection of the artist

P.a. nisbet

Following college and a stint in the U.S. Navy, Nisbet started a commercial art business, providing graphic design and illustration for over twenty-five national organizations. In 1980 the North Carolina native moved to the Southwest and began painting landscapes that are derived from his experiences throughout the world, including excursions to such remote places as the South Pole and China, and time spent in the deserts of the Southwest and Mexico. His art appeared on the first U.S. postage stamp featuring national parks. "What I am trying to say in paint is the same thing that artists have been trying to say for a thousand years," Nisbet says. "That the world is phenomenal and that nature is layered in an ever-deepening mystery."

I learned to paint around age 10 by copying photographs in *National Geographic* magazine and working from still life setups in my mother's studio. As a teen I found I could mimic any photo with ease but realized I needed to know more about the landscapes that interested me, so I began doing plein air sketches to support studio paintings. To this day, I use plein air work as a sketching tool to establish the sense of place that any good landscape painting requires.

I normally sketch as a preliminary visualization tool for new paintings. I do small thumbnail sketches to work out compositions or simply to brainstorm new ideas. I prefer soft lead pencils, Conté crayons or charcoal sticks on sketch paper. For plein air sketches I always work in oils, usually on prepared hardboard panels or cut canvases that are taped to a hard backing.

99

I have a sense of where I want to go before beginning a sketch, so I direct myself intuitively but also observe what appears as I am working. Thus I follow the sketch wherever it wants to go. I don't think as much as I sense what feels right.

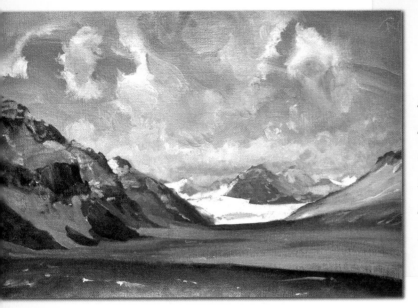

In our culture we are conditioned to see, judge and act with considerable speed. I have learned, through the act of sketching, to look at things for much longer periods of time, and subsequently have been able to see deeper into things.

When I sketch, I feel what I imagine it must feel like to be pregnant. What I mean by this is that I feel something wanting to come forth from within my psyche. I prefer to suspend judgment and work through the experience, then save or discard the sketch according to its merits. A sketch is just a way station to another place. It is part of an elaborate process that I use to come to final expression.

All sketching sessions, whether in studio or outdoors, help me to open my eyes to new things. Normally I come to sketch with ideas and preconceived notions that are unresolved and require exploration. It is this process of working through a sketch, over time, that will actually give birth to a better idea. Sketching is an indispensable tool for creative expression.

The things we see on a daily basis are not necessarily the truth. The truth in things is generally cloaked beneath a plethora of biases and pre-formed ideas, ideas that are colored by habits and cultural filters. Looking at things over time and sketching them tends to remove the scales from one's eyes and facilitates a new way of seeing something. In our culture we are conditioned to see, judge and act with considerable speed. I have learned, through the act of sketching, to look at things for much longer periods of time, and subsequently have been able to see deeper into things. Sketching has taught me to slow things down, suspend judgment and allow the unforeseen to come forth. This applies both to canvas and also to life.

Usually sketches are distant relations filled with memories. They are traces of actual places, whereas finished works reflect more of my personality and emotions. Sketches testify that I once walked in that real space and time, always with the intention of finding something new. They are the beacons that reveal what direction an artist has chosen to go.

R Lisbet

Saturday, November 24, 2007 9ᵃᵐ View from Orchard House... about 3" snow last night! Lots of white, and very subtle colors. Overall pale except for trees bordering Rio Ruidoso.

9-4-99 West side of Lincoln Pond, Hoyck Preserve, Rensselaerville, N.Y. Took photos here, too. Would like to develop a
11 am drawing something like this - Need to do some value studies first - Everything here seems so overall
70° shadowy - I keep wanting to see that strong New Mexico light, but it isn't here. This watercolor
 sketch turned out brighter and lighter than the scene really appeared. Transpose to lower key.

NOON
Sunday, September 28, 2008

Heading home - about 10 mi. south of Colorado, San Antonio peak rises (10,890') and we pull
off on Forest Service Road 118 just to contemplate its mounding bulk. Grasshoppers clatter all around me,
imitating rattlesnakes! Gold spills down its slopes, and as I get settled to paint, a pair of pronghorn
bound off in the foothills. ☑ Aspen populations have decreased in the southwest due to efficient fire suppression.
Conifer forests will crowd out aspens, which depend on fire or other natural disturbances to create openings and
sunlight to get established. This gold mountain caps off our weekend of 'leaf-peeping'.

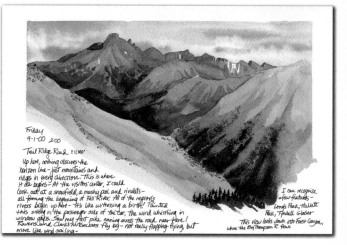

Friday
9-1-00 2:00

Trail Ridge Road ±11,000'
Up here, nothing obscures the
horizon line - just mountains and
ridges in every direction. This is where
it all begins - At the visitors' center, I could
look out at a snowfield, a mushy pool and rivulets -
all forming the beginning of Fall River. All of the region's
rivers begin up here - it's like witnessing a birth! Painted
this sitting in the passenger side of the car, the wind whistling in
window gaps. Saw my first pika running across the road near here!
Ravens and Clark's Nutcrackers fly by - not really flapping flying, but
move like wind sailing -

I can recognize
a few features -
Longs Peak, Hallett
Peak, Tyndall Glacier
This view looks down into Forest Canyon,
where the Big Thompson R. flows

Margy O'Brien

O'Brien's artwork reflects her lifelong dual interests in art and natural science. Since earning her Bachelor of Fine Arts degree at the University of Arizona, then moving to New Mexico nearly forty years ago, O'Brien has taught art in public schools, presented workshops on nature journaling, and created fine art in watercolor, acrylics and ceramic tile. Her drawings and paintings have appeared in Guild of Natural Science Illustrators' shows at the Smithsonian, the National Academy of Sciences and the Denver Museum of Nature & Science. She says her sketchbooks take her "instantly back to a specific time, place, and state of mind more easily than any of my studio artwork."

My journaling and sketching are inspired simply by being aware of the natural world around me and by the long tradition of keeping a nature journal. Right now, I'm watching eight robins out my studio window, circled around my birdbath fountain. They dip their beaks, then tilt their heads up in robin rhythm. All are slate-backed, but one has a much redder breast. Do I continue writing or stop and sketch? It usually depends on what else is going on. Sometimes it is enough to just stop and watch, building visual memory for the next time. Inspiration is never a problem; acting on the inspiration, though, is influenced by the other things going on in my life.

I don't have a daily sketching habit; it's more of an organic practice, slipping into my schedule as needed. I carve out time for my sketchbook when a trip takes me to a new locale, when I notice something exceptional in my garden, when a fellow artist suggests an outing, or when a seasonal change catches my attention. Sometimes I'm perplexed by something going on in my life, and taking my sketchbook and watercolors somewhere makes the world right. I try to be tuned in to the inner voice that tells me to stop. Notice. Record this, now.

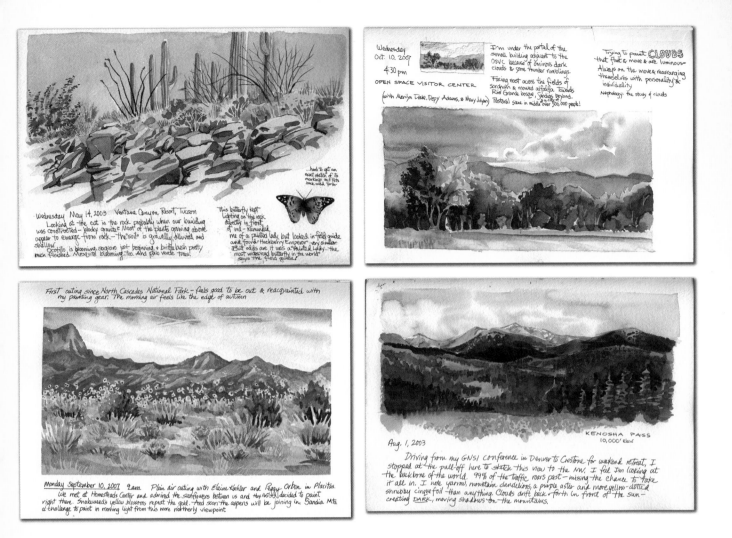

I have sketched outdoors in all four seasons and at all times of day. I have set aside an entire day to explore with my sketchbook, but also twenty minutes at a highway rest area. There is no "perfect" time or place—only what presents itself to me and my openness to it. An amaryllis on my windowsill or a grand vista on a destination trip—whenever something stops me and I pay attention—that's when I want to sketch.

I've sketched in many basic hardbound sketchbooks of drawing paper, but as I focus more on watercolor, I work in hardbound books of watercolor paper, working on both sides of the paper. A friend brought me some wonderful books from England that I'm unable to find here. So I learned coptic stitch book-binding and have made my own 8½" × 11" (22cm × 28cm) journals. A watercolor paper I especially love is Fabriano Artistico soft press, as it has a bit of tooth or texture, but not so much that it interferes with the writing I usually do alongside the sketch. For black and white sketching, I like the Rotring Art Pen, a fountain pen that uses ink cartridges and flows easily. I also like Derwent water-soluble graphite pencils that I use with a Pentel waterbrush.

When I'm sketching outdoors, the busyness of my ordinary thinking mind goes into remission, thankfully. It is replaced by directly responding to what I am looking at. I ask questions and the answers are recorded by my paintbrush or pen. Am I capturing what drew me to this view or object? Is this the color I'm seeing? Should it be warmer? Cooler? What happens when I put this color next to it? Is my sketch helping me learn something? Unlearning other things? Is it time to put away paint and brushes and write in words for the rest of the story?

Sketching can be a struggle, with distractions of ants, eye gnats and passersby, but usually it feels more like play. I am visually taking it all in, but also smelling damp leaf litter or warm pine needles. I'm tasting the saltiness of sweat and feeling the tree bark I'm leaning against. I am listening to bird calls, hikers on the trail and the wind through treetops. All the senses play into the sketching experience, evoking a response to being alive and part of the natural world.

PUERTO PENASCO

Tues. Feb. 8, 2005 9:30 am

Sunny clear, turquoise water at the horizon. Brown pelicans + gulls in front of me on a spit of sand until rising tide shoves them closer in. In front of me, a network of tidepools in volcanic, holey rock—I could poke around here all day! Surprises everywhere I look.

> *Right now, I'm watching eight robins out my studio window, circled around my birdbath fountain… Do I continue writing or stop and sketch?*

Keeping sketchbooks benefits me as an artist and as a human being, which is probably why I enjoy occasionally teaching nature journaling—sharing my passion. Sketching is an antidote to visual complacency and a way to discover something for (and sometimes about) myself. It provides a meditative quality that I don't get much of, and it fuels my indoor studio work. Keeping a sketchbook gives me a place to experiment with compositions, color choices, and subject matter—teaching me that the possibilities are endless.

The sketches in my sketchbook stand alone, complete, finished for their own sake. My sketchbooks are also the creative well I can dip into if needed. Sometimes I page back through one of them for something I'd like to develop further. It may take the form of a larger watercolor, a ceramic tile mural, or even the content for one of my handmade one-of-a-kind artist's books.

Sketching definitely shapes how I see the world. I see myself connected to the landscape and feel an awakening of my senses. Drawing the contorted exposed roots of a juniper, I sense my own aging limbs and how I cling to the familiar. Looking at a complex rocky cliff, I'm humbled by the forces of wind and water over eons. Sketching a pine tree, I'm surprised by an emerald and ruby woodpecker flying into a tree cavity and am reminded to enjoy the serendipity of the moment. Through sketching, I feel part of the fullness of life, not just a spectator.

margy o'brien

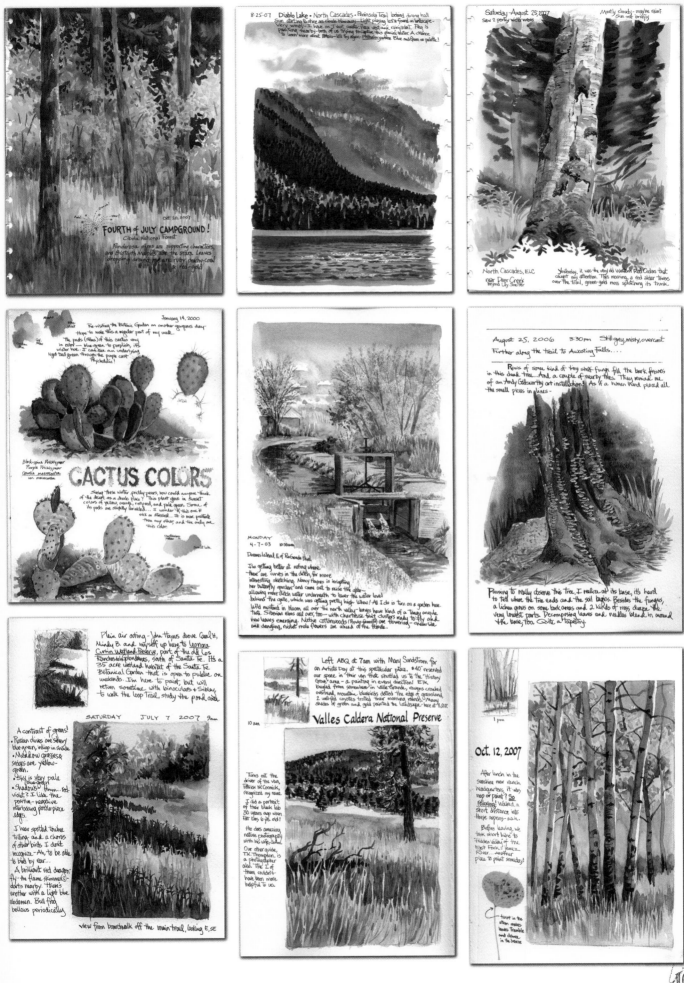

FOURTH of July CAMPGROUND!
Cibola National Forest
Ponderosa pines are supporting characters, and Bigtooth Maples are the stars. Leaves dropping around me are ruby peachy-coral & red-gold.
Oct. 20, 2007

8-25-07 · Diablo Lake · North Cascades · Peninsula Trail behind dining hall

Saturday, August 25 2007
Mostly cloudy - maybe rain? Sun out briefly
North Cascades, ELC near Deer Creek

January 14, 2000

CACTUS COLORS
Black-spine Pricklypear
Purple Pricklypear
Opuntia macrocentra var. macrocentra

MONDAY 4-7-03 10:30am

August 25, 2006 3:30pm Still grey, misty, overcast
Further along the trail to Awosting Falls....

SATURDAY JULY 7 2007 9am
A contrast of greens
view from boardwalk off the main trail, looking E, SE

Valles Caldera National Preserve
10 am

Oct. 12, 2007

105

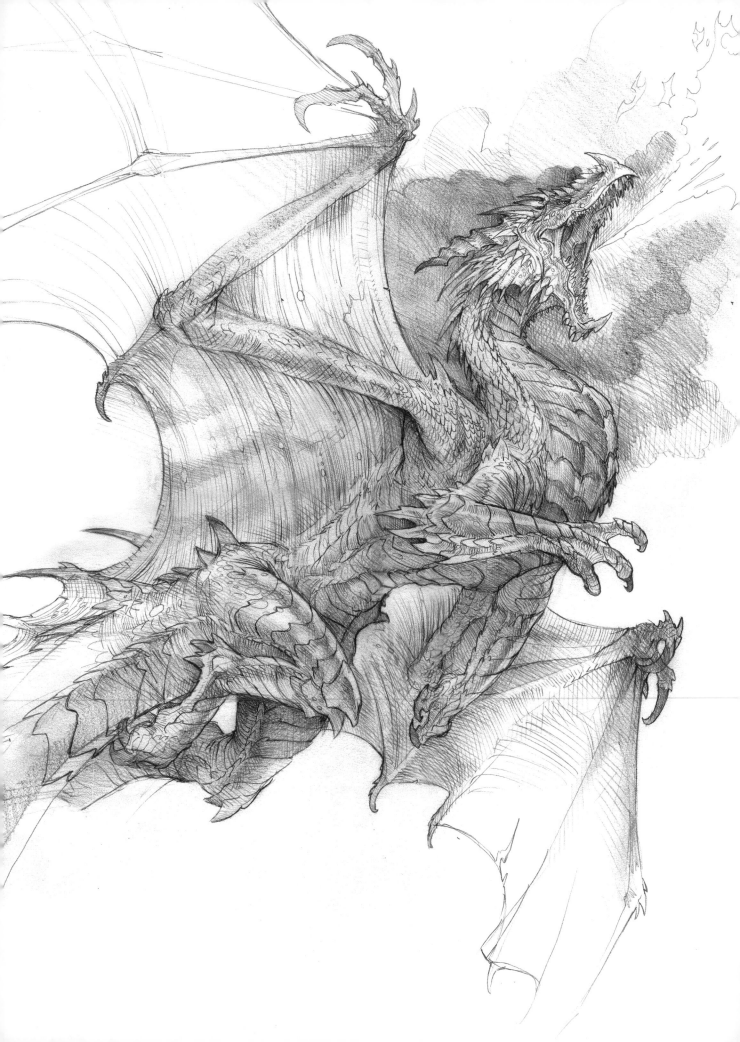

William O'Connor

O'Connor began drawing and painting monsters as a child, and never stopped. The sci-fi and fantasy artist from Long Island began his formal art training at age 10 at Huntington Fine Arts, then he received his B.F.A. in painting from Alfred University and continued his studies at the School of Visual Arts and Parson's The New School for Design. He has executed over three thousand illustrations for the gaming and publishing industries, as well as production designs, concepts, posters and advertisements. He is the author of DRACOPEDIA: A GUIDE TO DRAWING THE DRAGONS OF THE WORLD, published in 2009.

I am a voracious sketcher. I began working in my sketchbooks in 1988. To date I have filled sixty-seven volumes, which constitutes over seven thousand pages of sketches and notes. I can't say that I have any specific inspiration to sketch, but it's more of a habit and part of the artistic process. For me it is a way to visualize and put down on record my thoughts and processes so that I can access them at a later time. I can go back to any day over the past twenty years and see the sketching I did.

I usually sketch daily. I like to sketch in the morning over coffee. It's like doing warm-up exercises. When working on a particularly stubborn visual problem, I can sit for hours and sketch out thumbnails until I get the answer I'm looking for. Other times, I can go weeks without picking up my notebook. Today by working digitally, I do the majority of my sketching on the computer. This is a far more fluid process, and the ideas flow more rapidly. The only difference in digital sketching is that it is nonlinear. You cannot see a chronological, page-by-page process. This exists in exact parallel with writers as well. Some writers insist upon doing all of their drafts in long hand, while others prefer the freedom of working digitally.

A no. 2 pencil is probably the most common sketching tool I use, but I love a good black ink pen. I work in 8½" × 11" (22cm × 28cm) hardcover sketchbooks. Today, however, I use the computer to sketch as much as paper. This is very rewarding in that it's more like painting than drawing, but it ties you to the computer more. It's hard to sit in the park or a coffee shop and doodle on your computer.

When sketching, I feel very loose. For me it's the purist part of the art making process. There are no rules in sketching. Anything can happen. I think, hopefully, of nothing—it's easier that way. Sketching is like meditation for an artist: if you're thinking too much, you'll never get a good idea.

Sketching is where the ideas come from. Nobody just starts a painting, and it comes out finished. The sketch is the conception phase, the embryo of a finished work. A great painting or a terrible painting begins in the sketchbook.

I imagine that sketching is the point at which the artist is most purely himself. Nobody will ever see your sketches; you can be silly or earnest, make a mess and generally explore your thoughts and ideas.

I often wish that I had a little elf in my studio who would do the finished paintings for me, because that is often the least creative part. Years of craft and hours of laborious attention to detail painting chainmail or eyelashes or dragon scales or leaves requires very little creativity but a lot of patience. Sketching is the fun part! Imagining the images and designing worlds is the aspect I enjoy the most and is the most alluring part for young artists. When I teach, I find that it's easy to get a student to sketch, but very difficult to entice them to follow up with thirty hours of painting the finished image. When I'm sketching, it's always fun.

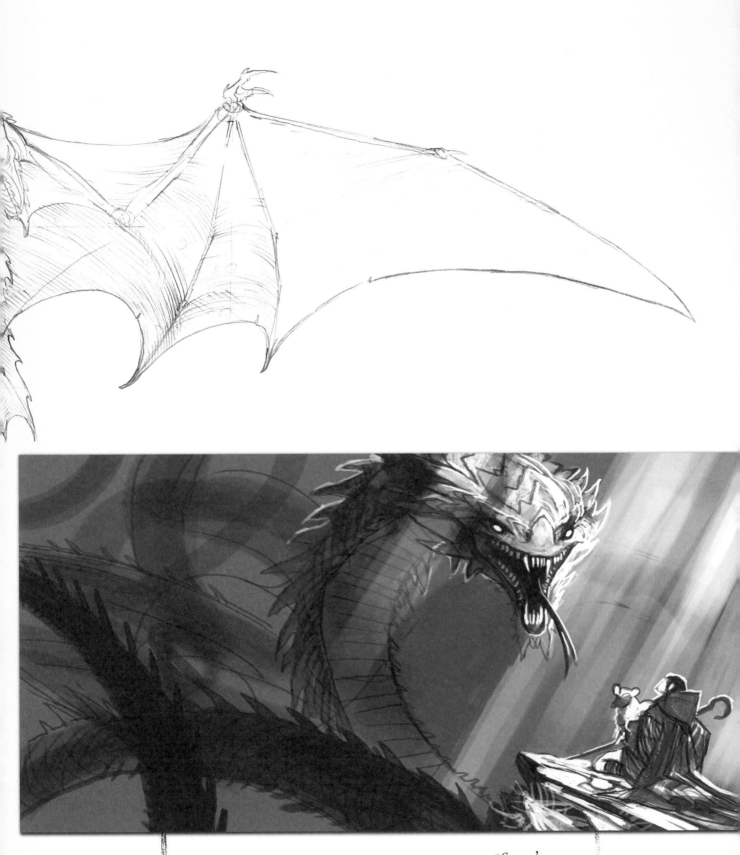

Sketching is like meditation for an artist: If you're thinking too much, you'll never get a good idea.

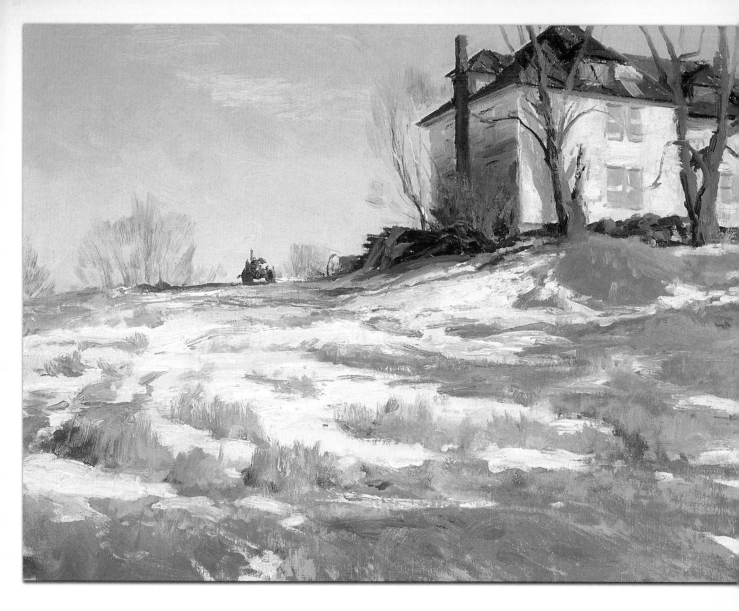

Joe Paquet

The inspiration for many of Paquet's landscape paintings, it has been said, comes from "the people and places in the middle." Industrial towns centered around factories and working-class neighborhoods are frequent subjects on his canvases—scenes familiar to Paquet, who teaches and paints in St. Paul, Minnesota. The New Jersey-born artist is a member of the Salmagundi Club of New York and the California Art Club and a signature member of the Plein-Air Painters of America, and he has been featured in THE ARTIST'S MAGAZINE, AMERICAN ARTIST, CLASSICAL REALISM JOURNAL and THE WASHINGTON POST MAGAZINE.

Sketching shapes how I see the world, but it also shapes how the world sees me.

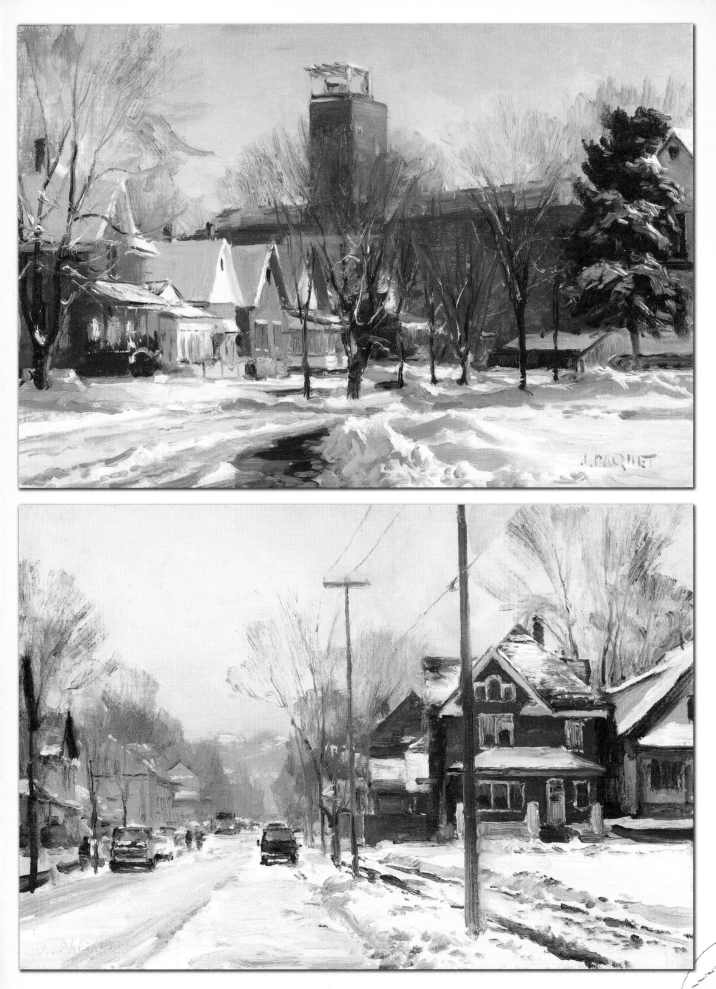

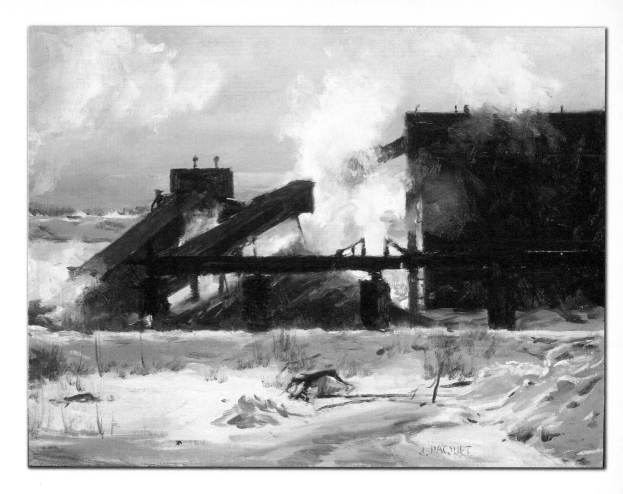

What inspires my sketching is the simple desire to record the world I live in. There are periods of protracted study and periods when life intercedes. I sketch when I am moved to say something. A sketch is the physical extension of metaphysical experience.

I sketch in oils on mounted linen panels. When I sketch, I think about capturing the essence of the experience. I feel panicked, joyous; there is usually very little time to record a great deal of information.

When working from life, speed begets risk, and risk in turn allows for the possibility of greater feeling in a work of art.

If they are wholly conceived, sketches are stand-alone works of art: clarity, economy and elegant subordination in the service of a singular vision.

Sketching shapes how I see the world, but it also shapes how the world sees me. Every distinct choice made in the crafting of an image is a mirror of the artist.

J. PAQUET

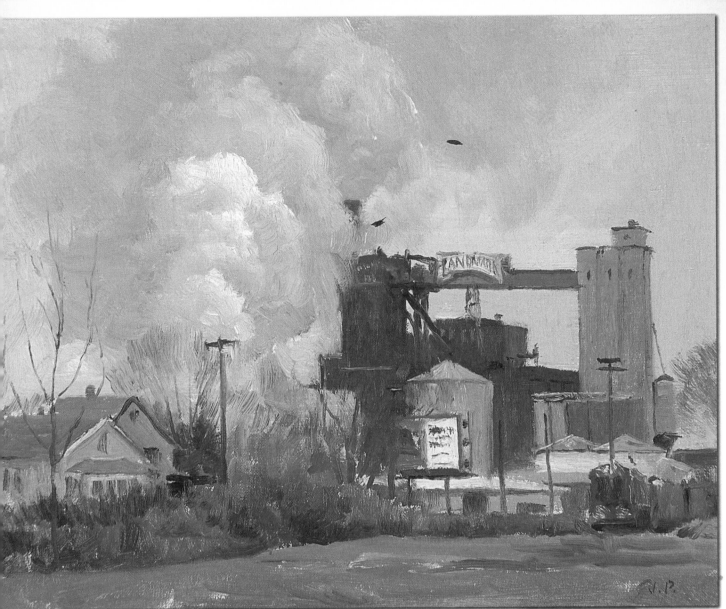

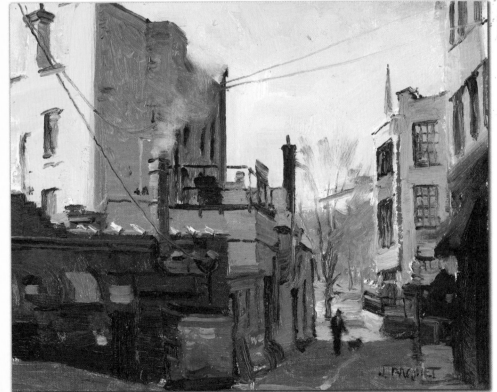

I'm playing with mixed media surfaces to draw on.

Jean Pederson

The subjects of Pederson's portraits are based on people she has met or who have impacted her, often reflecting different walks of life as well as diverse cultural and religious backgrounds. A painter for more than twenty years, she was the first recipient of the Federation of Canadian Artists' Early Achievement Award in 2005, and her work appears in the Royal Collection in Windsor, England, among many other collections. The author of EXPRESSIVE PORTRAITS: CREATIVE METHODS FOR PAINTING PEOPLE, Pederson continually explores new avenues of expression by adding mixed media to her watercolors and elements of abstraction to her works.

The time you put into sketching comes back to you within a painting whether you are aware of it or not.

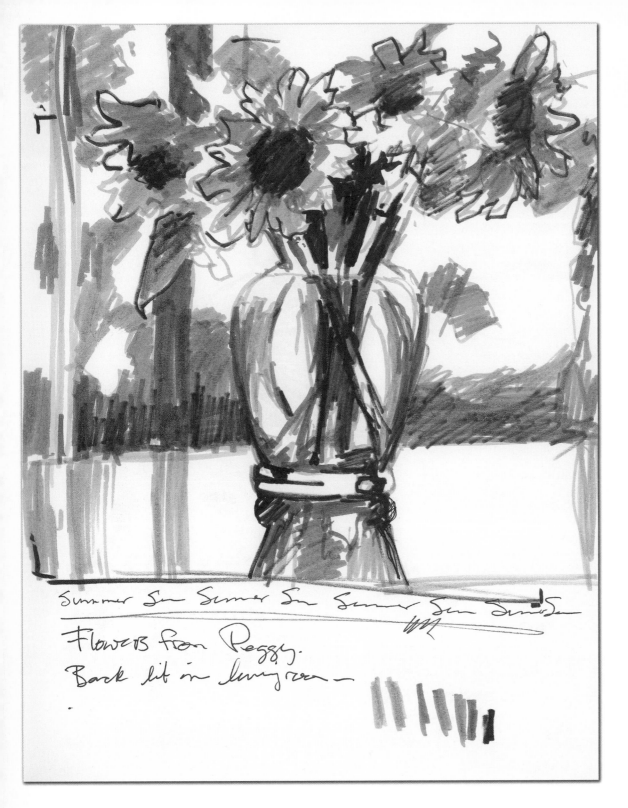

Summer Sun Summer Sun Summer Sun Summer Sun

Flowers from Peggy.
Back lit in living room—

Sketching is a great way to work out ideas, doodle, journal or capture a place and time. I like to use felt pens of different values and pencils. At home I may include painting and collage or anything close by. I find that sketching is really personal. I don't tend to share sketchbooks with a lot of people; it's like a diary—a safe place to explore yourself.

I seem to sketch in fits and bursts! I will be really dedicated for a time and then a change in schedule or a deadline will throw me off for a while. When I travel, I always take a sketchbook and try to do some sketches while I am away. I like to sketch on trips to keep my memory fresh for the place or feeling that I experienced. I like to try new things and may use my sketchbook to explore and give myself permission to succeed or fail. It is freedom to be fearless. Sketching has taught me that you can make changes, take chances and start a new book when the old one is full.

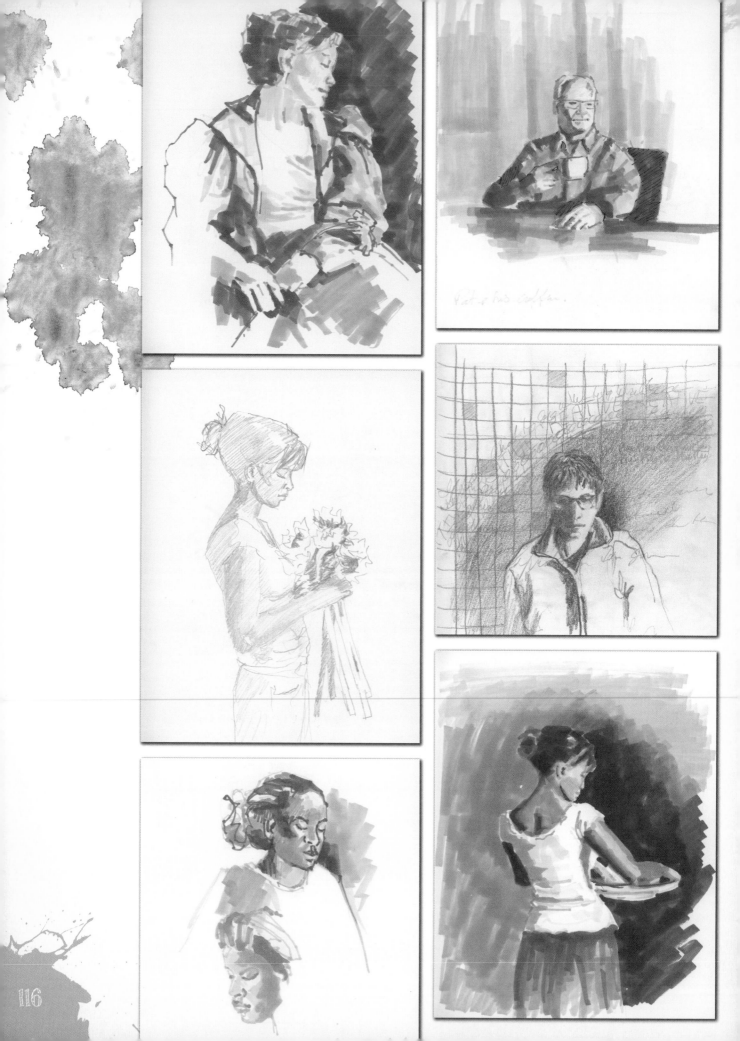

Sketching really helps your painting and your hand-eye coordination. As well, I think that sketching provides you with an opportunity to try and work out ideas and compositions so that when you go to the easel, you already have something in mind as a springboard.

I was doing a demo the other day and one of my students said, "Have you just gone into the zone?" I felt it myself—that endorphin-laced creative zone where time stands still and you don't really think, you just do. Whether painting or sketching, I am concentrating on the image and I feel very relaxed. If I go into the creative zone, I think that there is a bit of a high attached to it—kind of like a runner's high if you have ever trained for distance running. On the flip side, if things are not going well, I may want to rip the page out. I try to leave the pages in, though, because I learn from my failed attempts.

I believe sketching affects how we see the world, but how depends on what your intentions are. If you are trying to re-create something from life, then it teaches you to see relationships between shapes, values and colors. If you are trying to capture the feeling or essence of a place, then you are not concerned so much with re-creating as capturing an emotion or atmosphere or gesture. One involves analyzing, and the other, feeling.

Sketching is a time to play, but that doesn't mean that you don't work.

The sketch may or may not be beautiful; for me, it's (usually) never meant for framing or display (until now!). Finished work for galleries has to be polished to a certain level, but a sketch can be whatever you want it to be.

create depth—
layers that
are drawn o—

Mixed Media idea
for bkgrd.

Your past experience helps to shape your future actions. The time you put into sketching comes back to you within a painting whether you are aware of it or not. Your sketching time is time well spent.

MORE airport characters...

John Potter

Creating landscape and wildlife art is an act of reverence for Potter. "Painting, for me, is an intimate form of communication with, and gratitude for, our Creator," says the artist, "for the life and beauty of this Earth and our remaining wild places." After graduating from Utah State University, Potter spent twenty years as an award-winning illustrator before turning to fine art full-time. Today he divides his time between homes in Vermont and Montana and travels extensively, always with his paints and sketchbook. His works have appeared at the National Museum of Wildlife Art in Jackson Hole, Wyoming.

I've heard some artists complain that they "don't know what to draw (or paint)." I find this difficult to comprehend. Inspiration to draw is everywhere; my problem is TIME! Put simply, life inspires my sketching, drawing and painting.

I sketch daily, not so much as a "habit," but more as a necessity. I've never really been very good at drawing, and drawing—or any art form, for that matter—is a discipline, a learned skill, and must be done at least daily to hone, maintain or improve the skill. Like exercising any muscle!

I usually sketch during the morning. Or in the afternoon. Often in the evening. Sometimes at 3 a.m. I sketch because I have to, and because sometimes an idea will not let me rest until I make it tangible.

I will sketch using any materials at hand, but since I usually carry a sketchbook and pencils and pens with me all the time, that is what I use most often. However, I enjoy Conté crayon and charcoal as well.

One of the benefits of sketching often is a relaxation of the conscious and an engaging of the creative subconscious. This, in turn, helps one to learn to see. Learning to see helps bring line to life.

I try NOT to think when I'm sketching. Too much thinking can lead to an overly methodical approach, which, if relied upon every time, stunts artistic growth and experimentation. Instead of thinking, I just try to see simply.

Learning to sketch freely without focusing on the "end result" or worrying about validation or perfection teaches one to flow with the moment and seek creative solutions to problems. Valuable skills when dealing with creating art, and with the art of living.

When I am sketching, I feel "plugged in." Ideas, energy and inspiration are in a constant flux and move around us all the time. I feel connected to this movement and a part of something much greater than myself.

TRAIL TO TAGGART LAKE

UPPER GREEN RIVER — SQUARE TOP

Sketching provides much-needed license to fail—something I try NOT to do in my finished pieces! I have warmed myself many a night by the fire made from tossed drawings and paintings. My sketches relate to my finished work in that they are glimpses into what might be, what could be—and, frequently, my sketches are composed much better than my finished pieces, so I constantly go back to them for guidance.

Sketching definitely influences the way that I see and perceive the world because it helps me to see simply, to look for and to recognize what is most important and elegant, and to emphasize the beauty of truth, which needs revealed.

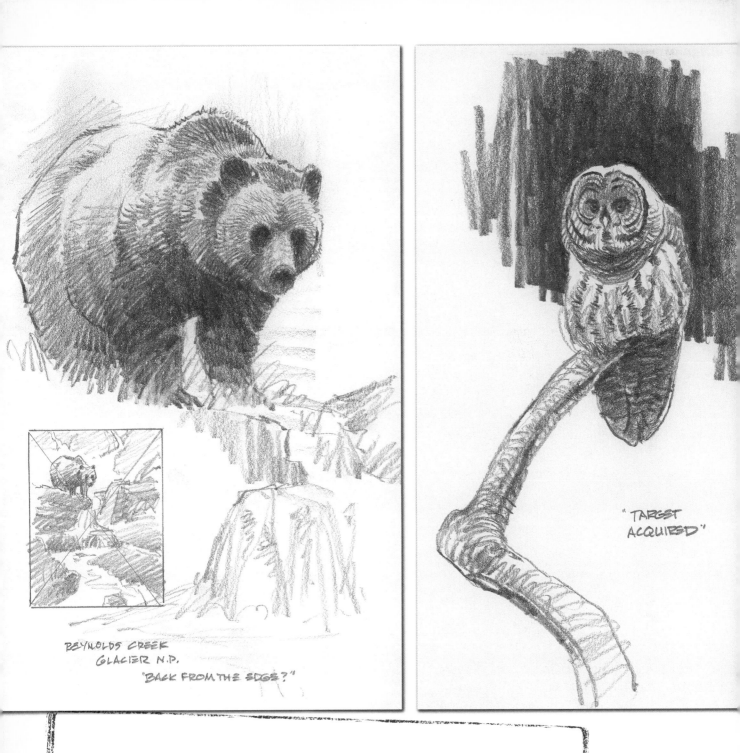

REYNOLDS CREEK
GLACIER N.P.
"BACK FROM THE EDGE?"

"TARGET ACQUIRED"

My sketches are glimpses into what might be, what could be—and, frequently, they are composed much better than my finished pieces, so I constantly go back to them for guidance.

"THOUGHTS OF WHISTLER"

WHY?
→ HOMAGE TO ONE OF MY FAVORITE PAINTERS

HOW?
OIL ON LINEN. VICKI AS MODEL. ENGLISH MODEL. LIGHT FLESH — DARK BACKGROUND

WHEN?
TIMELESS. NO PARTICULAR TIME. WHISTLER REFERENCE — CONTEMPORARY JEWELRY?

Tony Pro

Named by THE ARTIST'S MAGAZINE in 2006 as one of "20 artists under 40" to watch, Pro received his bachelor's degree in graphic design from California State University, Northridge, and simultaneously studied with famed illustrator Glen Orbik at the California Art Institute, where Pro himself now teaches. In 2005, Pro was awarded Best of Show at the 14th annual Oil Painters of America show and also was a top-ten finalist at the Portrait Society of America show in Washington, D.C. Pro counts John Singer Sargent, Anders Zorn and the French Naturalist artists among his influences.

If I sketch or journal, it's simply either an idea-generating process or doodling when I am bored or stuck somewhere listening to a lecture. However, I love to draw the figure from life in a charcoal sketch manner to capture the beauty of human form.

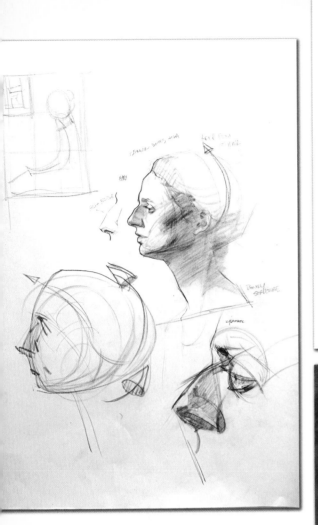

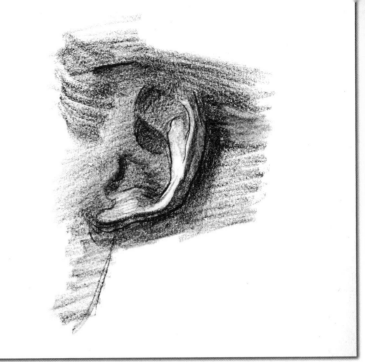

I try to sketch every day, although I paint more often than sketch. If I sketch, it's at night when I am in my studio and all is quiet. I try and get to a live figure class at least once a week to practice quick sketch or anatomical studies. I sketch using charcoal pencil and lead pencil.

I sketch a lot to work out composition, or to work out anatomy if I don't want to figure it out on canvas. Sketching gives me a lot more freedom to experiment with things before I hit the canvas.

In my years as a student, the first thing I learned was to "see like an artist," that is, seeing everything in shapes and pattern of value and contrast. This has made a major impact on how I see things. I am blessed to see this way because no other type of person can see the world in this manner—only an artist can.

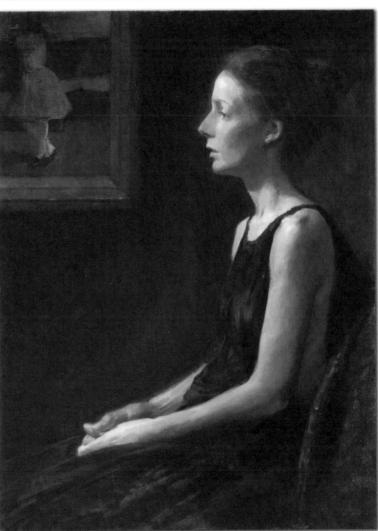

Thoughts of Whistler
Oil on linen (finished painting)
24" × 18" (61cm × 46cm)

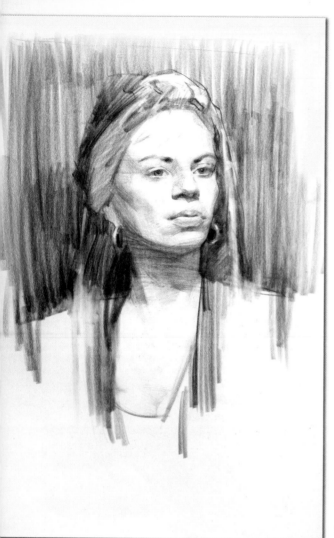

I think about trying to accurately portray what I am looking at and making sure I am conveying the two-dimensional abstract shapes working with the three-dimensional form. When sketching, I feel happy but sometimes frustrated.

Sketching teaches me to take the time needed to produce superb work. There is no shortcut to excellence. It keeps my eye sharp; it keeps me thinking like an artist.

Sketching teaches me to take the time needed to produce superb work. There is no shortcut to excellence.

125

I lost myself so completely on one occasion that when I rose slowly after an hour and a half on a sketch, two deer bolted from ten feet behind me, apparently looking over my shoulder.

alan Paine Radebaugh

Radebaugh recognizes nature's beauty not in its literal forms, but in the abstract shapes comprising all that he sees. These organic pieces and patterns are brought into focus in his "Fragments" paintings. After studying drawing, photography and jewelry design in college, the Boston-born artist (now living in New Mexico) spent ten years designing sculptural art furniture before returning to painting full-time in 1988. In 2004, his art career was celebrated with a twenty-year retrospective in Albuquerque, and he spent the next two and a half years painting thirty-six canvasses for a University of New Mexico Art Museum exhibit in 2007.

LODGEPOLE STAFF 6.8.01

My sketches are inspired by abstract forms in the natural world. These forms present themselves, "announcing" themselves to me as if they were asking me to sketch them. To do this, I have to look at natural lines, shapes and forms. Then I recognize that everything is connected.

I sketch with a soft pencil, a chisel drawing pencil, on drawing papers. I sketch outside and add color using maybe a rotten stick, moss or dirt.

My paintings are composites of drawings. Most of my time is spent with the paint. I sketch to create my paintings. Years ago I sketched daily; now I sketch when I want more material for paintings. Maybe every three months, I'll stop painting and sketch for a week or two. I take field trips then and spend all day for days at a time drawing.

When sketching, I am completely immersed. I feel honored to be in nature, to give myself up to the process. The eye and hand are totally on their own. I don't think while drawing; I look and make the line. Drawing is a form of meditation, one that can last for more than an hour. I lost myself so completely on one occasion that when I rose slowly after an hour and a half on a sketch, two deer bolted from ten feet behind me, apparently looking over my shoulder.

My paintings are composites of drawings and, therefore, necessary to my work. For me the drawing is the crucial, exacting document. It is a portrait. My paintings are composed of these portraits. I see the compositions as a dialogue among the portraits. Creative license comes in the assembly of drawings. The painting is the free-for-all.

Clockwise, from top left:

Taylor Fragment 1
Oil/earth pigments/acrylic/paper/canvas
(finished painting)
32" × 24" (81cm × 61cm)
Collection of the artist

Alberta Fragment 12
Pigment/acrylic/paper/canvas
(finished painting)
32" × 24" (81cm × 61cm)
Collection of the artist

Oro Fragments I, II
Oil/acrylic/canvas (finished diptych)
46" × 44" (117cm × 112cm)
Collection of the artist

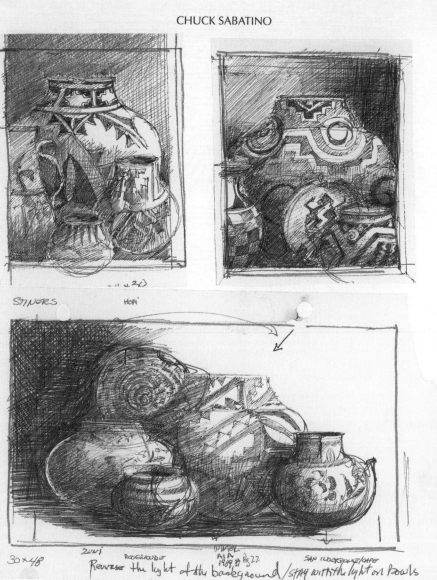

Chuck Sabatino

A collector of historic and prehistoric Southwest Pueblo pottery, Sabatino often arranges his pieces alongside Native American artifacts and rendered Edward S. Curtis photos for his oil paintings. After attending the Cartoonists and Illustrator School in New York (now the School of Visual Arts), he spent the next twenty-five years building an award-winning career creating ads for such companies as Johnson & Johnson and Procter & Gamble. Upon retiring in 1988, the longtime New Yorker moved to Scottsdale, Arizona, and now spends his days painting. He has been featured in SOUTHWEST ART, WESTERN ART COLLECTOR and ART OF THE WEST magazines.

Drawing is a way to learn more about the subjects you're working on. I do preliminary drawings for composition, space, value and lighting.

When I do find a unique artifact for a new painting, I start to do preliminary drawings of it with other artifacts to find the right composition, evaluating the use of negative space, value and lighting. Some of the things I think about when sketching are how objects relate to each other, color, texture, and getting a pleasing flow to the composition. At this point it's easy to move things around.

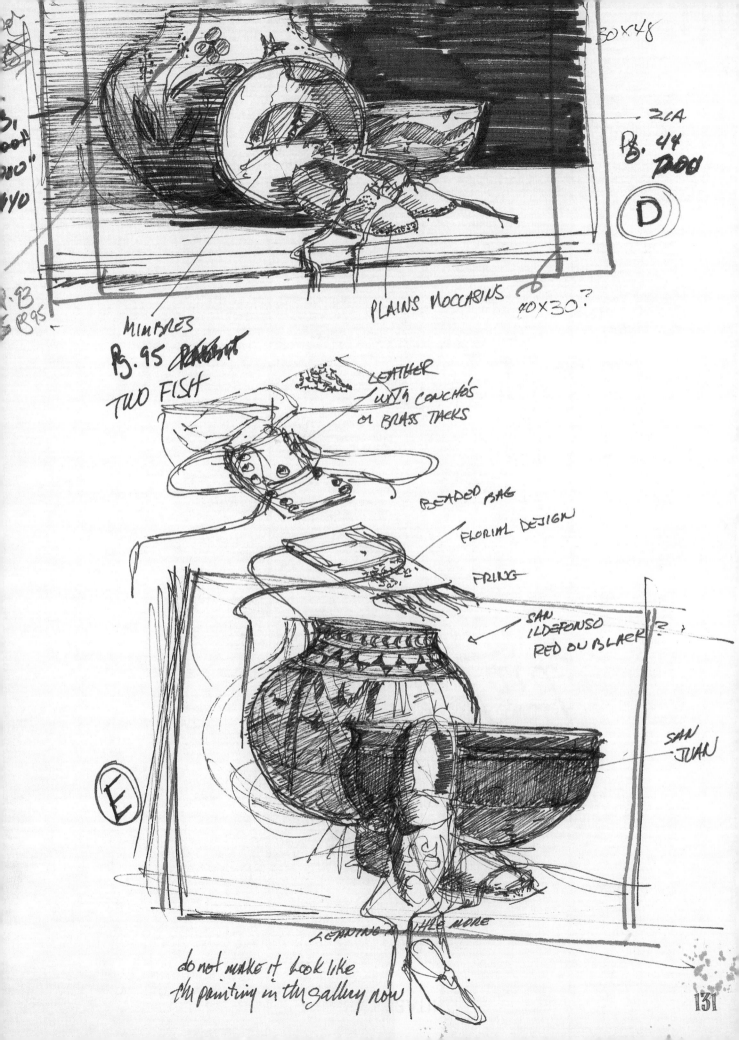

30×48

ZCA

Pg. 44
1200

D

PLAINS MOCCASINS 70×30?

MIMBRES

Pg. 95 RABBIT
TWO FISH

LEATHER
WITH CONCHOS
OR BRASS TACKS

BEADED BAG

FLORIAL DESIGN

FRING

SAN
ILDEFONSO
RED ON BLACK?

SAN
JUAN

E

LEANING A LITLE MORE

do not make it look like
the painting in the gallery now

131

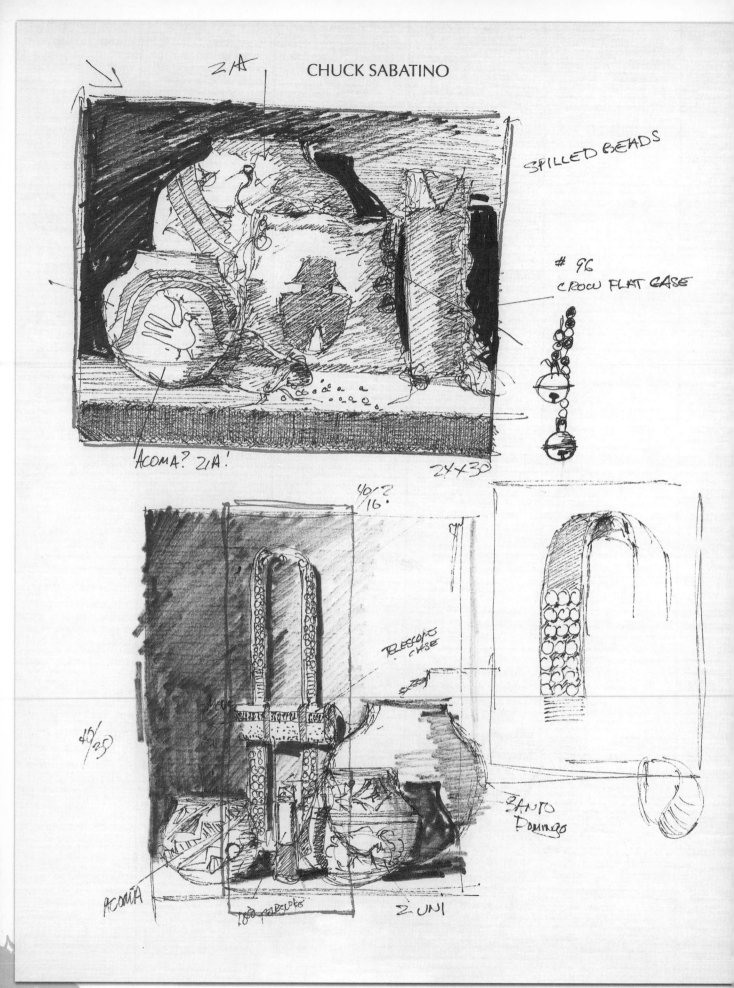

ZIA

SPILLED BEADS

96
CROW FLAT CASE

ACOMA? ZIA!

24 × 30

40"?
16"

TELESCOPE
CASE

45"
25"

ACOMA

TOO MINUTE

ZUNI

SANTO
DOMINGO

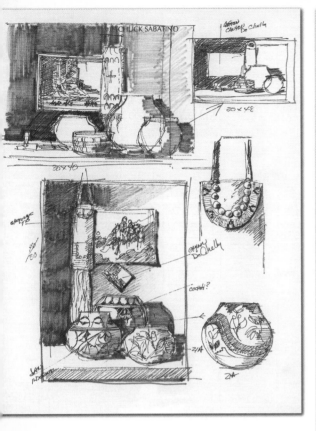

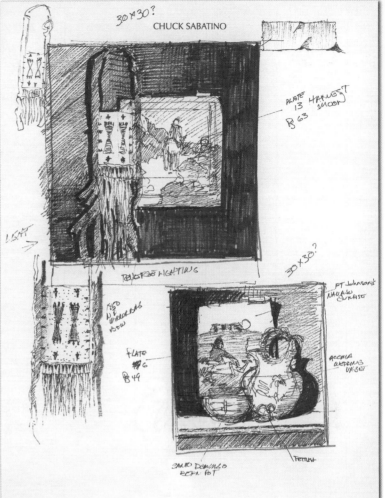

I usually sketch at night, after I've painted all day. It's a way of relaxing and being loose with ideas for other paintings. For sketching, I use a Sanford uni-ball fine point pen; for other sketches I use compressed and willow charcoal and Sharpies. I sketch on old letterhead paper.

Beginning a sketch starts the creative juices flowing—not knowing where it's leading, but knowing that at the end I will have something to be proud of.

When sketching ideas for a painting, I don't have to be as precise and detailed as in the finished art. It's merely a vehicle for information. Most of the drawings for my paintings are very accurate, however, to the finished art; composition, lighting, negative space, value and tone are worked out beforehand. It almost looks like the sketch was made from the painting.

In my finished sketch there is enough information as to the size of the subjects, lighting, shading and notes written that it could be possible for someone without any knowledge of the original subjects to paint the painting.

In my finished sketch there is enough information as to the size of the subjects, lighting, shading and notes written that it could be possible for someone without any knowledge of the original subjects to paint the painting.

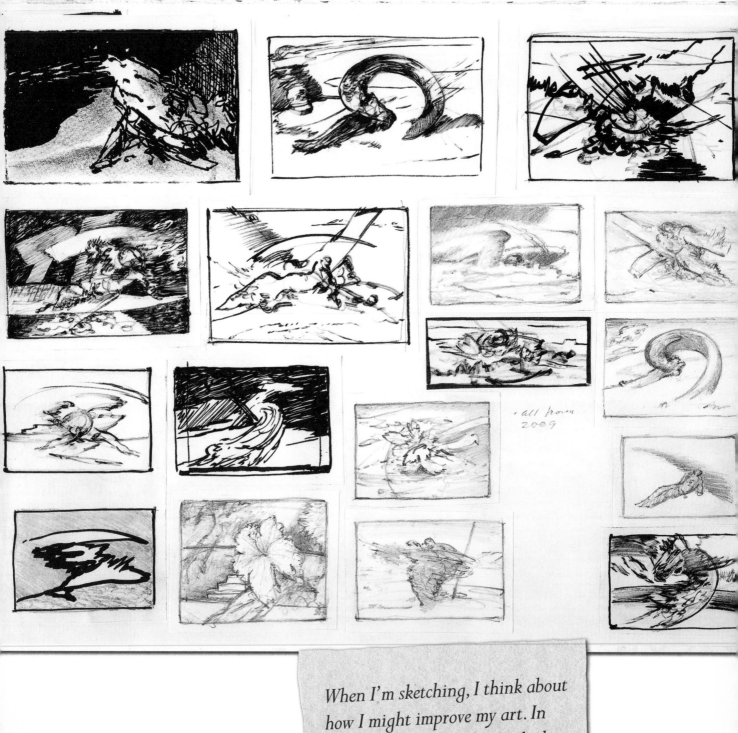

all from
2009

When I'm sketching, I think about how I might improve my art. In terms of composition, I think about going places I've never been before.

Bend
Oil on gessoed paper (finished painting)
10" × 15" (25cm × 38cm)

Mark Spencer

Joan Markowitz, formerly of the Boulder Museum of Contemporary Art, once wrote that Spencer's works "simultaneously stimulate the senses and challenge the intellect with images drawn from complex intertwinings of historical, mythological and psychological references." Pairing traditional technique with surrealistic imagery, Spencer's dreamlike, metaphorical oil paintings and monotypes have earned him a place in numerous collections and shows, as well as a number of solo exhibitions. Spencer studied at the School of the Museum of Fine Arts in Boston, the artist's hometown.

I have a sensibility or set of feelings that need to find expression. The thumbnail sketches are my way of keeping psychically caught up with myself. My finished paintings, more often than not, look like the thumbnail sketches that inspired them.

It is my daily habit to do something on my art. Sometimes that is my sketching. Usually, when the need takes control, I take out my paper and pencil.

When I'm sketching, I think about how I might improve my art. In terms of composition, I think about going places I've never been before. I'm not aware of feeling much of anything. In fact I'm blissfully ignorant of myself.

Sketching is the most immediate connection to my inner world. In my drawings I find connections to the world that enlivens my place in it. I get psychologically caught up with where I'm at.

Does sketching shape how I see the world? I believe it's the other way around. The way I see the world shapes my art. My sketches allow me to see how I know the world through the means of visual metaphor.

There are no rules when sketching. It's how the finished painting gets its start.

Kate Starling

Starling is an oil painter who lives and works in the canyons of southern Utah. Educated in geology, she spent years working as a geologist and National Park ranger. After formal art training in the 1980s, she devoted her work to painting the landscape. Schooled in the importance of direct painting from life, she has spent years painting outside, learning the way light plays on the land. Now she splits her time between the roadways and trails surrounding her home and the studio. Starling's paintings portray the natural world and focus on communicating a sense of place, atmosphere and dazzling light, retaining the immediacy of the painting experience.

I have heard of artists who start every day with an hour of drawing. I admire their discipline, but my drawing comes at odd times and through necessity.

Aside from sketches preliminary to painting, I draw as I can catch the time. I often sketch while waiting for someone or when caught with a compelling view and no paint box. It can be a way to survive the boredom of idleness or because too much time has passed without the pleasure of making something.

I sketch on a 5" × 8" (13cm × 20cm) ring-bound pad that slips into a leather cover. It is a replica of one that Maynard Dixon was fond of using and was a gift from the Thunderbird Foundation at the Maynard Dixon Country Art Show. For outdoor sketches I draw with a black Sharpie Twin Tip pen.

My sketchbook is a compositional tool that allows me to make sense of the visual stimulus around me.

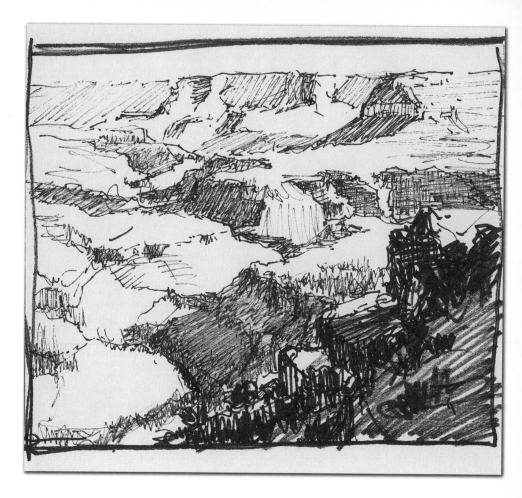

When I am painting outside, I often find myself starting with the basic question, "What was it that stopped me here?" It is usually one element that must be emphasized in the composition to convey the concept of the painting. If it is the scale of one dominant feature in the landscape or a strong shadow, it can be easy to sketch it out quickly, but it is more likely to be a subtlety of value or color. This requires me to remain conscious of this theme, so I sometimes write a note to remind myself and refer to it later in the painting process.

I always make a composition sketch before I start to paint, and while this started as a discipline to eliminate false starts in painting, I have found that it is a way of focusing my mind to the painting process. By sketching, I calm down and ready myself to concentrate; in a short while I can feel myself click into a different mental state.

One of my cherished activities is a weekly figure drawing session organized by a local artist, and very little will conspire to make me skip. It is a luxury to devote three hours to drawing, and with the human form so exacting, the concentration and discipline benefits my landscape painting. I also teach a beginning drawing class in my small town, and clearly articulating the basics of drawing every week has sharpened my understanding of two-dimensional representation and how the human mind perceives space and form.

As a landscape painter, I take liberties with the placement of objects in space, and the sketchbook is the place where I can experiment and play.

Kate Starling

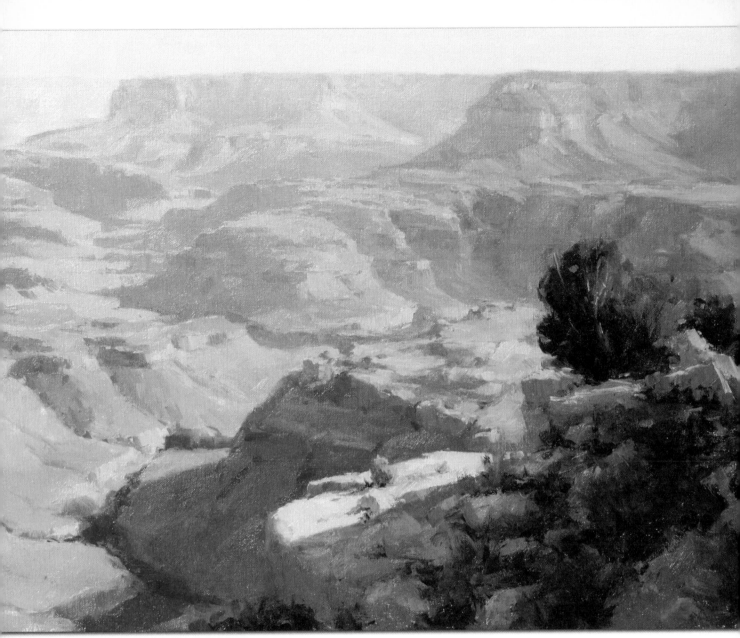

Jump Up Point
Oil on linen (finished painting)
18" × 24" (46cm × 61cm)

I always make a composition sketch before I start to paint, and while this started as a discipline to eliminate false starts in painting, I have found that it is a way of focusing my mind to the painting process.

aleksander Titovets

Born in Siberia, Titovets earned his M.F.A. from Saint-Petersburg State University before coming to the U.S. in 1992. Now living in El Paso, Texas, the artist finds inspiration for his landscape and figurative paintings in memories of his Russian homeland and in the works of Old Masters Titian and Diego Velázquez. Among his greatest honors are winning Best of Show in the International Fine Art Competition four years in a row among competitors in his region and being chosen by former First Lady Laura Bush to paint her portrait, which was unveiled in Washington, D.C. in 2008. His collectors include actress Sophia Loren and the King of Spain, His Majesty Juan Carlos.

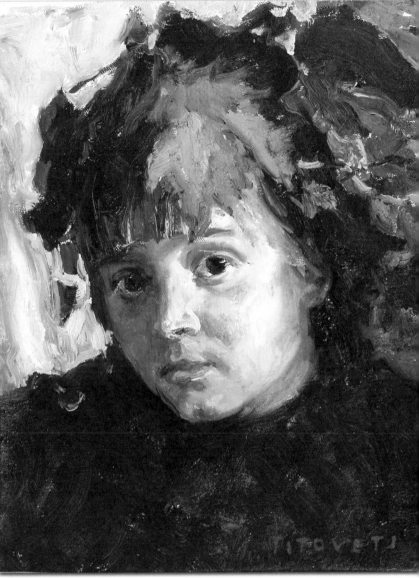

The sketch is just a preparation work, the same as drafts and preparations for a writer. Sometimes, a sketch becomes an independent, complete piece of art. It is similar to impressionism: it is a spontaneous, fresh and emotional impression of reality.

The sketch gives the artist a chance to think with brush in hand, because it is necessary to find a visual image on the two-dimensional surface. This type of work could be described as thoughts on canvas or development of thoughts.

If you have a theme that you'd love to develop into a painting and you have ten different ways to describe this theme, it means you do not have a really clear vision of how to interpret your idea on canvas. A sketch in that case gives you the chance to clarify and define the idea and find only one possible decision.

A sketch transfers emotions onto a two-dimensional surface. A sketch is just an instrument, but it is a small, definite step into creating a grand and finished idea—a painting. A very good sketch is impossible to re-create into a finished work; it's like a streak of genius.

A sketch transfers emotions onto a two-dimensional surface.

I'm working on sketches when I am developing a new theme or when I just need to "stretch my fingers," as Jean-Antoine Watteau said. I use any material that is available at the moment, although I prefer oil on canvas, board or paper.

A sketch is like practicing a scale for a piano player. It is an exercise for the mind and hands; it is a chance to clarify and solve the problem that you have out in front of you. It gives an opportunity to understand the ability of the material you are using and the possibility of it, to realize where the border between reality and art is (when oil painting in particular).

If you make enough research (in sketches), you have a chance to complete a good painting. The painting dictates you in which direction to develop your work. Follow the sketch and well-found fundamentals, and you can find the way to create the complete painting without complicating the process or forcing it, which will eventually ruin the painting. Sketching "clears" the eyes, so you can see the whole plan and development of the big picture.

TITOVETS

Lyuba Titovets

Titovets began her formal art training with private lessons at age 5, ultimately earning her M.F.A. from Saint-Petersburg State University, where she worked in stage and costume design. She taught art and art history before moving to the U.S. in 1992. She's had fourteen solo exhibitions and many more together with her husband, Aleksander. She has illustrated several books and created posters and other artwork for various cultural events and organizations. Her art has appeared at Westminster Abbey in London, and she has been featured as a guest artist in the "Great American Artists" exhibit in Cincinnati, Ohio. Her name is included in the archives of the National Museum of Women in the Arts in Washington, D.C.

Sketching doesn't come from inspiration; it comes from need. I have a short time to work, or I may forget my idea or colors I've seen. Then, I sketch using anything handy to capture that moment in nature or in my mind visually, so when I have time, I'll use this idea in some future work or keep it as a reminder of what once struck me in reality or in the dream.

I sketch as much as I need to, so sometimes it is a lot in a day, until the idea is clear in my mind and on the paper or canvas. Sometimes I start the sketch on canvas and develop it into a finished work, because everything seems pretty clear from the beginning, and it turns into a completed work.

Any materials can be used for sketching: watercolor while on the go, pencil on a scrap of paper anywhere, including on an airplane. Or oil, when it is necessary (for example, when trying to show all the incredible colors of fresh fish) in the studio, or on location in a planned plein air, which happens at least twice a year in different areas for me, mostly in Maine and New Mexico.

There is a pattern of thought involving how I create a composition, how I define my focal point, what will be my pattern of dark and light, what will better describe my idea or give certain movement. If it is a color sketch, it either describes the mood or intricate harmony of the scene or object, which neither photography nor memory could preserve.

Sketching gives me a chance to think more abstractly, free of reality as it is, and more in general, without going into details. It also breaks stereotypes on things that I thought I knew.

147

While sketching, I am concentrating, trying to find the visual answer to what is in front of me or in my mind. I am generating an idea, which is the most distinct moment of human ability. So, I am under some pressure, which is challenging but exciting. The more clear the idea is in my mind, the more fun it is to paint, and the chances are higher that I'll get results without frustration.

Sketching gives me a chance to think more abstractly, free of reality as it is, and more in general, without going into details. It also breaks stereotypes on things that I thought I knew. Plein air paintings "clean" my palette (less muddy or primitive open colors are used), give me a fresher look on big relationships (such as land and sky), and help me find the pattern and harmony, which I can't imagine or make up.

Sketching provides freedom of thinking and expressing thoughts, an easy way of changing direction or switching to new decisions, and ways of solving the problems. In finished paintings, that freshness, bravery and spontaneity can vanish.

If you have enough patience to work on a sketch until everything is clear in your mind and on your paper, board or canvas, then your completed work should just be a defined, enriched version of your sketch. Does this happen often? No, not really, because artwork lives its own life, and sometimes you need to follow what is on the canvas. Does it always get to the result you expect? No, but that's what makes an artist create and re-create, trying to describe the visual image clear and complex enough, and the first step in that process is sketching.

Lyuba Titovets

Joshua Tobey

Tobey's appreciation for art and the outdoors took root during his upbringing in New Mexico with renowned bronze sculptors Gene and Rebecca Tobey. Though he began attending Western State College in Colorado without the intention of becoming an artist, he emerged with a bachelor's degree in sculpture and gratitude for the family who supported but never pushed. Tobey's bronze wildlife sculptures can be found in numerous galleries and collections. Of his sculpting style, he once told SOUTHWEST ART magazine, who in 2002 named him one of their "31 under 21" artists to watch, "I use bright, contemporary patinas but a classical approach to form, with a little stylization."

This concept was developed from an encounter I had with three bears planning to raid a campground. I carried the idea of the "conspirators" around in my head for almost ten years. One day while waiting for a collector to join me for lunch, I sketched this concept on a napkin. When I showed it to my collector, he said, "Let's make them." I never knew that napkin sketch would lead to the sale of fifteen sets of bears in eighteen months.

My sketches are inspired by life, experience, people, my pets, my wife, and mostly myself. I am each one of my sketches and sculptures. My artwork depicts the way I see the world. It is a reflection of my experience and my interpretation of the world.

I do two types of sketches these days. I sketch for idea documentation, which are the sketches that are for me and that I use in the studio, and when required, finished line drawings of sculpture I am about to make. These drawings are clean and simple and help to show a concept to my galleries and to my collectors. I developed this style of sketching to complement my sculpture style and for the purposes of reproducing via email and fax. These drawings are "near" accurate depictions of the final sculpture; they are literally like blueprints for the construction project. I don't actually need them for sculpting; however, they are a product of requests from my collectors. It takes weeks or months to sculpt something and minutes to describe the object in a sketch.

Most of my sketches are brief and note-like. Most of my ideas hit me when least expected and while doing something not art-related. As a result they are undeveloped and very spontaneous. I have a file cabinet with an eclectic collection of napkins and receipts, pieces of cardboard and Post-It notes. It probably represents where I've been as much as what I've been thinking about.

I like to let my artwork be spontaneous, and sometimes my ideas come at odd times. It's not unusual for me to start daydreaming and excuse myself from a conversation to get an idea down on the first serviceable flat object I can find.

Often my sculptures are concepts that are years old. The sketches help me preserve them. When I browse through my pile of sketches, it's like finding an old photograph that you lost or forgot about. The discovery revives the creative spark.

When sketching, I think, How big will it be? How will the sculpture be displayed? What's its name? What patina will I create for it? What is the personality, and what is it doing? How will I pull it off? For the last twelve years or so, my sketches have almost always been for sculpture. As a result, my number-one thought is usually, "Hurry up so you can get back to what you were doing." Sketching makes me feel excited and impatient, because I have a new idea and want to get it down ASAP. Every idea is like a new discovery, even though most never become sculpture.

For me as a sculptor, sketching is a shortcut. I can use it to manipulate a concept fast and easy. It's just easier to manipulate a sketch than it is to cut and move a sculpture. When I sculpt, I don't need sketches to map out what I'm going to do. I sculpt as I sketch. It's in my head, and I trust my hands to faithfully reproduce my concept and my feelings.

I think sketching makes me look inside myself. I explore my ideas and experiences. My sketches are like puzzle pieces. I push them around—sometimes briefly, sometimes for a long time—but sooner or later they start fitting together.

Joshua Tobey

When I browse through my pile of sketches, it's like finding an old photograph that you lost or forgot about. The discovery revives the creative spark.

"Worry Stone Hare"

How many toes Does a Rabbit Have?

elan Varshay

Originally from Israel, Varshay started out painting before heading for New York and ultimately building an impressive career in jewelry making. His experiences led him to the world of high fashion, where he made bold accessory pieces for the seasonal collections of Valentino and Donna Karan in the 1980s. The 1990s brought Varshay to Santa Fe, New Mexico, where he next channeled his creative energy into designing contemporary belt buckles. Varshay currently focuses on teaching others and designing jewelry with limited runs and the finest materials in a range of styles. "I believe the past is what fuels the forward-looking art scene," says the artist, who recently created a collection inspired by Frida Kahlo.

I often sketch when I want to record an idea, visualize a concept, or when I am contemplating a mechanically challenging design. I prefer using parchment paper and 0.5mm mechanical pencils. When they are not available, I improvise with whatever is at hand.

I usually sketch when I enter into the designing phase of a new collection. Sketching is a relatively easy first step in determining the viability of a design. Sketching is also essential when I am teaching. It is a very powerful communication tool when I have to do a presentation related to a process or an object for my students.

A sketch is the first draft in the visualization and planning of a three-dimensional work, therefore an essential part in the evolution of the work. It is the part of the process where anything is possible, and then the actual executing of the piece is where the challenges—and occasionally, limitations—appear.

When I sketch, I feel very focused and grounded—completely absorbed in the process. I think about capturing the essence of my vision and how it will translate into a three-dimensional object.

In my finished work, I try to remain as close as possible to my original sketch. I also allow the natural flow to shape my moves—or the "dance," as I like to describe these processes—when I am engaged in sculpting a three-dimensional object, especially when the subject is more organic in nature. When the subject is more mechanical in nature, it is essential to stay connected to the initial plan.

FRIDA COLLECTION

Sketching for me is an articulation and understanding of the physical structure of our world. It forces the close observation of our natural surroundings and the interpretation that can be derived from it.

CUFF LINK

A.

B.

F.

C.

D.

E.

G.

H.

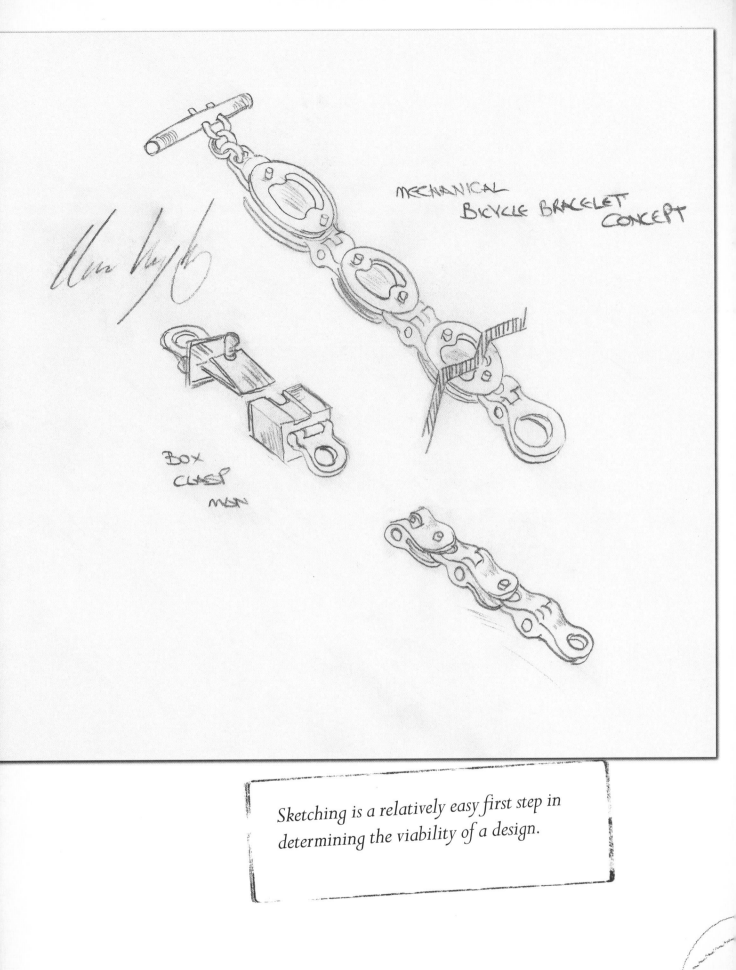

MECHANICAL
BICYCLE BRACELET
CONCEPT

BOX
CLASP
MEN

Sketching is a relatively easy first step in determining the viability of a design.

Frederico Vigil

Traditional Hispanic cultural values carry on through the works of Vigil, a native New Mexican who is known internationally for his wall art. A devotee of the ancient art of buon fresco—a painstaking process of plaster and paint application that peaked in popularity in 16th-century Italy—Vigil has created more than twenty frescos since the 1980s, decorating the walls of public places as well as private residences. A recipient of the New Mexico Governor's Award for Excellence in the Arts, Vigil has spent the past decade creating a recently unveiled 4,000-square-foot (372-square-meter) fresco at the National Hispanic Cultural Center in Albuquerque.

The world shapes my sketching, either the past, present or future.

My sketching is inspired by some idea, event or vision, especially if I am working on a project, event or theme. My sketches are the first impressions, expressions of the original vision that has occurred. They are the foundation of the finished work.

I sketch whenever or wherever, usually daily, and it can be in the morning or evening. It is not trackable for me. I use colored pencil, pen and ink, markers, charcoal, inks, watercolors, acrylics and/or inorganic pigments. I use any paper available, from napkins to fine sketch pads or fine paper.

While I am sketching, I think about the vision that has developed, or the idea of a theme and/or the event or person, and how it will express itself on the paper from the vision in my brain or subconscious. The benefit is accomplishing on paper what I have received as a vision. When sketching, I feel maybe some emotion of what I am working on, either positive or negative, beautiful or ugly, bloody or bloodless.

If anything, sketching shows me the struggle(s) that all artists have to deal with, and there are no shortcuts in the process of developing a vision. Sometimes I experience much more freedom and expression of movement, without worry as to what is released, and sometimes the sketch is better than the final product.

The world shapes my sketching, either the past, present or future.

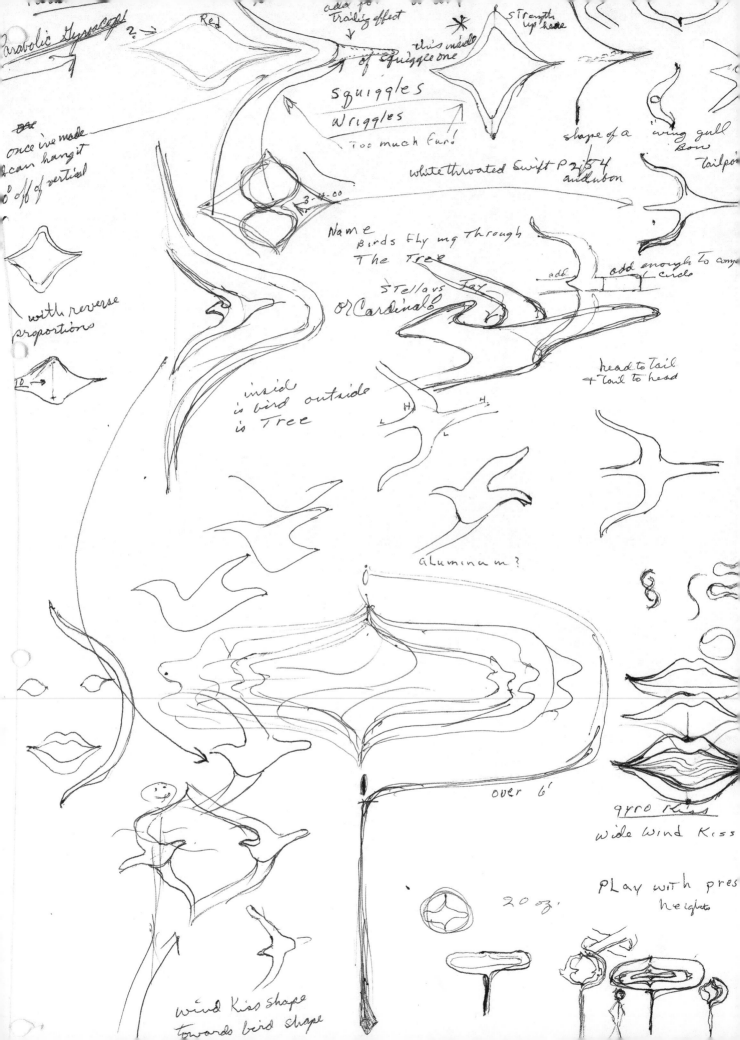

Parabolic Gyroscope?

Red

add for Trailing effect
this made of squiggle one

Strength up here

shape of a wing gull
Bow
Tailport

once ive made
A can hang it
0° off of vertical

Squiggles
Wriggles
Too much fun!

white throated Swift P2,5,4
audubon

with reverse
proportions

Name
Birds Flying Through
The Tree

Stellars Jay
or Cardinal's

add
add enough to comp
of circle

head to Tail
& Tail to head

inside
is bird outside
is Tree

aluminum?

over 6'

gyro Kiss
wide Wind Kiss

Play with pres
heights

20 oz.

wind Kiss shape
towards bird shape

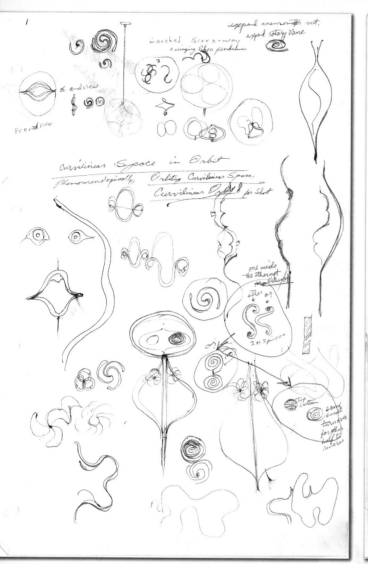

Mark White

White's kinetic sculptures, crafted with handworked copper blades on stainless steel mechanicals, are designed to spiral and spin in the slightest wind, but, says the artist, "the art of my work is the motion itself—the intricate patterns and optical effects created by the sculptural elements rotating in continually changing tensions and harmonies." At once mesmerizing and meditative, White's acclaimed sculptures have made their way into the collections of former president Gerald Ford and 1979 Nobel Prize winner in physics Sheldon Glashow. White also completes patined engravings on metal.

Sketching can provide a shorthand communication that only I have to understand.

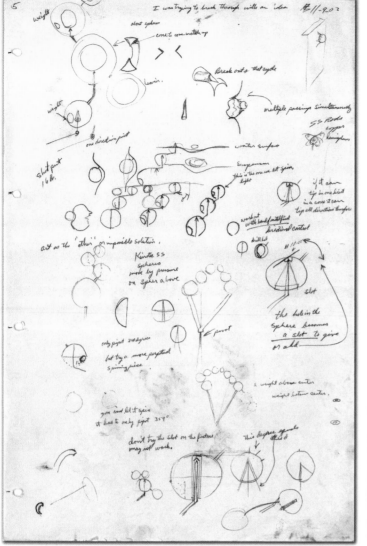

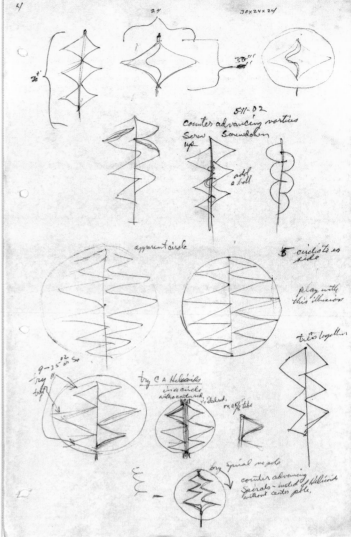

I feel compelled to sketch or make notes when I see something that makes me stop and wonder or something I find particularly fascinating. I have a very visual memory, and I don't like to forget observations or ideas. My shirt pocket always has a 3" × 5" (8cm × 13cm) notepad and fine-point black Bic pen for notes and quick sketches.

I do most of my sketching and journaling between three o'clock and six in the morning. I also often wake up in the middle of the night and sketch ideas. This is the time of day when I seem to replay the events of the previous day and incorporate them into meaningful images.

Sometimes while sketching, I'm thinking of ways to solve problems related to the execution of ideas on which I am working. Often I am trying to figure out a way to bring an idea that I have never completely imagined into existence.

While sketching, I often feel a sense of relief. It's as if I need to get something off my mind and into a physical form. Sketching an idea brings the idea to a tangible form that presents a new reality that informs a new interpretation of all phenomena.

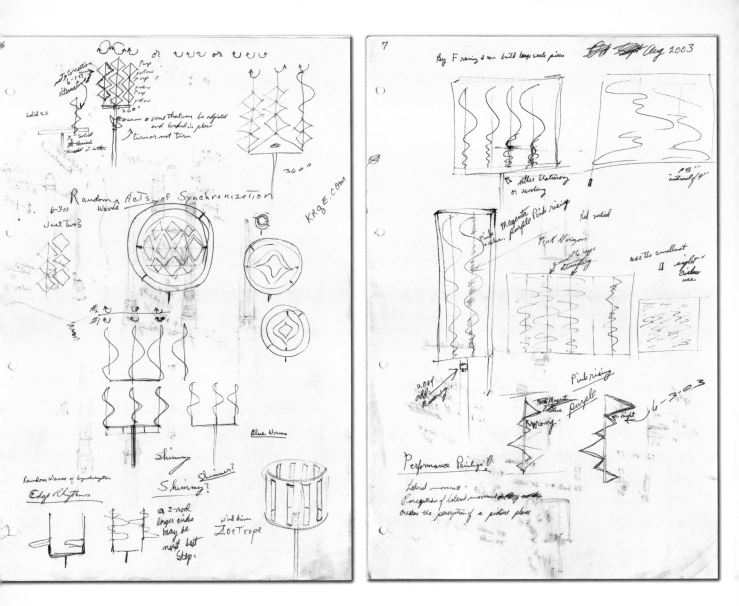

Sketching provides an ongoing dialogue between my mental life and the interpreted world around me. My life changes as I reinterpret my world through the invention of these new ideas.

Sketching can provide a shorthand communication that only I have to understand. When I am sketching for myself, I don't have to worry about anyone else's perceptions.

Sketching often solves the problems that make it possible to develop the final piece of artwork. Sketching often provides the inspiration to create artwork that is a very personal interpretation.

Mark White

Mark Willenbrink

An internationally known artist and teacher living in Cincinnati, Ohio, Willenbrink works primarily in watercolor but also enjoys oils, graphite drawing and scratchboard. Willenbrink has contributed nearly forty articles to WATERCOLOR ARTIST magazine, and his published books include WATERCOLOR FOR THE ABSOLUTE BEGINNER, along with two follow-up books on drawing and oil painting for beginners, as well as a series of art-instruction workshops on DVD. He has also illustrated children's books for Harcourt Achieve and two greeting cards for National Geographic, and he has done over two hundred illustrations for Standard Publishing.

Many times I am inspired to sketch or journal when I want to record a new idea or when I see a previous subject with fresh eyes. I can also find inspiration by viewing someone else's artwork. Inspiration comes to me naturally when I am outdoors.

Sketching is recording what you see visually on paper, and it is also communicating what you see to someone else. I can't say I sketch every day for the purpose of sketching. It is natural for me to pick up a pencil to sketch what I am trying to communicate to someone or to capture something visual. I may sketch a piece of furniture I saw to describe it to my wife. I may sketch a tree or someone's face as we are sitting in the park so that I can capture the interest that has been sparked and put it down on paper. I sketch to plan finished art, to problem-solve or to study a subject for my teaching or a book I am working on. I sketch to capture or record an idea, vision or dream.

When sketching, I use different materials according to my purpose for sketching. If I am casually out and about, I may use a small sketchbook (about 6" × 9" [15cm × 23cm]) or 8½" × 11" (22cm × 28cm) copier paper used with a Masonite board and a 2B or mechanical pencil. For more serious sketching, I use larger, heavyweight drawing paper (usually 80 lb. [170gsm] or more) along with 4H, HB and 4B graphite pencils.

When sketching, I may think about how to approach a common subject in a new way or about the magnificence of the world around us, but if it's lunchtime, I am probably thinking about food.

Working out my artwork not only requires knowledge, experience, observation and talent, but it also takes the right frame of mind. When sketching, I try to be relaxed and easygoing so that I am able to be more creative and also comfortable with my artwork as I progress.

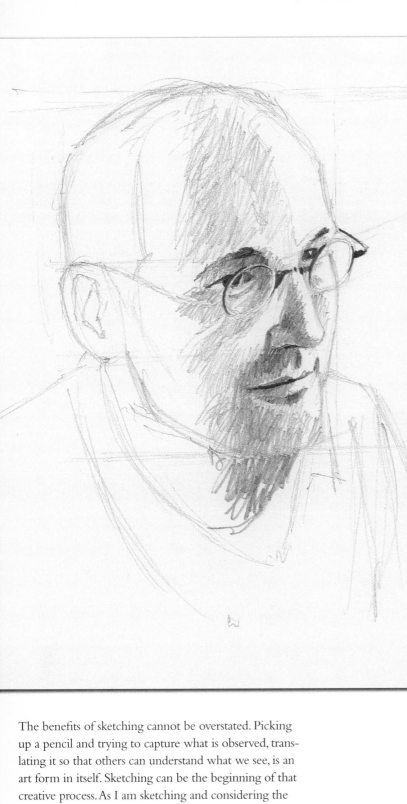

The benefits of sketching cannot be overstated. Picking up a pencil and trying to capture what is observed, translating it so that others can understand what we see, is an art form in itself. Sketching can be the beginning of that creative process. As I am sketching and considering the subject, my focus expands and I become more open to the possibilities of new subjects to study all around me. Creativity breeds more creativity.

Sketching is recording what you see visually on paper, and it is also communicating what you see to someone else.

6 . 2007

Not only can sketching shape how we see the world, but the world can shape how we view sketching. It's all interactive. Sketching involves observation of a subject that can take us into a deeper understanding of ourselves and the world around us. More than just a mechanical artist, I try to be conscious of the physical, emotional, spiritual and mental aspects of life and art.

Finished art is the culmination of ideas, an edited version of the sketches. Sketching is the development of ideas and also observational study. It keeps the mind open to creative problem-solving and new possibilities so that when you go to finished art, you will have confidence in the direction of your artwork.

It is good to develop the discipline of sketching what you observe so that you can refine your skills. Time and discipline are needed until sketching becomes so natural that it becomes a part of your everyday life.

LAUS DEO

More on the artists

ROBERT T. BARRETT
897 Walnut Ave., Provo, UT 84604
www.roberttbarrett.com
Email: robert_barrett@byu.edu
Author of *Life Drawing: How to Portray the Figure With Accuracy and Expression* (North Light Books)

DAN BECK
www.danbeckart.com
Email: danbeckart@yahoo.com
Represented by Abend Gallery (Denver, CO; www.abendgallery.com), Concetta D. Gallery (Albuquerque, NM), Greenhouse Gallery of Fine Art (San Antonio, TX; www.greenhousegallery.com), Sanders Galleries (Tucson, AZ; www.sandersgalleries.com), Waterhouse Gallery (Santa Barbara, CA; www.waterhousegallery.com), Watts Fine Art (Zionsville, IN; www.wattsfineart.com)

WILLIAM BERRA
Represented by Galleria Silecchia (Sarasota, FL; www.galleriasilecchia.com), Greenhouse Gallery of Fine Art (San Antonio, TX; www.greenhousegallery.com), Nedra Matteucci Fine Art and Nedra Matteucci Galleries (Santa Fe, NM; www.nedramatteuccifineart.com and www.matteucci.com), The Sylvan Gallery (Charleston, SC; www.thesylvangallery.com), Westbrook Galleries (Carmel, CA; www.westbrookgalleries.com)

ROBERTO (BOB) CARDINALE
23 Sabroso Rd., Santa Fe, NM 87508
http://churches.bobcardinale.com
Email: bob@bobcardinale.com
Represented by Jane Sauer Gallery (Santa Fe, NM; www.jsauergallery.com), Duley-Jones Gallery (Scottsdale, AZ; www.duleyjones.com)

ERIN CURRIER
www.erincurrierfineart.com
www.blueraingallery.com
www.parksgallery.com
www.masottatorres.com.ar

GEORGE ALLEN DURKEE
www.gadurkee.com
Represented by The Art Gallery in Murphys (Murphys, CA; www.gallerymurphys.com)
Author of *Expressive Oil Painting: An Open Air Approach to Creative Landscapes* (North Light Books)

DOUGLAS FRYER
P.O. Box 394, Spring City, UT 84662
Email: fryer@cut.net
Represented by Howard Mandville Gallery (Kirkland, WA; www.howardmandville.com), Marshall/LeKae Gallery (Scottsdale, AZ; www.marshall-lekaegallery.com), Meyer Gallery (Santa Fe, NM; www.meyergalleries.com)

TAMMY GARCIA
Represented by Blue Rain Gallery (Santa Fe, NM; www.blueraingallery.com)
Author of *Tammy Garcia: Form Without Boundaries* (Tapestry Press)

ALBERT HANDELL
www.alberthandell.com

WILLIAM HOOK
www.williamhook.net
Email: hookstudio@comcast.net
Represented by Meyer Gallery (Santa Fe, NM; www.meyergalleries.com)

CATHY JOHNSON
www.cathyjohnson.info
Online workshops: www.cathyjohnson.info/online.html
Blog: http//katequicksilvr.livejournal.com
Email: kate@cathyjohnson.info
Visit Cathy's Amazon.com page for books available from the artist, including *Watercolor Tricks & Techniques: 75 New and Classic Painting Secrets* (North Light Books).

NANCY KOZIKOWSKI
510 14th St. NW, Albuquerque, NM 87102
www.nancykozikowski.com
Email: nancyk@dsg-art.com
Represented by DSG Fine Art (Albuquerque, NM; www.dsg-art.com)

GEOFFREY LAURENCE
www.geoffreylaurence.com
Represented by Pacini Lubel Gallery (Seattle, WA; www.pacinilubel.com), Skotia Gallery (Santa Fe, NM; www.skotiagallery.com)

STEPHANIE PUI-MUN LAW
Shadowscapes Inc.
www.shadowscapes.com
Email: stephlaw@shadowscapes.com
Creator of Shadowscapes tarot deck (Llewellyn Publications)
Author of *Dreamscapes: Creating Magical Angel, Faery & Mermaid Worlds With Watercolor* and *Dreamscapes Myth & Magic: Create Legendary Creatures and Characters in Watercolor* (IMPACT Books)

BEV LEE, P.S.A., P.S.C.
www.bevlee.com
bleefinearts@q.com
Author of *Painting Children: Secrets to Capturing Childhood Moments* (North Light Books)

LINDA LESLIE
www.lindaleslieart.com
Email: linda.leslie3@gmail.com

CHUCK LUKACS
www.chucklukacs.com
Email: chuck@chucklukacs.com
Author of *Fantasy Genesis: A Creativity Game for Fantasy Artists* and co-author of *Wreaking Havoc: How to Create Fantasy Warriors and Wicked Weapons* (IMPACT Books)
Contact directly for privately commissioned work and dates for workshops in the Portland, OR, area.

JENNIFER McCHRISTIAN
www.jennifermcchristian.com
Blog: www.jmcchristian.blogspot.com
Email: liv4art@hotmail.com

RICHARD McKINLEY

www.mckinleystudio.com
Email: web@mckinleystudio.com
Author of *Pastel Pointers: Top 100 Secrets for Beautiful Paintings* (North Light Books)
DVDs: *A Studio Session, Pastel* and *A Studio Session, Oil* (Artist Productions); *Bold Underpaintings for Lively Pastel Landscapes* and *Three Stages for Successful Pastel Paintings* (North Light and artistsnetwork.tv)

JEFF MELLEM

www.jeffmellem.com
Author of *Sketching People: Life Drawing Basics* (North Light Books)

ED MORGAN

Ed Morgan Studio, P.O. Box 3280, Taos, NM 87571
www.edmorgangallery.com
Represented by Settlers West Galleries (Tucson, AZ; www.settlerswest.com)

ART MORTIMER

www.artmortimer.com

CLAUDIA NICE

Brightwood Studio
www.brightwoodstudio.com
Email: cjnice@verizon.net
Visit Claudia's Amazon.com page for books available from the artist, including *How to See, How to Draw: Keys to Realistic Drawing* (North Light Books).

P.A. NISBET

www.panisbet.com
Email: panisbet@mindspring.com
Summer/winter workshops from 2011 yearly
Represented by Meyer East Gallery (Santa Fe, NM; www.meyereastgallery.com), Medicine Man Gallery (Tucson, AZ; www.medicinemangallery.com), Christopher-Clark Gallery (San Francisco, CA; www.clarkfineart.com)
Visit www.panisbet.com/artist/publications.php for books and publications featuring the artist.

MARGY O'BRIEN

www.margyobrien.com

WILLIAM O'CONNOR

www.wocstudios.com
Author of *Dracopedia: A Guide to Drawing the Dragons of the World* (IMPACT Books)

JOE PAQUET

www.joepaquet.com

JEAN PEDERSON

www.jeanpederson.com
Email: artform@telus.net
Author of *Expressive Portraits: Creative Methods for Painting People* (North Light Books) and *Artist's Pocket Guide to Better Painting*
DVD: *Wet Glazing Watercolor Portrait* (Creative Catalyst Productions)
Represented by The Alicat Gallery (Calgary, Alberta, Canada; www.alicatgallery.com), White Rock Gallery (White Rock, British Columbia, Canada; www.whiterockgallery.com)
Workshops for Red Deer College, Leading Edge and the Federation of Canadian Artists

JOHN POTTER

P.O. Box 35, Roscoe, MT 59071
www.johnpotterstudio.com
Email: jpotterpainter@gmail.com
Represented by Mountain Trails Galleries (Sedona, AZ; www.mountaintrails.com), Mountain Trails Gallery (Cody, WY, and Jackson, WY; www.mtntrails.net)

TONY PRO

www.tonypro-fineart.com
Online painting and drawing classes: www.zarolla.com
DVD: *The Portrait Sketch With Tony Pro* (www.profineart.com/DVD)

ALAN PAINE RADEBAUGH

Alan Paine Radebaugh Studio, P.O. Box 37112, Albuquerque, NM 87176
www.radebaughfineart.com
Email: alan@radebaughfineart.com
Visit www.radebaughfineart.com/bio.htm for book publications, illustrated catalogs and public collections featuring the artist.

CHUCK SABATINO

Represented by Big Horn Galleries (Cody, WY; www.bighorngalleries.com), McLarry Fine Art (Santa Fe, NM; www.mclarryfineart.com), Sorrell Sky Gallery (Durango, CO; www.sorrelsky.com), Willow Gallery (Scottsdale, AZ; www.willowgalleryusa.com)

MARK SPENCER

www.markspencerart.com
Email: markwspencer@msn.com
Represented by Skotia Gallery (Santa Fe, NM; www.skotiagallery.com)

KATE STARLING

www.kstarling.com

ALEKSANDER TITOVETS

6443 Belton Rd., El Paso, TX 79912
Email: user415058@aol.com

LYUBA TITOVETS

6443 Belton Rd., El Paso, TX 79912
Email: user415058@aol.com

JOSHUA TOBEY

www.joshuatobeystudios.com

ELAN VARSHAY

www.elanvarshay.com
Email: evarshay@msn.com
Represented by Evoke Contemporary (Santa Fe, NM; www.evokecontemporary.com, email: info@evokecontemporary.com)
Workshops at Santa Fe Community College

FREDERICO VIGIL

Email: frederico0733@peoplepc.com

MARK WHITE

www.markwhitefineart.com
Email: info@markwhitefineart.com
Represented by Mark White Fine Art (Santa Fe, NM)

MARK WILLENBRINK

www.shadowblaze.com
Author (with Mary Willenbrink) of *Watercolor for the Absolute Beginner, Drawing for the Absolute Beginner* and *Oil Painting for the Absolute Beginner* (DVDs also available)

Index

Other fine North Light books are available from your favorite bookstore, art supply store or online supplier. Visit us at our website at www.fwmedia.com.

14 13 12 11 10 5 4 3 2 1

DISTRIBUTED IN CANADA BY FRASER DIRECT
100 Armstrong Avenue
Georgetown, ON, Canada L7G 5S4
Tel: (905) 877-4411

DISTRIBUTED IN THE U.K. AND EUROPE
BY F+W MEDIA INTERNATIONAL
Brunel House, Newton Abbot, Devon, TQ12 4PU, England
Tel: (+44) 1626 323200, Fax: (+44) 1626 323319
Email: postmaster@davidandcharles.co.uk

DISTRIBUTED IN AUSTRALIA BY CAPRICORN LINK
P.O. Box 704, S. Windsor NSW, 2756 Australia
Tel: (02) 4577-3555

Library of Congress Cataloging in Publication Data
Sketchbook confidential : secrets from the private sketches of over 40 master artists / edited by Pamela Wissman and Stefanie Laufersweiler.
 p. cm.
 Includes index.
 ISBN 978-1-4403-0859-8 (pbk. : alk. paper)
 1. Artists' preparatory studies. 2. Graphic arts--Technique. 3. Artists--Interviews. I. Wissman, Pamela. II. Laufersweiler, Stefanie.

N7433.5.S48 2010
741.9--dc22 2010025081

Art edited by Pamela Wissman
Content and production edited by Stefanie Laufersweiler
Designed by Wendy Dunning
Production coordinated by Mark Griffin

ABOUT THE EDITORS

Pamela Wissman is Editorial Director for North Light Books, IMPACT Books and ArtistsNetwork.TV, all imprints of F+W Media, where she has worked on hundreds of titles over the course of her sixteen-year career there. She has been working in the arts for over thirty years in various capacities, with a Master of Arts in Arts Administration and a Bachelor of Fine Arts from the University of Cincinnati.

Stefanie Laufersweiler is a freelance editor and writer living in Cincinnati, Ohio. She was a senior editor for North Light Books and IMPACT Books before becoming a freelancer, and she has spent over ten years editing more than fifty titles specializing in fine art, comics and crafts.

METRIC CONVERSION CHART

To convert	to	multiply by
Inches	Centimeters	2.54
Centimeters	Inches	0.4
Feet	Centimeters	30.5
Centimeters	Feet	0.03
Yards	Meters	0.9
Meters	Yards	1.1

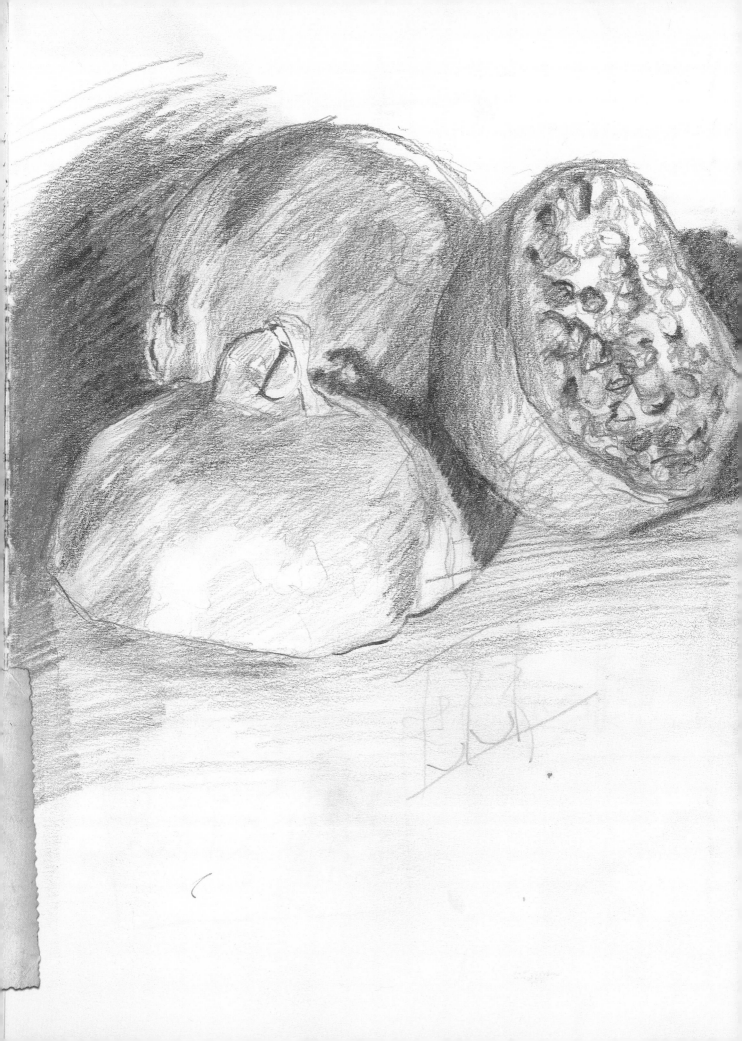

Ideas.
Instruction.
Inspiration.

These and other fine North Light products are available at your favorite art and craft retailer, bookstore or online supplier. Visit our websites at www.artistsnetwork.com and www.artistsnetwork.tv.

ART JOURNEY
NEW MEXICO

104 PAINTERS' PERSPECTIVES
from the editors of The Collector's Guide

ISBN-13: 978-1-60061-993-9
Z6449 | hardcover, 224 pages

NORTH LIGHT
BRINGING ART TO LIFE

NANCY REYNER'S
acrylic
REVOLUTION

Watercolor & Oil Effects
with Acrylic Paint

an artistsnetwork production

IBSN-13: 978-1-4403-0307-4
Z6883 | DVD running time: 45 minutes

Piecing It Together: New Trends in Collage

How To Make the Most of a Life Drawing Class

the **Artist's**

Amazing Acrylics
Representation to Abstraction

Fresh Florals
in Colored Pencil, Watercolor, Acrylic & Pastel

Paint With Wax
Learn Encaustic Technique

An Intuitive Approach to Abstraction in Acrylic

the **Artist's** magazine

Mixing Dry Media

Masters of
the Real
Daniel E. Greene
& Steven J. Levin

Best Frame Forward
Preserve & Present Your Work

A New (Twisted) Take on Perspective

June 2010
www.artistsmagazine.com

Find the latest issues of *The Artist's Magazine* on newsstands.

Receive a **FREE** downloadable issue of *The Artist's Magazine* when you sign up for our free newsletter at **www.artistsnetwork.com/newsletter_thanks**

Visit www.artistsnetwork.com and get Jen's North Light Picks!
Get free step-by-step demonstrations along with reviews of the latest books, videos and downloads from Jennifer Lepore, Senior Editor at North Light Books and Online Education Manager.